KU-354-766

Mission Statement: *Graphis* is committed to presenting exceptional work in international Design, Advertising, Illustration, Mission & Photography.

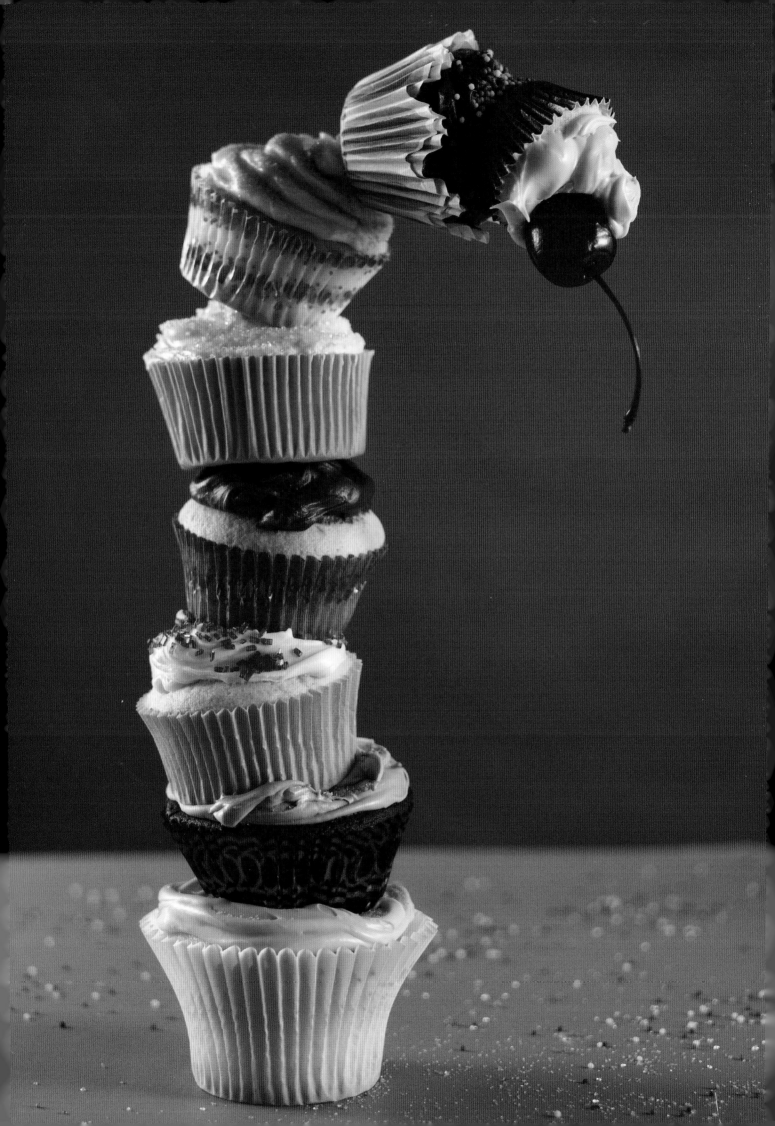

CEO & Creative Director:
B. Martin Pedersen

Publishers:
B. Martin Pedersen,
Danielle B. Baker

Editor:
Anna N. Carnick

Designer:
Kristin Johnson

Support Staff:
Rita Jones,
Carla Miller

Interns:
Veronica Castillo,
Tae Mee Chang,
Alejandro Largo,
Daniel Reece

Published by
Graphis Inc.

Opposite Page:
Val Bourassa,
General Mills
Photography Studio

Design2007

MANY AWARDS.

MANY THANKS.

Contents

Opposite Page:
Jack Anderson,
Hornall Anderson
Design Works

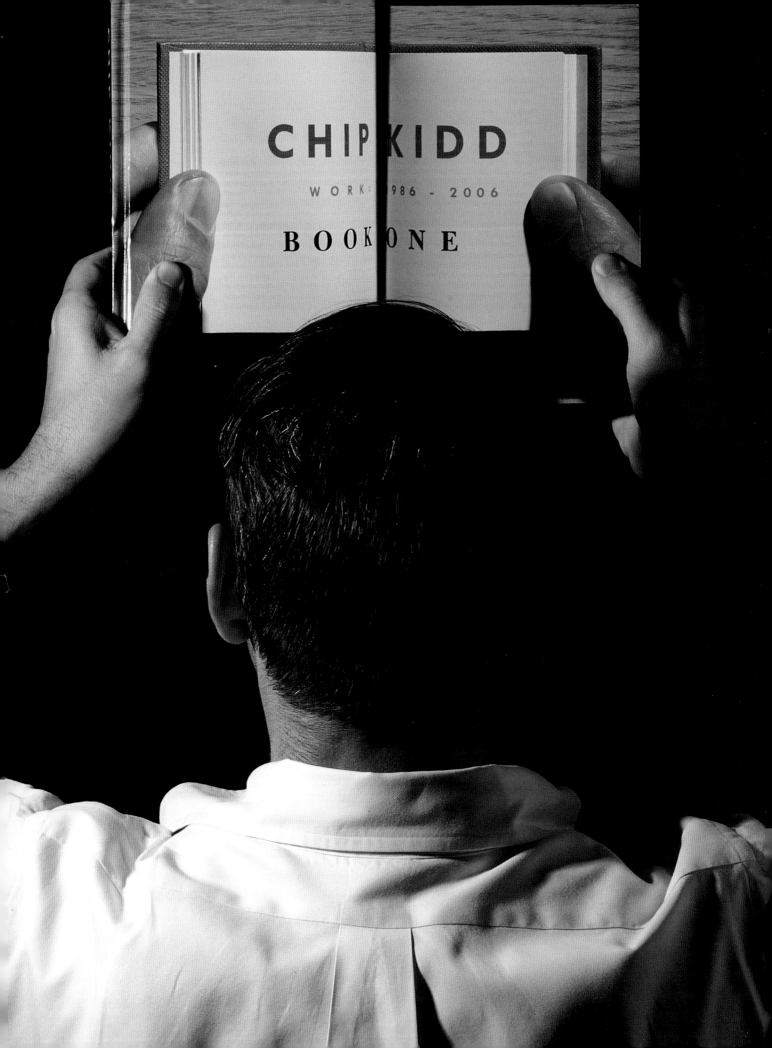

A Conversation with Chip Kidd We recently had the pleasure of an exchange with the celebrated designer and sought-after speaker, Chip Kidd. His christened name seems to make stardom inevitable, but he has earned his noted status by consistently delighting audiences with his witty presentations. For 20 years he has designed book covers at the prestigious Alfred A. Knopf publishing house. More recently, he has ventured within the book covers by writing a national bestselling novel, *The Cheese Monkeys*. Now, Kidd himself is the subject of an eleven-pound monograph detailing his prolific career. Because he's a devoted fan of DC comics and Charles Schulz, we knew we would get along. What we didn't know, is which celebs are stalking him these days. Turn the page to find out…

BLACKBURN COLLEGE
LIBRARY

Acc. No. BB10130

Class No. 741.6 PED

Date 12|06

oto by Geoff Spear

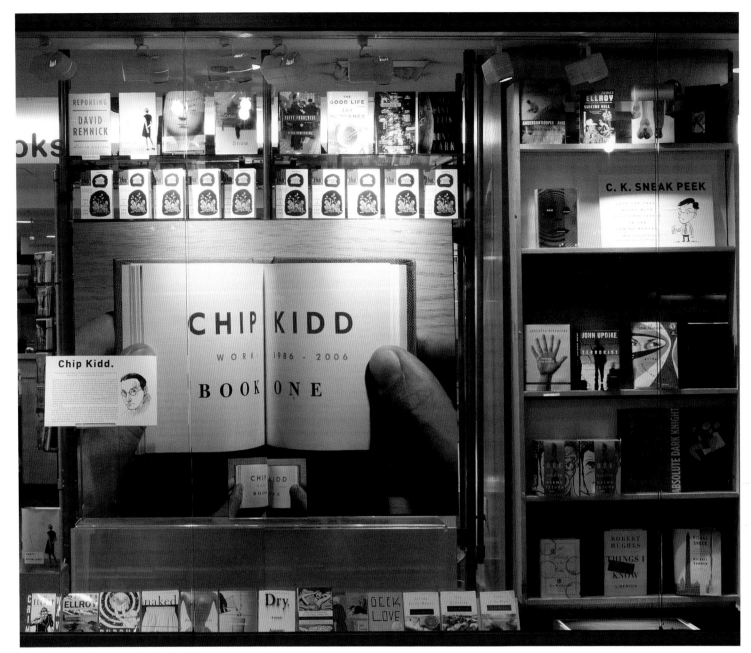

Posmanbooks Display Window, photo by Geoff Spear

"You could digitize the entire Library of Congress
(which is no doubt under way) and that would
never stop people from wanting beautiful books
to hold, look at, page through, own."

"The logo for the AIGA. Dear God, a professional
organization dedicated to graphic excellence
with that logo is like Frank Lloyd Wright living
in a homeless shelter."

Can you remember the first book cover that left a strong impression on you?

No, but I remember the first design element that did—the Bibles in the pews at Calvary UCC Church in Reading, Pennsylvania, which I read as a boy, had all the text printed in black, EXCEPT for Jesus's dialogue. It was so clear: anything Jesus said was in RED. To this day I can't hear so much as "The meek shall inherit the Earth" without seeing it in 11 point Times Roman, the color of lamb's blood.

You write so warmly in the book about the environments in which you've been educated—both at Penn State and at Knopf. It seems as though talent, luck and timing have really coordinated well for you. Where do you think you'd be today if you hadn't landed that first job at Knopf?

I shudder to think, but I suspect there would be plenty of pulmonary resuscitators, same-day cleaners, sherpas and grief counselors involved.

What do you believe helped most in your success?

You nailed it on the head when you mentioned luck. That was a HUGE part of it. That and my special giant cardboard ashtray hat that I made myself and that lights up and plays "Baubles, Bangles and Beads" in Latvian when you rub it. And I mean really, really rub it.

Who was your greatest professional mentor?

In college, it was my professor Lanny Sommese. Then, during the first year that I started working (1986), Knopf art director Sara Eisenman and Random House VP art director Robert Scudellari really showed me the ropes. Since then, current Knopf AD Carol Carson and editor-in-chief Sonny Mehta have been most responsible for enabling me to grow as a designer.

Do you recall an instance where your ability and work as a designer made you particularly proud?

A couple of years ago I redesigned all the Batman comics for DC, designed covers for John Updike and Cormac McCarthy, and did a poster for the Telluride Film Festival—all in the same week. I love the variety of subjects and sensibilities, really thrive on it.

You've designed a number of hard covers, and described them as permanent objects because no one really throws them away. What are some favorites? Are there any covers out there that you'd like to take back?

The three closest to my heart, as of this writing, are the covers for my novel *The Cheese Monkeys*, *Batman Collected*, and the monograph (*Book One*). As for covers I'd like to take back, there are too many to single out. We were going to put an entire section of my most appalling jackets in Book One but scrapped the idea because of space limitations. There was a LOT there, believe me.

What part of your work do you find the least interesting?

Having to start over after something gets rejected is obviously a drag. Yes, after twenty years, it still happens, and not infrequently. Then again, forcing one's self to make that situation interesting is what helps one grow. For example, my designs for David Sedaris's 'Dress Your Family In Corduroy and Denim' were rejected six times until I came up with the final one, which was by far the best. So they were right to keep pushing me. Bastards.

Is your work based on intuition, rational consideration or both?

I'd say a mix of the two that varies with the project. But certainly intuition is more valuable and harder to conjure. It's like a truffle—you just have to act like a pig and start sniffing the dirt.

Any books you wouldn't do the covers for? Any instances where you chose to turn down an assignment?

At this point I'd have to say that any book by or in favor of anyone in the Bush administration would be out of the question, unless I could figure out some way to encrypt the design with a subliminal message that would finally get everyone to understand how fucking evil they are. Ditto anything pro the Catholic Church. Or that godless, narcissistic, ball-chewing shrew, Anne Coulter. But somehow I doubt I'll ever be asked, which is just fine with me. I did turn down a cover for "financial guru" Suze Orman once, she of the maniacally terror-inducing leer.

Where do the ideas most often strike you—at your desk, in the bathtub, walking down the street?

The ideas that strike me in the bathtub aren't really printable here, at least not in any sort of polite, palatable manner. So let's just not go there. But walking down the street in New York gives you plenty of ideas too, like about buying pepper spray, dodging out-of-control traffic, and unexpected uses for sequins.

How do you keep the process fresh and the results original?

I think living in New York City has a lot to do with that. Not only because it's so stimulating, but because the level of competition is so high. I thrive on that, and it forces me to constantly re-think approaches to design problems. When I think of other designers vying for the same jobs I am, to motivate myself I picture pieces of them in my stool. But in a really good-natured, supporting kind of way. That's so important.

What satisfies you most in your work?

In the immortal words of Paula Scher, making stuff. Stuff that you can hold and put on a shelf and look at and then make more. As in, of course, books. There's been more talk recently of digital, or 'e-books' replacing the printed page. Ridiculous. You could digitize the entire Library of Congress (which is no doubt under way) and that will never stop people wanting beautiful books to hold, look at, page through, own. There's a whole new generation of kids who are reading *Harry Potter*, etc. and they're NOT doing so on a screen. It's not like what happened to the music industry. There were books around centuries before recorded music and they'll be around long after everything else has been reduced to ones and zeros.

If there was one project in the world that you would love to see redesigned, what would it be and why?

The logo for the AIGA. Dear GOD, someone please do an intervention. A professional organization dedicated to graphic excellence with that logo is like Frank Lloyd Wright living in a homeless shelter.

Identify a stellar example of effective and meaningful design.

One hundred percent cashmere, moisture resistant penis cozies. And the Constitution of the United States.

You seem to love your job, but if you could do anything at all in the world, regardless of credentials, what would it be? What's your dream job?

Can we use the 'Way-Back' machine? Because if so, then I want to be Chris Partridge on *The Partridge Family*. But then of course that means that by now I'd be well into my third stint of rehab. Oh well. Every day is a gift!

Does being a first-rate book designer translate into a glamorous social life? Do you spend your off work hours attending galas, receptions, and other festivities?

It's funny that you asked that. Just now I've had to put Paris Hilton on hold to answer this question. Well, I say let her hang, that skanky ho. Really, I don't know how these perceptions get out into the world, but the boring truth is that at this point I'm a largely domesticated animal. Admittedly, when I started at Knopf there seemed to be a book party to go to at least once a week (and I did, burp!), but those have become practically an endangered species.

We think you're a rock star, but admittedly, it's in a relatively obscure genre. Do you get lots of requests for autographs, and do you enjoy being in the limelight?

Relatively obscure? There's nothing relative about it! It's obscurity itself!

May we have your autograph?

Sure!! Bend over, please …

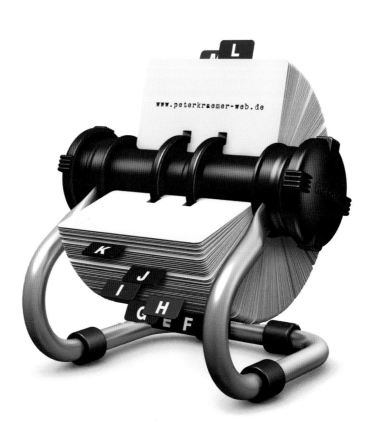

Credits&Commentary

Previous Spread:
Peter Kraemer, Forum Magazine

Introduction

2 *Let's Play*
Design Firm: General Mills
Creative Director/Food Stylist: Carol Grones
Photographer: Val Bourassa
Client: General Mills

This photograph was intended to be a playful fun shot. It is a surreal cupcake scape. This photograph was also submitted to a juried photography exhibit for the International Association of Culinary Professionals convention in Seattle. The theme was "The Art of Food."
© General Mills 1996

4 *Hornall Anderson Awards Certificate Display Case*
Design Firm: Hornall Anderson Design Works
Art Director: Jack Anderson
Designers: Jack Anderson, SKB Architects
Client: Hornall Anderson Design Works

We wanted a unique way to display our various award certificates and chose to encompass them in see-thru glass, folded in half as a means of showing we don't take ourselves too seriously when it comes to awards; after all, it's all about great design—not just how many awards you win. However, we included a message that emphasizes our sincere gratitude for all of our wins.

10 *Mr.*
Design Firm: Peter Kraemer
Art Director/Designer: Peter Kraemer
Client: Forum Magazine

This 3D illustration of a rolodex was used to promote my website.

Annual Reports

22 *New and Improved Formula*
Design Firm: Squires & Company
Client: FelCor
Creative Director: Brandon Murphy
Designers: Brandon Murphy, Laurie Williamson
Illustrators: Ernesto Pacheco, Laurie Williamson
Photographer: James Bland
Writers: Monica Hildebrand, Laurie Williamson

23 *Ameristar Casinos 2005 Annual Report*
Design Firm: Kuhlmann Leavitt Inc.
Art Director/Creative Director:
Deanna Kuhlmann-Leavitt
Designer: Thomas Twellman
Photographer: Roxanne Lowit
Writer: Penelope Rowlands
Client: Ameristar Casinos Inc.

24, 25 *2005 Annual Report*
Design Firm: Addison
Creative Director: David Kohler
Designer: Miho Nishimaniwa
Photographer: Jody Dole
Client: GATX Corporation

26 *Designbericht Bayern 2003-2005*
Design Firm: hafelinger+wagner design
Creative Director: Frank Wagner
Art Director: Thomas Tscherter
Client: bayern design GmbH

27 *Annual Report '05*
Design Firm: Squires & Company
Client: Crosstex Energy
Creative Director: Brandon Murphy
Designer: Bret Sano
Photographer: Pete Lacker
Writer: Crosstex

Award Annuals

28, 29 *Book of the Year*
Design Firm/Client: School of Visual Arts
Art Director: Geneveive Williams
Creative Director: Richard Wilde
Designers: Ha Do, Lenny Naar, Ana Pavlovic,
Chris Spooner, Lisa Sobcynski
Photographers: David Miao, Kanako Sasaki

Book of the Year 2005 is the yearbook of the class of 2005.

Awards

30 *Midas Gold Bars*
Design Firm: Flow Creative
Art Director/Designer: Jeff Clift
Client: Midas Award Show
(sub-brand of New York festivals)

A three dimensional gold bar was designed for the Midas Gold Award. All awards are custom engraved with credits for the award-winning team.

31 *IDA Statuette*
Design Firm: Ron Taft Design
Designer/Art Director: Ron Taft
Client: The International Design Awards

The International Design Awards recognize and celebrate outstanding achievements of the world's best designers in all disciplines. Architecture, fashion, automotive design, environmental design, electronics engineering, graphics, and product design are just a few of the many categories in consideration. The brushed steel IDA statuette, standing 13 inches tall, is a sophisticated typographic expression of the universal values of great design: form, space and simplicity. The polished platinum base houses the recipient's category and information in a retractable dome-shaped backlit drawer that slides out when triggered by a light sensitive sensor.

32 *The Codie Award*
Design Firm: Bussolati Associates
Art Director/Designer: Monica Bussolati
Client: Software and Information
Industry Association

One of SIIA's principle missions is to promote the common interests of the software and digital content industry as a whole, as well as its component parts. The Codie Award celebrates and promotes the achievement and vision in software, education technology and digital content. Codie Awards identify the best in the software and information industry.

33 *The Brain Award*
Design Firm: Saatchi & Saatchi Los Angeles
Designers/Art Directors:
Joshua Gilman, Alex Alvarado
Executive Creative Director: Harvey Marco
Print Producers:
Lorraine Alper Kramer, Gloria Olegario
Client: Saatchi & Saatchi Los Angeles

An award for thinking. Thinking=brain. How about a brain? Hot rod brain. Fat wheels. Big Daddy Ed Roth. Sketch artist. Sculpt. Re-sculpt. Cast. Wheels. Paint. Find a base. Assemble. Choose recipient. Engrave plaque. Done.

Books

34, 35, 36, 37 *Zaha Hadid—Complete Works*
Design Firm: Thomas Manss & Company
Art Director: Thomas Manss
Designer: Damian Schober
Client: Thames & Hudson

The Complete Works by Zaha Hadid, one of the world's most celebrated architects, consists of four volumes presented in a 3-D ruby-red Lucite slipcase. The brief: Design the definite overview, incorporating four volumes of differing sizes that offer multiple perspectives—Major and Recent Projects, Projects Documentation, Models and Sketches, Essays and References—leading to one of the most complex monographs ever produced. The design takes the content and the architectural forms that Zaha Hadid is known for and presents it in an interesting way.

38, 39 *In My Stairwell*
Design Director: Fred Woodward
Art Director: Ken DeLago
Photographer: Mark Seliger
Text: Matthew Barney and Lou Reed
Client: Rizzoli
Produced By: GQ Magazine

40 *Mario Vargas Llosa. Complete Work*
Design Firm:Carrio/Sanchez/Lacasta
Art Directors/Designers:
Carrio/Sanchez/Lacasta
Illustrator: Pep Carrio
Photographers: Marco Monti, David Jimenez
Writer: Mario Vargas Llosa
Client: Editorial Alfaguara

The collection includes the complete work of the writer Mario Vargas Llosa. All the book covers are illustrated combining photographs and objects in order to recreate the author's universe.

41 *Faberge: Treasures of Imperial Russia*
Design Firm: Sotheby's
Art Directors: Sandra Burch, Harold Burch
Designers: Harold Burch, Tirso Montan
Photographer: Jerry Fetzer
Writer: Geza von Habsburg
Client: Viktor Vekselberg, Chairman,
The Link of Times Foundation

Design Brief: To produce a 352 page volume, printed in both Russian and English, that captures these Faberge treasures of Russian art as no other book ever has. Each page In the hardbound, slipcase volume has to be a glimmering testimony to Faberge's genius, with illustrations that bring the Imperial Eggs into crystal-clear focus, so close you can almost touch them.

42 *Foster Works 4*
Design Firm: Thomas Manss & Company
Art Director: Thomas Manss
Designer: Lisa Sjukur
Writer: David Jenkins
Client: Norman Foster

Foster Works is a collection of six volumes featuring Norman Foster's complete œuvre from the early Team 4 beginnings to the latest projects. The six books will be published over a period of three years by Prestel. Norman Foster sketches explain the key principles which have informed much of his career, lavish dividers announce the main features, specially commissioned illustrations explain the workings of the buildings and pictures by leading architectural photographers show the projects with all their facets. The books are finished in grey cloth with an acetate dustjacket silkscreened in silver and have two main distinctive parts. The first part contains the individual projects explored in detail and the second part is a collection of essays from various contributors. In addition, there is the 'film section' which runs at the top all the way throughout the books. These have quotes and images that inspired the projects and also historical events that might be of interest to the reader. To distinguish the essays from the projects, the projects are always in colour and the essays in B/W. Foster Works 4 explores the first years of the 90s including the making of the Great Court and The Reichstag. Works 4 was published in October 2004.

43 *Paula Rego—Virgin Mary's Life Cycle*
Design Firm: RMAC Brand Design
Art Directors: Ana Cunha, Ricardo Mealha
Designer: Ana Cunha
Client: Museu da Presidencia da República/
Presidential Museum

Paula Rego's paintings have vastly enriched the collection at Belém Palace. They were created specially for the old chapel and fit in wonderfully. This album is being published to enable as many readers as possible to get to know this original Life of the Virgin in its full beauty. These paintings dedicated to Our Lady of Bethlehem, donated to the Portuguese state by artist, offer a decidedly contemporary view of an essential theme of Western culture, which has so inspired artists over time. This is undoubtedly one of the most significant contributions to have taken place at Belém Palace in the last 100 years, and it launches a new phase in the artistic life of the palace.

44 *NEW*
Design Firm: New Moment New Ideas Company
Art Directors: Dragan Sakan, Nebojsa Rogic,

Milos Djukelic, Milan Popovic, Svetlana Copic
Creative Director: Dragan Sakan
Designers: Tomas Ljumovic,
Milica Katic, Ana Cvejic,
Writers: Dragan Sakan, Bogdan Tirnanic
Client: New Moment New Ideas Company

After 55 years of life and 30 years in creative business, Dragan Sakan, founder and creative director of New Moment New Ideas Company, created "New Dragan Sakan" book—a multimedia autobiography about the past and the future-new ideas.

45 *The Last Place on Earth*
Design Firm: National Geographic Books
Art Director: Yolanda Cuomo, Design NYC
Design Director: Marianne R. Koszorus
Designer: Yolanda Cuomo,
Design NYC, Kristi Norgaard
Photographer: Michael Nichols

46 *Studio MX 2004 (China Edition)*
Design Firm: A Charles Design Inc.
Art Director: Ann Gallenson
Creative Director: Kirst Aho
Designers/Illustrators:
Ann Gallenson, Victor Cheung
Writer: Kirsti Aho
Client: Macromedia Inc (Adobe Inc.)

Student textbook for teaching web design using software products in Macromedia Studio MX 2004.

47 *Stumpjumper: 25 Years of Mountain Biking*
Design Firm: Vehicle SF
Creative Director: Dennis Crowe
Designers: Mark Winn, Kevin Head,
John Schall, Stefan Grigg, Drew McGaraghan
Illustrator: Brian Taylor
Writer: Mark Riedy
Client: Specialized

This book celebrates the colorful history of the Stumpjumper—the first commercially massproduced mountain bike—from Specialized Bicycles. The tree rings of a stump are utilized as a time / navigation device. The archival photos, gleaned from shoe boxes and photo albums, are reproduced faithfully with the authenticity that scratches, blemishes and faded color provide.

48, 49 *Jed Johnson: Opulent Restraint*
Design Firm: Matsumoto Incorporated
Art Director/Designer: Takaaki Matsumoto
Client: Rizzoli

50 *Chanel*
Design Firm: Matsumoto Incorporated
Art Director/Designer: Takaaki Matsumoto
Client: The Metropolitan Museum of Art

51 *HIROSHI SUGIMOTO*
Design Firm: Matsumoto Incorporated
Art Director/Designer: Takaaki Matsumoto
Client: Mori Art Museum

52 *Tihany Style*
Design Firm: Mirko Ilic Corp.
Art Director/Designer: Mirko Ilic
Client: Tihany International

Promotional book for Tihany International, an interior design firm.

53 *The Art of Gaman*
Design Firm: Pentagram San Francisco
Art Director: Kit Hinrichs
Designers: Kit Hinrichs, Takayo Muroga
Photographer: Terry Heffernan
Writer: Delphine Hirasuna
Client: Ten-Speed Press

54 *Surf Book*
Design Firm: Lloyd (+ co)
Art Director/Designer: Doug Lloyd
Photographer: Michael Halsband
Client: Michael Halsband Studio

55 *Frost* (sorry trees)*
Design Firm: Frost Design
Creative Director: Vince Frost
Designers: Vince Frost, Anthony Donovan
Writer: Lakshmi Bhaskaran
Client: Frost Design

(sorry trees) is the first book to comprehensively document the work of award-winning graphic designer, Vince Frost. Written by Lakshmi Bhaskaran the book provides 500 pages of ideas and inspiration, created to be both accessible and entertaining to all.

Presenting a complete overview of the designer's life and career, the book explains Frost's philosophy and approach, while individual descriptions reveal the key characteristics of each project. The book includes hundreds of photographs from Frost's personal collection, presented in contrast to design projects.

(sorry trees) offers a unique insight into Frost's daily working practice—from his early days cutting it as a young designer in London to his recent relocation to Sydney, and is peppered with personal, and often amusing anecdotes and insights along the way.

The book also tells the story of Frost's own life—from how growing up in Canada laid the foundations for Vince's bold aesthetic and subsequent rise through the London design scene, to the nomadic lifestyle that has seen him live in 44 houses in 40 years. It is this existence that enables Frost to cross traditional boundaries—working on anything from postage stamps to the built environment. His genuine love for his craft ensures his work remains both heartfelt and sincere.

"For me, good design is about ideas—and the difference they can make to a business," says Frost. "I also wanted to open up the design process to show where those ideas come from and how they are realised."

56 Kendrick Revealing Character Campaign
Design Firm: McGarrah/Jessee, CHAOS
Creative Director: Bryan Jessee
Designers: Ryan Rhodes, Derrit DeRouen
Photographer: Robb Kendrick
Client: Robb Kendrick

The mission of this project is to preserve the character of Texas in a collection of photographic art to inspire the citizens of Texas. In 2004, Frost Bank, in partnership with Texas Monthly, asked renowned Robb Kendrick to document today's Texas Cowboy in an effort to not only rekindle our heritage but also to remind us all that character is alive, well and just as important today.

57 Harley-Davidson Ride Atlas of North America
Design Firm: Rand McNally
Design Director: Joerg Metzner
Designers: Joerg Metzner, Paul Lefebvre
Editor: Mary Lu Laffey
Client: Rand McNally & Company

Head off the highway with this new title from Rand McNally and Harley Davidson. The Ride Atlas of North America is a perfect companion for weekend cruising or cross-country rides on your motorcycle. With a durable, rubber-like cover, this rugged little atlas contains route suggestions that help riders navigate off the beaten path by highlighting secondary routes. Features include: 25 fully detailed motorcycle rides and ride maps; motorcycle laws, emergency roadside assistance, gas finder information; Harley dealerships spotted on state maps; 8.5"x 11" dimensions allow the book to fit in a saddle bag; Elastic band closure; wiro binding for easy page-turning; helpful hints, like the best season to tour a specific area and attractions along the way; 320 full-color pages

Branding

58, 59, 60, 61 ISSIMBOW
Design Firm: Shin Matsunaga
Art Director/Designer: Shin Matsunaga
Client: Nippon Kodo Co.,Ltd.

"ISSIMBOW" is a brand created through a fusion of the knowledge compiled in "Ishinho," Japan's oldest medical dictionary with a history dating back one thousand years, and 21st century science. For humankind in this modern age, being more healthy, lively and beautiful is an eternal desire involving the five senses. In order to satisfy this desire, ISSIMBOW aims to create fantastic products based on the theme; wellness. The Ishinho dictionary is a world-class cultural asset, designated as a Japanese national treasure, while ISSIMBOW is a registered trade name of Nippon Kodo Co., Ltd., well known as a leading incense manufacturer. While incense related products are created by Nippon Kodo, the rest are created in collaboration with companies in different fields which support the brand concept. The key-visual element is flexibly developed in all directions, based on the freely applied logotype. Shown here are design items of the initial stage.

62, 63 Boudin at the Wharf: The Signage
Design Firm: Pentagram San Francisco
Art Director: Kit Hinrichs
Designers: Kit Hinrichs, Laura Scott
Client: Boudin

64 Shopping Center with Designer Stores
Design Firm: Stromme Throndsen Design
Creative Director: Morten Throndsen
Designers: Eia Grødal, Morten Throndsen
Photographer: Lasse Berre
Client: Steen & Strøm

Steen & Strøm shopping centre was reopened after a total reconstruction. The corporate identity creates a substantial and memorable image, with a very elegant and classic character. Elements of visual identification, logotype and monogram reflects the modern shopping centre with its high quality designer stores.

65 Look and Feel
Design Firm: Landor Associates
Executive Creative Director: Nicolas Aparicio
Senior Designer: Anastasia Laksmi
Photographer: Michael Friel
Client: Panorama

Western Grasslands, Inc., a player in the grass-fed beef category, retained Landor to develop a new name and identity for the brand. The result, the new name "Panorama" and a distinctive core signature, communicates a premium positioning of the brand in a niche marketplace.

66 NewActon
Design Firm: emerystudio
Creative Director: Garry Emery
Designer: Job van Dort
Client: Molonglo Group

The New Acton designed by architects Fender Katsalidis, is a property development in Canberra surrounded by the recreational locale of Lake Burley Griffin and the campus of the Australian National University. What people love about Canberra is the wide open space and the ease of everyday life, but what many (particularly those who come from other places) miss is the buzz, conviviality, street life and the stimulation of a vibrant urban community and culture. For the first time in Canberra the best of both worlds will spring to life in a vital new city's edge urban village on the lake, built around heritage Acton House. The village will have an arts and culture focus. emerystudio is developing the brand identity and marketing communications program including the signage and site identification, all of which have been considered as an integrated whole. As a primary point of difference for the marketing, the project has been positioned as an arts precinct. The brand identity aspires to elaborate and reinforce this key attribute. Expressions of the brand identity will be visible in two, three and four dimensional spatial environments.

67 Gasworks
Design Firm: emerystudio
Creative Director: Garry Emery
Designers: Mark Chen, Ben Kluger, Jane Mooney, Tim Murphy
Client: Gasworks

Gasworks is a residential, commercial and retail property development in Brisbane, the Capital city of Queensland, Australia's sunshine state. The nature of the project refers to the historic use of the site and remnants of the nineteenth century heritage listed gasometer landmark have been retained and will be incorporated as part of a contemporary architectural feature with a commercial and civic function. emerystudio has developed the marketing communications program and the brand identity for the project. The brand identity comprises a flexible system of elements, each with a specific purpose; naming, a wordmark, a symbol, and photographic imagery conveying a sense of place and the aspiration for marketing and the ongoing re-use of the site. The project symbol has been embedded in the evocative pictorial representations that introduce the proposed spirit for the place and the marketing positioning intentions. Various expressions of the brand will be represented in two, three and four-dimensional spatial environments. The architecture is by Ian Moore and Donovan and Hill.

68 Identity
Design Firm: NOISE, Inc.
Art Director: Dave Kotlan
Creative Directors: John Sprecher, Dave Kotlan
Designers: Kelly Heisman, Jackie Zernia
Writer: John Sprecher
Client: NOISE, Inc.

This is a branding identity for a terrific multi-media branding communications agency.

69 Identity
Design Firm: Siegel & Gale LLC
Art Directors: Young Kim, Anne Swan
Creative Director: Howard Belk
Designer: Lloyd Blander
Writer: Peter Swerdloff
Client: The New School

The New School is a novel, lively and unconventional institution that, for that very reason, faces major branding challenges. Its eight schools are highly independent. Some are as well or better known than the parent university. The heritage of change and personal expression that makes the university exciting also makes it more complex to reach consensus. The new branding effort is the culmination of a two year process that began with a major research study. It included lengthy conversations with the leaders of the university, and ended with open "town-hall" meetings with the entire New School community. The result is a naming architecture that makes the name of the university—The New School—an integral part of the names of the divisions. A design approach that captures the attitude and urban excitement of the campus and the students. And a new advertising campaign that tells the public what the university is—and what it stands for. To date, enrollments are up, alumnae giving is strong and, most important, there's broad agreement that the new brand captures the essence of the university.

70 Inner Beauty
Design Firm: Foote Cone & Belding
Art Directors: Poh Hwee Beng, Cetric Leung, Lee Pui Ho
Creative Directors: Poh Hwee Beng, Danny Chan, Cetric Leung
Designers: Cetric Leung, Lee Pui Ho
Illustrators: Lim Peng Yam, Lee Pui Ho
Photographer: Sam Nugroho
Writers: Danny Chan, Antonius Chen
Client: Natural Beauty

Natural Beauty is a beauty brand in China that has a full range of beauty related 'products' like running university in Shanghai & beauty salons in various cities of China. It also carries a full range of skin care products and health supplements. The object of this campaign is to communicate the corporate philosophy of Natural Beauty that inner beauty is more important than superficial beauty.

71 Chi of Beauty
Design Firm: Foote Cone & Belding
Art Directors/Designers/Illustrators: Cetric Leung, Lee Pui Ho
Creative Directors: Poh Hwee Beng, Cetric Leung, Danny Chan

Natural Beauty is a corporation firmly established in the health and beauty business, providing products and services ranging from cosmetics, beauty treatment, health products, and spas to a College of Beauty. Natural Beauty believes that true beauty should come from deep within the soul, and aims its product and service lines to enhance the inner beauty of a woman, rather than to distort or overshadow it. To faithfully reflect corporate beliefs, the new Natural Beauty identity carries the theme of "The Chi of Beauty." Chi "C" the air, lifeforce or energy within a person in traditional Chinese medicine and philosophy is represented in a graphic aura, symbolizing the way a woman's inner beauty permeates through from within her soul and spirit. This visual identity comes in a variety of forms and colours, representing the different beauty of different women, and can be adopted according to usage and occasion, creating an ever-changing, ever-progressing image for Natural Beauty without diluting the core essence of the identity. The brand name is simplified to a logo comprised of the initials "nb" and placed at the core of the Chi aura, defining the place of the brand in beauty.

Brochures

72 Ink! Launch Brochure
Design Firm: Mytton Williams
Creative Director: Bob Mytton
Designer: Tracey Bowes
Writers: Tom Chesher, Simon Jones
Client: Ink! Copywriters

Ink! is a new team of copywriters who needed a launch brochure as part of their new identity to promote their company and services. The brief specified that the brochure should "appeal to the country's best, and most cynical, designers."

73 FIDM News
Design Firm: Danielle Foushee Design
Art Director/Designer/Hand-lettering: Danielle Foushee
Writer: Victoria Namkung
Photographer: Brian Sanderson
Client: The Fashion Institute of Design & Merchandising

Client Brief: Create a magazine that presents the successful careers of the college's alumni. Intended Audience: High school students interested in pursuing careers in fashion, interiors, graphics, and entertainment. Objectives: This piece intends to show students the range of career possibilities with degrees from FIDM. Special Features: Notice the three different hand-lettered typographic headline treatments.

74 Laurene Krasny Brown Art Catalog
Design Firm: Weymouth Design
Art Director/Photographer: Michael Weymouth
Designer: Arvi Raquel-Santos
Client: Copley Society of Art

Copley Society of Art sponsored an exhibit for their featured artist, Laurene Kransy Brown. Laurene's artwork are assemblages with paper and color, and therefore, the catalog was meant to exhibit Laurene's work while capturing the essence of her pieces.

75 Loudspeakers 800 Series
Design Firm: Thomas Manss & Company
Art Director: Thomas Manss
Designers: Damian Schober, Lisa Sjukur
Client: Bowers & Wilkins

Bowers & Wilkens is considered by the hi-fi specialist industry to be the No 1 high end loudspeaker manufacturer in the world and has become the reference speaker in nearly all of the world's classical recording studios (including EMI Abbey Road, Decca and Deutsche Grammophon). The hardbound 800 Series brochure is aimed at music industry professionals and

the discerning home theatre user. It is not only used for point of sale and retail purposes but is also sent out as a direct marketing tool to every existing owner to entice them to upgrade to the even more technically advanced new product. The content shows a mixture of the pioneering technical advances, interviews with well-known B&W enthusiasts and striking images. The cover shows a simple illustrated drawing of the diamond tweeter dome and incorporates the DVD which has become the leitmotif for most printed collateral. The magazine-style layout helps to make complex technical information easier to digest and the use of interviews to separate the sections makes it more engaging to read. The attached DVD tells the full story of how everything keeps moving on at B&W. The DVD and hardbound brochure are designed to be too valuable to throw away. They provide multi-sensory access to the whole B&W story: analog/paper and digital/screen. The brochure with DVD was printed and distributed in January 2005.

76, 77 *Bath & Bath Brochure*
Design Firm: ico Design Consultancy
Art Director: Vivek Bhatia
Creative Director: Ben Tomlinson
Designer: Vivek Bhatia
Photographer: Lee Mawdsley
Client: Bath & Bath

We were commissioned by development company Bath & Bath to produce a brochure to market an extravagant, Grade II listed house over five floors in the heart of Belgravia, London. It was redeveloped over two years with a vision and a passion by its developers to provide the highest quality of living and interior design. This was echoed in the solution by using a host of complementary, tactile materials, production techniques and clean stylish photography. This enabled us to capture the historic, prestigious nature of the house and its location, as well as the contemporary benefits demanded by its market. With a price tag of over £30 million the target audience consisted predominantly of international businessmen and women, wealthy entrepreneurs from as far afield as Russia and the Middle East, looking to buy a family residence in London. It was also important the book appealed on an emotional level, so it engaged not only buyers but their families too, so all could imagine living there for potentially only several weeks of the year. The brochure's principal goal as a marketing tool was to generate interest in the target market, by communicating and confirming the prestige of the house and its location. The piece itself acted as an exclusive invite and ambassador for the house.

78 *Bell Helicopters 2006 Sales Brochures*
Design Firm: Vic Huber
Client: Bell Helicopters
Art Director: Ron Head/imatrix
Creative Director: Scott Brewer/t:m agency
Designer: Ron Head
Photographer: Vic Huber
Writer: Geoff Owens

Strategically speaking, this series of brochures was designed for Bell to break out of the traditional mold for the helicopter/aircraft industry. Much in the same fashion that any high-end car brochure might romance a customer with beautiful photography and the right voice, our goal was to captivate the prospect with an artful representation of each of the aircraft's unique features.

79 *IE Singapore—Printing Brochure*
Design Firm: Equus Design Consultants Pte Ltd
Art Directors/Designers:
Tay Chin Thiam, Chung Chi Ying
Creative Director: Andrew Michael Bain
Photographer: Ken Seet
Writers: Natalie Foo, Andrew Thomas
Client: International Enterprise Singapore

The Client, IE Singapore (the Singapore government's trade development arm) wanted a bro-

chure to raise awareness about the quality of the Singapore printing industry among international print buyers. The brochure also had to act as a showcase for the broad range of high-end capabilities & printing techniques one can find in Singapore. Our concept, built around the theme of "Better things to do (than worry)" takes a humorous approach, communicating the message that with Singapore printers on the job, print buyers won't need to worry about anything—they can just sit back & do all the things people do when they have time to kill, like popping bubble wrap, doodling, check their makeup, daydreaming about holidays, catching a nap, or doing the crossword. The brochure enables the reader to do all these things, in the process showcasing all the tricks & printing techniques that Singapore printers excel at.

80 *En quelques mots*
Design Firm: Atelier Trois Petits Points
Art Director: Sylvie Nowak Hainneville
Client: ENSAD Paris

"En quelques mots" (in English: In few words) is a 7-word-artistic-expression that explains the graphic designer's job: Qualité, Imagination, Conception, Création, Communication, Individualité Liberté.

81 *2006 Infiniti Brochures*
Design Firm: The Designory
Art Directors: Noah Huber, Scott Izuhara, Paula Neff, Andrew Reizuch
Creative Directors: Steve Davis, Chad Weiss
Photographers: Vincent Dente, Toshi Oku, Micahe Rupert
Writer: Jon King

The objective was to present and reinforce a new brand position as progressive and emotionally stimulating automobiles by capitalizing on Infiniti's leadership in design. Increase vehicle opinion and intentions by immersing readers in the rich vehicle experience, allowing them to feel the difference design makes.

The result was this brochure direction, which since debuting in early 2005, has helped Infiniti increase overall opinion by 10% in the last year. The Infiniti client has described the brochures as breathtaking, the best ever.

82 *C + A Magazine*
Design Firm: emerystudio
Creative Director: Garry Emery
Designers: Tim Murphy, Sarah O'Keefe
Writer: Joe Rollo

C+A magazine is the new flagship magazine of Cement Concrete & Aggregates Australia, the industry body representing the concrete construction industry in Australia. C+A publishes in detail examples of concrete architecture in Australia and internationally, to promote the possibilities of concrete as a material of choice in architecture. Each project published is documented extensively using words, photographs, plans, elevation and, where appropriate, earliest conceptual sketches.

83 *Domani Luxury Brochure Kit*
Design Firm: Gouthier Design: a brand collective
Art Director/Creative Director: Jonathan Gouthier
Designer: Kiley del Valle
Illustrator: Spine 3D
Photographer: Fiddler Productions
Client: Kolter Communities

Brand image created for a new Tuscany-inspired residential development. Domani, which in Italian means "tomorrow," is a new development by Kolter Communities. It is the most lavish and expensive property development project that this company has undertaken. Kolter hired Gouthier Design: a brand collective to bring the new property's image to life. "When we approached our creative direction and marketing plan on Kolter's most luxurious condominium project, Domani, Gouthier Design succeeded in achieving the tremendous attention to detail and above caliber

design that we needed to break through the clutter and attract our most discerning client base," says Mary Kay Willson, Vice President of Marketing and PR at Kolter Communities. "Our solution was to give the residences a clean sophistication with a hint of early Italian rococo throughout the design." Says Jonathan Gouthier, Principal of Gouthier Design. The project outline started with us producing a flow chart of how contact leads would be addressed through invitation, direct mail, email blast, etc… We then noted that we had to produce a series of brochures for each one of these lead segments. We developed a sheet-format brochure of the product launch/media opening. This allowed for the attendees to take back the incredible images of Tuscany and frame them for their own wall art. The second piece created was for those who inquire about the property, but might not be potential property buyers. The inquiry brochure is housed within a slip case and still portrays the elegance of Domani. The main luxury brochure is a more elaborate and conclusive box of elements for those contacts that are on the A-list for potential real estate in South Florida. "From the invite to the floor plans, each element has its own elegance," states Gouthier. "Each piece had to be designed to feel special." The creation of these elaborate marketing materials was to match the project. They become artifacts that buyers will want to hold onto throughout the project's progression. All pieces were created on a mix of uncoated papers including GMUND Bier and Mohawk Superfine for their tactile and warm feeling, something you would find on the countryside in Europe. Simple foil stamping and artful placement of the engraved logotype adds to the hand-made qualities found within inspirational pieces. Clean layout and typography throughout the pieces plays to the modern side of the property development and places the reader inside the property throughout the story.

84 *Optimism*
Design Firm: Vanderbyl Design
Art Director/Creative Director: Michael Vanderbyl
Designers: Amanda Linder, Michael Vanderbyl
Photographers: Jim Hedrich/Hedrich Blessin, David Peterson
Writer: Penny Benda
Client: Teknion

This was developed as our client's industry was recovering from the recent recession. The concept engages the classic quandary of whether the glass is half-full or half-empty. The brochure encourages the positive perspective (the glass if half-FULL) by presenting uplifting facts about the world around us.

85 *Holland Performing Arts Center Commemorative Pop-up Book*
Design Firm: Webster Design Associates
Art Director: Sean Heisler
Creative Director: Dave Webster
Designer: Rudy Evans
Client: Heritage Services

This pop-up book was designed to thank the donors of the Holland Performing Arts Center, which is featured in the center of the book as a to-scale pop-up. The donors each received a book at the private donor preview.

86 *Bugs—Red, Green, Blue, Yellow*
Design Firm: BBDO Detroit
Art Directors: John O'Hea, Paul Szary
Creative Directors: Robin Chrumka, Bill Morden, Mike Stocker
Photographer: Madison Ford
Writer: Ty Hutchinson
Client: Jeep

Brief: Jeep was unveiling the Wrangler Unlimited, the first 4-door Wrangler. They wanted to highlight this with a sense of fun and adventure.

Solution: Strap various types of outdoor gear to the roof of the Wrangler Unlimited and photograph it from above with the doors open. The result—bugs.

87 *Under Construction!*
Design Firm: Sonner, Vallee u. Partner
Art Director/Designer: Sonner, Vallee u. Partner
Photographer/Writer:
Gecco Scene Construction Company
Client: Gecco Scene Construction Company

The title "Under Construction!" symbolizes the offered services, namely the planning and completion of quality sets and interior design. These themes were applied graphically using symbols such as construction lines and measurement. To optimize the attraction to our target group (architects, agencies, marketing directors), we applied the design using inserted transparent paper, Dutch folding and binding, and UV spot varnishing, reflecting the precise craftsmanship offered.

88 *Unbound 3*
Design Firm: Concrete Design
Art Directors: Diti Katona, John Pylypczak
Designer: Andrew Cloutier
Writer: Larry Gaudet
Client: Masterfile

Masterfile had an image problem. Despite building an archive that represents some of the most creative talent around, this largest remaining independent stock image agency was still perceived by its clients as being too conservative. To address this challenge, Concrete produced a strategic campaign that included the development of a series of direct-mail pieces called "Unbound," a collection of images "real and implied." Unbound uses the interpretation of imagery as a form of visual creative inspiration. While it uses many images from Masterfile's extensive library, just as many of the images have been modified, obscured or "implied."

89 *Fine Bone China*
Made in Germany 2005/2006
Design Firm: Haase & Knels + Schweers
Art Directors: Sibylle Haase, Katja Hirschfelder
Creative Director: Sibylle Haase
Photographer: Hans Hansen
Client: Dibbern GmbH & Co.KG

Calendars

90, 91 *Colour Your Day*
Design Firm: BARLOCK bv
Art Directors/Creative Directors/Designers:
Hélène Bergmans, Saskia Wierinck, Käthi Dübi
Illustrator: Frederiek Westerveel
Writer: Jan Luijendijk
Client: BARLOCK bv

The theme of this diary is 'Colour your day.' The diary gives you a very colourful and refreshing feeling through the use of different types of papers, the special binding and the design. The cover is printed on linen with a silk-look. A week per spread, full of inspiring colour experiences which take you by surprise and take your mind off stressful days!

Extra special finishing techniques will keep you busy, such as thermo-printed fortune cookies, sexy die-cuts, stickers, colour charts and good wine stains. This diary will colour your days in 2006!

92 *Masterfile Calendar 2006*
Design Firm:
Concrete Design Communications Inc.
Art Directors: Kiti Katona, John Pylypczak
Designer: Andrew Cloutier
Client: Masterfile

93 *Coloratura*
Design Firm: Riordon Design
Art Director: Shirley Riordon
Designers: Dawn Charney, Shirley Riordon

Catalogues

94, 95 *School Catalogue 05-08*
Design Firm: Vanderbyl Design
Art Director/Creative Director: Michael Vanderbyl
Designers: Amanda Linder, Michael Vanderbyl

Photographers: Ed Kashi,
Karl Petzke, Douglas Sandberg
Client: California College of Arts & Crafts

This catalogue is a glimpse into the CCA experience—and it comes from the actual people there—the students and faculty, not the marketing department.

96 *My China!*
Design Firm: Sieger Design GmbH & Co. KG
Art Director/Designer: Michael Sieger
Photographers:
Thai-Cong Quach, Jorg Grosse Geldermann
Writer: Elke Dopelbauer
Client: Sieger Design

SIEGER, the first brand of the full-service agency, Sieger Design, intends to perspectively establish itself alongside famous luxury brands on the lifestyle sector.

97 *SIEGER COUTURE*
Design Firm: Sieger Design GmbH & Co. KG
Art Director/Designer: Michael Sieger
Photographers: Thai-Cong Quach,
Jorg Grosse Geldermann
Writer: Elke Dopelbauer
Client: Sieger Design

SIEGER, the first brand of the full-service agency, Sieger Design, intends to perspectively establish itself alongside famous luxury brands on the lifestyle sector.

98, 99 *THE NAYLOR COLLECTION*
Design Firm: Communications for Learning
Art Director/Creative Director: Jonathan Barkan
Designer: Yuly Mekler
Client: THE NAYLOR COLLECTION

This package introduces for sale this premier collection on the history of photography. It was sent to a carefully researched international list of museums, foundations, collectors, philanthropists, and entrepreneurs. It includes a reprint of a WSJ article; additional advance publicity included an NPR feature with web links to the catalog and streaming video.

100 *SIEGER FURNITURE*
Design Firm: Sieger Design GmbH & Co. KG
Art Director/Designer: Michael Sieger
Photographers:
Thai-Cong Quach, Jorg Grosse Geldermann
Writer: Elke Dopelbauer
Client: Sieger Design

SIEGER, the first brand of the full-service agency, Sieger Design, intends to perspectively establish itself alongside famous luxury brands on the lifestyle sector.

101 *Purse-everance*
Design Firm: Moses Media
Art Director/Designer: Icarus Leung
Creative Director/Writer: Deborah Moses
Photographer: Ilan Rubin
Client: Edidi

This was the first catalog for Edidi by Wendy Lau and served as an image and branding piece as well as a catalog. The company makes handcrafted, jeweled evening bags in precious metals with precious and semi-precious stones. As Edidi is new and therefore not a well-known brand, we wanted to establish a personality for the brand that would appeal to fashionable, smart women who spend significant money on luxury goods and accessories. The concept for the catalog addressed the perennial struggle of woman and evening bag: what can you fit in your evening bag for a night out? What can be taken? What must be forsaken? And, what do your choices reveal about your personality? We created five global personality profiles—from women like Paris Hilton to Nan Kempner—that could be identified by their purse contents and interspersed them throughout the book using clear transveys to illustrate the message. It was also important to photograph the bags in a modern, quirky way, illustrating the individuality and personality each

bag has. The reaction has been excellent and resulted in a reprint for Saks Fifth Avenue to send to 1500 customers. The sell through of the collection has topped at 92 percent…an auspicious beginning for a luxury brand.

102 *Champion Catalog*
Design Firm: Henderson Bromstead Art
Art Director/Designer: Kris Hendershott
Creative Director: Hayes Henderson
Client: Champion

103 *2007 Cadillac Escalade Catalog*
Design Firm: Leo Burnett
Art Director: Harriet Hitchcock
Creative Directors: Tor Myhren, Will Perry
Designer: Michele Hudak
Illustrator: Skidmore, Inc.
Photographers:
Tim Kent, Sandro and Doug Rosa
Writer: Nick Bickner
Client: General Motors, Cadillac

Following its introduction in 2002, Escalade quickly became THE dominant full-size luxury SUV. It also became an icon in American popular culture, a fixture in music videos and photo shoots, a mainstay at red-carpet events and the vehicle of choice for elaborate high-end customization. Likely purchasers tend to be supremely confident, self-actuating people, whether they are athletes, rap artists, entrepreneurs or affluent, if "ordinary," suburbanites. In developing a catalog to introduce them to the all-new 2007 Escalade, we attempted to tap into the glamour of Escalade's celebrity status by creating a piece with the size, look, and feel of a glossy, premium fashion magazine. The vehicle and its elements are shot as if they were jewelry, with a deliberate plan to build from a series of details—lights, wheels, chrome, wood and leather—before revealing the entire vehicle. At various points, we use the human face and form to suggest values provided by the various elements of the vehicle. The sections of the catalog, designed to correspond to various articles in a magazine, each have their own character. The ultimate goal was to reflect favorably on this beautiful new vehicle by creating a brochure that people would want to keep and display.

104 *Love Shopping*
Design Firm: NB Studio
Art Directors: Alan Dye, Nick Finney, Ben Stott
Designer: Sarah Fullerton
Client: Land Securities

Land Securities are bringing shopping to London's more retail-starved areas. In order to keep potential retail tenants informed of the most up-to-date Land Securities spaces available, we designed a brochure for distribution to estate agents. Commissioned photographer Martin Morrell's glamourous style perfectly reflects high-end, high-quality retail and gets the message across perfectly in our glossy brochure.

105 *Namiki Pen*
Design Firm: Sutton Cooper
Art Director/Creative Director: Linda Sutton
Designer: Roger Cooper
Photographer: Richard Foster
Writer: Ken Kessler
Client: Alfred Dunhill

The Challenge: To sell a limited edition $80,000 Namiki lacquer pen produced to celebrate 75 years of the partnership between Alfred Dunhill and the Pilot Pen Company of Japan.

106 *Spring/Summer 2006 Catalogue*
Design Firm: Tangram Strategic Design s.r.l
Art Director: Alberto Baccari
Creative Director: Enrico Sempi
Designer: Anna Grimaldi
Photographer: Arcangelo Argento
Client: Davide Cenci

107 *Talisman*
Design Firm:
Osamu Misawa Design Room Co., Ltd.

Art Director: Osamu Misawa
Designer: Satomi Kajitani
Photographer: Kenji Aoki
Client: World Commerce Corporation

Designer Promotions

108, 109 *Black Oscars Book*
Design Firm: Hans Heinrich Sures
Art Director/Designer: Hans Heinrich Sures
Photographer: Elke Bock
Client: Elke Bock

The is a promotional book for an exhibition by the photographer Elke Bock featuring a series of portraits of black actors in the United Kingdom.

110 *Liver*
Design Firm: Venables, Bell & Partners
Art Director: Ray Andrade
Creative Directors: Greg Bell, Paul Venables
Writer: James Robinson
Client: Venables, Bell & Partners

An invitation to the Venables, Bell & Partners 2005 holiday party.

111 *Mixer*
Design Firm: Bailey Lauerman
Art Director: Cathy Solarana
Creative Director: Marty Amsler
Designers: Randal Meyers,
Michah Schmiedeskamp
Writer: Rich Bailey
Client: Bailey Lauerman

"Mixer" is the invitation to Bailey Lauerman's open house following a complete office remodeling effort. Paint-mixing sticks were dipped in the colors of the new office and mailed to guests with the information engraved on the back.

112 *Favorite Things*
Design Firm: Palazzolo Design
Creative Director: Gregg Palazzolo
Designer: Ben Benefiel
Client: Palazzolo Design

A fun exercise to identify one's personal brand.

113 *Eat, Drink & Be Merry*
Design Firm: Saint Hieronymus Press
Art Director/Designer: David Lance Goines
Client: Saint Hieronymus Press

This is an advertisement for the 40th anniversary of Saint Hieronymus Press & the 60th birthday of David Lance Goines.

DVDs

114 *The Man Who Fell to Earth*
Design Firm: Kellerhouse, Inc.
Art Directors: Sarah Habibi, Neil Kellerhouse
Creative Director/Writer: Neil Kellerhouse
Designers/Photographers:
Peter Grant, Neil Kellerhouse
Client: The Criterion Collection

The Man Who Fell to Earth DVD packaging includes a slipcase, 180 page novel, 32 page booklet DVD package, and two discs with Motion and Menu design.

115 *Gate of Flesh*
Design Firm: Kellerhouse, Inc.
Art Directors: Sarah Habibi, Neil Kellerhouse
Creative Director/Designer/
Illustrator/Photographer: Neil Kellerhouse
Client: The Criterion Collection

Gate of Flesh DVD package was created for The Criterion Collection, and includes an 8-panel insert with wrap and DVD Motion and Menus.

Editorial

116 *The Great Escape*
Photographer: Kevin Mackintosh
Mr. Mackintosh is represented by Pearce Stoner Associates. (www.pearcestoner.com)
Stylist: Anne Shore
The Great Escape's layout and Design:
Matthias Huebner, Hendrik Hellige.
© Die Gestalten Verlag GmbH & Co, KG,
Berlin 2006

Published October 2005.
Originally photographed for
"View on Colour" in Paris.

116 *Wonderland*
Cover Design: Takeshi Hamada
Photography: Hitoshi Hasebe
Makeup: BIN
Stylist: Annett Bourquin
© Die Gestalten Verlag GmbH & Co, KG,
Berlin 2006. Published October 2004.

117 *The Great Escape*
Design Firm: Hort
The Great Escape's layout and Design:
Matthias Huebner, Hendrik Hellige.
© Die Gestalten Verlag GmbH & Co, KG,
Berlin 2006.
Images featured are from pages 134 & 135.
Published October 2005.

117 *The Great Escape*
Image Title: Kingston Karma
Illustrator: Steven Wilson
Mr. Wilson is represented by Pearce Stoner Associates. (www.pearcestoner.com)
The Great Escape's layout and Design:
Matthias Huebner, Hendrik Hellige.
Photographer: Lacey.co.uk@lacey.uk.com
Stylist: Charles Davis
Model: Madja@ICM
Hair: Duffy@premier
Makeup: Shinobu 2004
Client: Jalouse Magazine
(France, February 2005)
© Die Gestalten Verlag GmbH & Co, KG, Berlin
2006. Published October 2005.

117 *The Great Escape*
Design Firm: Adapter
Art Direction/Artwork: Kenjiro Harigai
Designers: Matthias Huebner, Hendrik Hellige
Model: Mikami Chisako
Photographer: Hiroshi Manaka
All Clothing: Takayuki Suzuki
Stylist: Yuki Murayoshi
Hair: Rui Hayashi
Makeup: Michiko Funabiki
Client: Creage, 2005.
© Die Gestalten Verlag GmbH & Co, KG,
Berlin 2006. Published October 2005.

118, 119 *Fabrica*
Art Directors: Matthew Haigh (UK),
Andy Rementer (USA)
Cover Concept:
Yianni Hill (Australia), Nicole Kenney (USA)
Cover Photographer:
Marian Grabmayer (Austria)
Top Spread:
Concept: Matthew Haigh (UK)
Photographer: Yianni Hill (Australia)
Middle Spread:
Photographer: Federico Urdaneta
Text: Guillermo Rivero (Mexico)
All images are from Winter 2005/06
Fabrica issue.

120 *Men of the Year, covers*
Design Firm: GQ Magazine
Design Director: Fred Woodward
Art Director: Ken DeLago
Photographer: Peggy Sirota
Photo Editor: Dora Somosi
Client: GQ Magazine
Cover images featured on
December 2005 issues.

121 (top left) *American Idol*
Design Firm: GQ Magazine
Design Director: Fred Woodward
Art Director: Ken DeLago
Photographer: Mario Testino
Photo Editors: Bradley Young/Dora Somosi
Client: GQ Magazine

121 (top right) *Why I Steal*
Design Firm: GQ Magazine
Design Director: Fred Woodward
Designer: Thomas Alberty
Photographer: Phillip Toledano

Photo Editor: Dora Somosi
Client: GQ Magazine

121 (right) *Jackass*
Design Firm: GQ Magazine
Design Director: Fred Woodward
Art Director: Ken DeLago
Photographer: David Sims
Senior Photo Editor: Dora Somosi
Client: GQ Magazine

121 (right) *The Great Fuel-Injected Society*
Design Firm: GQ Magazine
Illustrator: Dynamic Duo Studio
Design Director: Fred Woodward
Art Director: Ken DeLago
Illustrator: Dynamic Duo Studio
Client: GQ Magazine

121 (bottom right) *Black Power*
Design Firm: GQ Magazine
Photographer: Mark Seliger
Photo Editor: Dora Somosi
Design Director: Fred Woodward
Art Director: Ken DeLago
Client: GQ Magazine

121 (bottom left) *Heath Ledger*
Design Firm: GQ Magazine
Design Director: Fred Woodward
Art Director: Ken DeLago
Photographer: Nathanial Goldberg
Photo Editor: Dora Somosi
Client: GQ Magazine

121 (left) *AWOL*
Design Firm: GQ Magazine
Design Director: Fred Woodward
Art Director: Ken DeLago
Photographer: Jeff Riedel
Photo Editor: Dora Somosi
Client: GQ Magazine

121 (left) *16 Dead in Ohio*
Design Firm: GQ Magazine
Design Director: Fred Woodward
Designer: Anton Ioukhnovets
Client: GQ Magazine

122 *Matador Magazine, Volume I*
Design Firm: Pentagram Design (UK)
Art Director/Designer: Fernando Gutierrez
Client: Matador/La Fabrica

Matador is a magazine about Culture, Ideas and Trends, published annually, which will expire with its 29th issue in 2022. Each issue is given a sequential letter from the Spanish alphabet (A, B, C, Ch, E, etc.) and a central theme which determines the nature of the editorial content. Each issue is set in one unifying typeface, to further consolidate the binding qualities of this central theme. Fernando Gutiérrez has described the magazine as "a testimony," a document which, whilst remaining exclusive, considers events from around the world. Contributors to recent issues have included Oliver Stone, Andrés Serrano, Yves Saint-Laurent and Peter Greenaway. Each issue includes an in-depth feature on a major contemporary artist; past contributors include Sean Scully, Louise Bourgeois, Miquel Barcelo, Juan Munoz and Sol LeWitt. The featured artist is also asked to produce a sketchbook to accompany the magazine and to design the label for a limited edition bottle of wine. Telmo Rodriguez is commissioned to produce a unique wine to coincide with each issue of Matador, further confirming its status as a high-quality publication.

123 *Zink Magazine*
Design Firm: Zink Magazine
Art Director: Seán Murray
Photographer: Eva Mueller
Inspired by: Ellsworth Kelly
Stylist: Mindy Saad for Art House Management
Hair: Tuan Anh Tran for L'Atelier NYC
Makeup: Moondust
Model: Marina Theiss for MC2
Neck Piece: Boudicca
Cover image is from December 2005 issue of Zink Magazine.

124, 125 *Vanity Fair Magazine (series)*
Design Firm: cento per cento
Art Director/Creative Director: Pier Paolo Pitacco
Client: Conde Nast

This work was an editorial project for the Italian version of the weekly Vanity Fair Magazine.

126 *The New York Times Style Magazine, Women's Fashion Spring 2006*
Design Firm: The New York Times
Art Director: Arem Duplessis
Creative Director: Janet Froelich
Photographer: Raymond Meier
Client: The New York Times

Women's Fashion Spring 2006 cover features a photograph of Rachel Weisz.

126 *The New York Times Style Magazine, Men's Fashion Spring 2006*
Design Firm: The New York Times
Art Director: Arem Duplessis
Creative Director: Janet Froelich
Photographer: Raymond Meier
Client: The New York Times

Men's Fashion Spring 2006 cover features a photograph of Jamie Foxx.

127 *The New York Times Style Magazine, Travel Summer 2006*
Design Firm: The New York Times
Art Director: Arem Duplessis
Creative Director: Janet Froelich
Photographer: Raymond Meier
(inspired by a photograph by Ralph Gibson)
Fashion Editor: Tiina Laakkonen
Hair: Bok-Hee for Streeters
M+J Savitt wood bracelet
Makeup: Fabiola for Giorgio Armani
at the Wall Group
Model: Reka Ebergenyi
Client: The New York Times

Distracted in Dubai: Be it summer or winter, the Burj Al Arab hotel, Dubai is a hot draw in the Persian Gulf.

127 *The New York Times Magazine, September 18th, 2005*
Design Firm: The New York Times
Art Director: Arem Duplessis
Creative Director: Janet Froelich
Photographer: Dan Winters
Client: The New York Times

Features a shot of Bono, "The Statesman."

127 *The New York Times Magazine, The Movie Issue, November 13, 2005*
Design Firm: The New York Times
Art Director: Arem Duplessis
Creative Director: Janet Froelich
Photographer: Dan Winters
Client: The New York Times

Issue's cover story: Hollywood Goes to War!

127 *The New York Times Magazine, February 19, 2006*
Design Firm: The New York Times
Art Director: Arem Duplessis
Creative Director: Janet Froelich
Photographers:
Inez van Lamsweerde and Vinoodh Matadin
Client: The New York Times

Features the 3rd Annual Great Performers in Film selection, as well as a shot of actor George Clooney on its cover.

128 *Esopus 5 (Fall 2005) cover*
Design Firm: Esopus
Designer: Tod Lippy

128 *Azuro July/August 2005*
Design Firm: Concrete Design Communications, Inc.
Client: Azure Magazine
Art Directors: Diti Katona, John Pylypczak
Designers: Andrew Cloutier, Natalie Do, Omar Morson, Jordan Poirier

129 *See: The Potential of Place*
Design Firm: Cahan & Associates

Art Directors: Bill Cahan,
Todd Richards, Steve Frykholm
Creative Director: Bill Cahan
Designer: Todd Richards
Illustrators: Gary Clement, Joseph Hart,
Jonathon Rosen, Brian Cairns, Joseph Hart,
Blair Thornley, Jeffrey Decoster,
Alan E. Cober, Joseph Hart
Photographers:
Chen Bairong, Marcel Duchamp, H.G. Esch,
Dwight Eschliman, Roland Halbe,
Simon Høgsberg, Richard Ross, Andy Sacks,
Tim Simmons, Ingvar Kenne, Henning Bock,
Todd Hido, Michael S. Yamashita, Neal Preston,
Fredrik Clement, Jan Roth, Allan Chochinov,
Tyler Gourley, Florian Holzherr, Nathan Perkel
Writers: Armin Moehrle, Allan Chochinov,
David Willett, Dick Holm, Carol Lecocq,
Julie Ridl, Pamela Erbe, Dan Sorensen,
Linton Weeks, Rick Duffy
Client: Herman Miller

SEE: The Potential of Place is the company's latest publication to share with a broad audience ideas and research concerning the built environment. The bi-annual magazine gears its articles and images to people interested in the potential of the built environment to heighten human ability and creativity. To reach this audience, we are placing SEE in selected bookstores (for example, MOMA, Museum of Art and Design, Folk Art Museum, Architectural and Design Books and Supplies) appealing to architects, designers, artists, interior designers, and space planners. We include no advertisements in SEE; it is meant to feature ideas, not products. —Todd Richards

129 *Items, Magazine for Design and Imagination*
Design Firm: Studio Dumbar
Creative Director: Michel de Boer
Design Director: Vincent van Baar
Designer: Dennis Koot
Client: BIS Publishers, the Netherlands

Briefing: Covers: Create more appealing covers and a stronger connection between cover and content of the magazine.

Result: The portraits function as the red thread for a great variety of expressive means. For various covers, a special refinement printing technique has been applied, such as glitters, spot UV and thermal ink. These effects increase the appeal of the magazine.

Environmental

130, 131 *Chaos to order*
Design Firm: emerystudio
Art Director: Garry Emery
Designer: Job van Dort
Client: PMP Limted

Architects Bates Smart and the client, a media production and magazine distribution company, wanted a three-dimensional, dramatically up-lit installation for a double-height office reception space. The abstract design is generated by the activities of the business, with references to streams of digital information and the idea of a performance indicator, a visual representation of the transition from chaos to order. Fragments of this work are located throughout the workplace. The negative 'waste' sheet material remaining after the positive elements have been cut out are suitable for smaller installations.

132, 133 *Signage System*
Design Firm: Thinking Caps
Creative Director: Julie Henson
Designers: Julie Henson, Lisa Ranzenberger
Client: Arizona State University Foundation

To develop an identity system for the new Foundation building on the ASU (Arizona State University) campus. "Honoring the past and looking toward building the future" is what the Foundation is all about. This premier building was designed and built on one of the most prominent corners of the campus. The south façade of the build-

ing sits directly across from the campus historical buildings and "Old Main." It was important for the building to reflect and respect the origins of the campus; therefore the sign elements could only do the same. The overall project consisted of the Foundation office building, the President of the University's office, a parking garage, just a little of everything. The signage elements were designed to respond to the varied needs of the project. The "hero" signs are the 4' tall glass letters attached to the buildings' glass façade. A 30' by 20' glass window prism holds another jewel on the project. A 3-banner rotating system with a mechanism allows the owners to rotate around the banners as often as they like. The original banner designs created the ongoing banner program templates.

134, 135 *McDonald's*
Design Firm: Lippincott Mercer
Creative Director: Peter Dixon
Designers: Fabian Diaz, Ryan Kovalak,
Andres Nicholls, Randall Stone, Susan Teal
Client: McDonald's

While McDonald's was one of the most recognized and admired brands in the world, it had faced many challenges to its position as an industry leader. The challenge for the Lippincott Mercer team was to refresh and update the McDonald's restaurant experience and improve the overall customer experience. The team utilized the firm's proprietary Customer Experience MappingSM methodology to create a detailed design brief to specify how the McDonald's brand attributes could be expressed at every point of the customer's journey. Ultimately, the Lippincott Mercer team created a clean, modern, and fun environment targeting young adults while providing a wholesome setting appropriate for the whole family and one that demonstrates McDonald's commitment to its customers. Lippincott Mercer achieved this through design changes to the exterior architecture, signage and environmental graphics, updates to the old "double-mansard" roof design, transformations of the drive-thru area, and zoned seating configurations. An array of décor concepts were employed to provide options for local adaptations. The re-imaging concept is flexible so that it can be adjusted to the local context and appeal to restaurant operators and their communities.

136, 137 *B Street Gallery/Civic Condominiums Sales Office*
Design Firm: ZIBA
Creative Director: Steve McCallion
Associate Creative Director: Clancy Boyer
Art Director: David Ewald
Designers: David Ewald, Elizabeth Blades,
Tom Lakovic, Greg Martin
Illustrators: Jenn Manley Lee, Ildefonso Resuello
Client: Gerding Edlen Development

Our client wanted to transform a city block into a mixed-use building. The building is located in an atypical residential location on Burnside Street, a diverse, gritty urban street sprinkled with few modern comforts. Our client wanted to sell the condos to young cultural creatives. To appeal to hip first-time buyers, we replaced a typical condo real estate office with an art gallery showcasing commissioned art pieces inspired by Burnside Street. The condominium sales kiosk is treated like a piece of sculpture dropped into the middle of the gallery. Visitors are invited to browse floor plans, availability and views using Atari 2600 joysticks.

Exhibits

138 *Retail Environment*
Design Firm: Landor Associates
Executive Creative Director: Nicolas Aparicio,
Senior Designer: Anastasia Laksmi
Photographer: Jamie Padgett
Client: Papyrus

Primarily regarded as a card store, Papyrus faced the challenge of revitalizing the brand in a commoditized business, and building new revenue streams for aggressive growth goals.

Papyrus realized they were delivering a sub-optimal retail experience because consumers were confused by what Papyrus stood for, the Papyrus product offering, and how to relate to the Papyrus environment. The Landor team helped to migrate Papyrus from just a paper store in a commoditized market to a lifestyle brand with more expansive possibilities.

139 *Bone Marrow Research Story Wall*
Design Firm: Michael Courtney Design
Creative Director: Michael Courtney
Designers: Debra Burgess, Michael Courtney, Margaret Long, Ivan Silantyev, Zach Shallcross, Larry White
Photographers: Tom McMackin, Zach Shallcross
Writer: Gordon Todd, FHCRC
Client: Fred Hutchinson Cancer Research Center

An internal team at Fred Hutchinson Cancer Research Center (our clients) had a big idea: recognize the contributions of FHCRC patients who pioneer critical advances in research, specifically Bone Marrow transplants. Our office was commissioned to create a very visible Thank You to the patients who volunteer for this research. The primary audience for this project includes participants in the program, their families and friends, visitors to the campus. The secondary audience is the FHCRC team members from caregivers to researchers and the rest of the FHCRC community. Designed to both provide background and turn heads, the story wall is 7' high x 17' long, and contains a plasma screen with dynamic content. The rich colors, unique materials and presentation and thought provoking nature of the story wall are designed to contrast to (more conventional) donor recognition walls in the facility. "Fred Hutchinson Cancer Research Center, home of three Nobel laureates, is an independent, nonprofit research institution dedicated to the development and advancement of biomedical technology to eliminate cancer and other potentially fatal diseases." —Seattle Times

140 *Tundra Exhibit*
Design Firm: Saatchi + Saatchi LA
Executive Creative Director: Harvey Marco
Art Directors: Alex Alvarado, Mike Czako
Creative Director: Erich Funke
In Collaboration With:
The George P. Johnson Company
Photographers:
James Nachtwey, Steve McCurry, Jeff Dunas, Paul Hemsworth, Jamie Padgett
Writer: Bob Fremgen
Client: Toyota Motor Sales, USA, Inc

One of the biggest events in Toyota's history was the revealing of the new Tundra. For a project this important the advertising agency was partnered with the exhibit design firm. The agency discovered that before designing the new Tundra, the engineers undertook a cross-country trek. The reason was to gather input from actual pickup truck drivers and implement these findings into the truck design. To depict the people encountered during this expedition, we hired three of the world's greatest photojournalists, James Nachtwey, Steve McCurry and Jeff Dunas. Apart from their extensive award collection, the three were chosen for their integrity, unique comprehension of the topic and empathy for their subjects. We assigned each photographer a different aspect of the pickup world. Together they generated over 15,000 images. Our proposed concept was to recreate this epic journey within the exhibit space. We felt it was a chance to explain how the truck was designed with all trucker's needs in mind. The space would display the various truckers that were studied before the Tundra ever made it onto the drafting table. Each of the different trucker worlds captured were represented in a different area within the exhibit space. The sum of all the areas created what was dubbed "Tundra Country." The journey through the exhibit climaxed with the display of the new pickup.

141 *Speedo Tradeshow Booth*
Design Firm: Speedo in cooperation with Authentic Fitness
Art Directors: Ali Filsoof, Tina Virani
Creative Director: Ali Filsoof
Designers: Karen Carney, Kenny Felix, Ali filsoof, Jay Fitzgerald
Photographers: Michael Muller, Odette Sugeman
Client: In House

The challenge was in helping Speedo evolve as a brand—leaving the pool and moving onto the land. Speedo's prior booth was dated, constructed of heavier materials with wooden highlights—not appropriate at all for a brand that wants to be known as sleek and sexy. The new booth is very forward in thought and feeling, using space age fabrics and lighting to stand out and stand alone on the tradeshow floor. A tradeshow booth is a show case for the brand. Seen by retail buyers from around the country and the world, the booth must quickly convey this message and capture the interest of clients. We want the clients to want to stay and see the swim and apparel lines, to bask in the cool factor. The clean but user friendly feel continues in the show room areas, where modular panels with a circular theme help account representatives show lines professionally yet in a fun forward atmosphere. Music and imagery pulsate through 16 speakers and a bank of plasma TVs to create excitement in the booth.

142, 143 *New Design Paradigms*
Design Firm: Graham Hanson Design LLc
Art Director and Creative Director:
Graham Hanson
Designers: Pilar Freire, Graham Hanson, Eileen Moore, Jonathan Posenett, Jay Telles, Lyz Ward
Photographers: Deborah Kushma, David Sundberg (ESTO)
Writers: Graham Hanson, Sheldon Werdiger
Client: Macklowe Properties

The client was able to envision the redevelopment of a hopeless commercial property in New York City, long troubled by holdout buildings at the street level. A unique approach allowed the developer to redevelop the building into a well-designed and desirable Class-a building. Our firm was tasked with developing an equally unique way to promote the building. Our solution was to explore the ways previous designers have taken on new paradigms towards design in order to arrive at unexpected solutions.

Illustration

144 *Limited Edition Posters*
Design Firm: Michael Schwab Studio
Art Director: Sissy Estes
Designer/Illustrator: Michael Schwab
Client: Amtrak

145 *Ukulele Luau*
Design Firm: Michael Schwab Studio
Art Director: Jim Frey
Designer/Illustrator: Michael Schwab
Client: Printing Industries of Northern California

146 *The L Spa Poster*
Design Firm: RBMM
Creative Director: Horacio Cobos
Designer: Phillip Smith
Illustrator: Horacio Cobos
Writer: Carol St. George
Client: Baylor Health Care System

147 *Voting in France*
Design Firm: Mirko Ilic Corp
Art Director: Paul Lussier
Illustrator: Mirko Ilic
Client: Time International

Interactive

148 *Design Firm: ico Design Consultancy*
Creative Director: Ben Tomlinson
Designers: Leigh Kayley, Kelvin Luck, Andy Spencer
Client: The Hayward Gallery, London

We were commissioned by the Hayward Gallery, London, to create an installation for the artist Dan Flavin's retrospective. This installation is called "Dedications" and it allows visitors to the exhibition to create virtual lightworks and dedicate them to their friends. To view the dedications that visitors have made or to make your own, we created a special web site: Visit www.hayward.org.uk/flavin-dedications.

149 *www.jonorotman.com*
Design Firm: DNA Design
Designer: Charlie Ward
Photographer: Jono Rotman
Client: Jono Rotman, Photographer

An online portfolio for one of New Zealand's preeminent photographers, the site had to be simple in its execution and behaviour. It is targeted at a global audience.

150 *BOMBAY SAPPHIRE*
Website Redesign
Design Firm: Damashek Consulting/ CollectiveLab
Art Directors: Paul Bazay, Dael Wasylenka
Creative Directors: Marko Bon, Harris Damashek AC-Director
Writer: Julianne Casper PM, Richard Brown Developer
Client: Bacardi Global Brands

The redesigned BOMBAY SAPPHIRE website (www.bombaysapphire.com), optimized for users with high-bandwidth connections, pushes the boundaries of technology and design on the web, creating a high-impact, multimedia site experience. The site's main objectives are: to create a top-shelf brand experience befitting a super premium spirit; to define and reinforce BOMBAY SAPPHIRE's rich heritage and distillation process; to assert and articulate BOMBAY SAPPHIRE's commitment to supporting the International Design Community through the use of cutting edge site design; to encourage site visitors and brand enthusiasts to experiment with making cocktails beyond the standard martini and gin and tonic; to generate buzz among those in the design and interactive communities.

151 *Drew Donovan Website*
Design Firm: Savage Design
Art Director: Doug Hebert
Creative Director: Paula Savage
Designer: Daren Guillory
Illustrators: Daren Guillory, Chris MacGregor
Photographer/ Writer: Drew Donovan
Client: Drew Donovan Photography

The Drew Donovan professional/portfolio website is a collection of selected images from the photographer. The design references Drew's personal transition from traditional film-based medium to the digital realm with subtle use of illustration and transition. Content is driven via XML so that Drew can easily edit/relocate images site-wide.

152 *Savage Design Group Website*
Design Firm: Savage Design
Art Director: Doug Hebert
Creative Director: Paula Savage
Designer: Daren Guillory
Illustrators: Chris MacGregor, Craig Tooms
Photographers: Drew Donovan, Bryan Kuntz
Writers: Bethany Haley, Doug Hebert
Client: Savage Design Group, Inc

The Savage Design website characterizes our brand-Smart.Fresh.Human. Our breadth of corporate design and branding expertise is showcased in an easy-to-use, visually-rich portfolio. Elegant interactive animations showcase our personality, people and studio. One can easily navigate through the portfolio section by clicking on thumbnail images for larger views, or selecting from drop-down menus to query content relative to a particular industry or project type.

153 *Design Build Bluff website*
Design Firm: Flow Creative
Art Director: Jeff Clift

Creative Directors: Jeff Clift, Peter Zapf
Designer: Whalen Louis
Photographer: Jane Barrett
Writer: Peter Zapf
Client: Design Build Bluff

A website was created to help communicate Design Build Bluff's message, create interest in prospective students, and prospective donors. It also serves as an online portfolio. Design Build Bluff designs and builds houses for Navaho families in need, in the four corners region of Utah.

Letterhead

154 *Mjólka*
Design Firm: Ó!
Art Director/ Designer: Einar Gylfason
Client: Mjólka

Mjólka is a dairy production company in Iceland.

155 *Bottle Rocket Post*
Stationery Package
Design Firm: Luckie & Company
Art Director: David Adams
Creative Director: Brad White
Client: Bottle Rocket Post

156, 157 *Total Content Stationery*
Design Firm: NB Studio
Art Directors: Alan Dye, Nick Finney, Ben Stott
Designer: Daniel Lock
Client: Total Content

We were asked to create a set of stationery for copywriter, Total Content. The design took its cue from the company name and features the total contents of a copywriter's most basic everyday tool, the alphabet. Character and punctuation symbols were placed in a variety of different fonts to reflect the different personalities and styles of their writing. The typographic design was letterpress printed in fluorescent orange to reflect the dutch heritage of the company. For the smaller stationery items, the design was split up to create three different compliment slips and eight different business cards which, when all placed together again, create the total contents of the alphabet.

158 *Self-promotional Stationary Set*
Design Firm: California State University, Fullerton
Art Directors: John T Drew, Satoshi Kawahara
Designer: Satoshi Kawahara
Client: Self

This self-promotional Stationary Set has 2 important elements of me. One is the format. This stationary functions like TOYs. I collect toys and play so that I can relax and be flexible for ideas. The other element is my beard. I have grown the beard for almost 10 years and it has become a part of my personality. Cartoon-like illustration was chosen because I am young and Japanese. The 3 different business cards were made so that people can enjoy and expect another one. For business cards, they needed a pull beard for full function.

159 *Blake Brand Growers*
Design Firm: Evenson Design Group
Art Director: Stan Evenson
Creative Director: Mark Sojka
Designer: Mark Sojka
Illustrator: Wayne Watford
Client: Blake Brand Growers

160 *Ulola Stationery*
Design Firm: Elevator
Art Director/ Creative Director Tony Adamic
Designers: Tony Adamic, Lana Vitas
Illustrator: Lana Vitas
Client: Ulola

Project Description: Ulola decided to introduce a new identity to help position its brand more accurately on the market. The Client: Ulola produces bath products and cosmetics based strictly on all-natural ingredients. The Brief: Design a stationary set that shows company's orientation to all-natural bath products for a younger market. The Solution: The front of the letterhead features only the embossed Ulola logo. No color is used on the front to suggest cleanness. The back fea-

tures the camouflage pattern in various colors that represent the naturalness of the ingredients used in the products.

161 *Ian Robertson Photography*
Design Firm: DNA Design
Creative Director/Designer: Charlie Ward
Photographer: Ian Robertson
Client: Ian Robertson

The identity has a strong link to the photographer's online presence. Every individual piece of stationery is used to portray the photographer's work in an unconventional manner.

162 *124 Design*
Design Firm: 124 Design
Art Director/Creative Director:
Philip de Josselin de Jong
Designers: Andréa Casarin,
Evelien van der Zaken
Client: 124 Design

A letterhead that separates the two main design ingredients: form and colour. By folding the paper the receiver can bring form and colour together.

163 *Stationery System*
Design Firm: Meta4 Design
Art Director: Fred Biliter
Designer: Audrey Saberi
Client: McCormick Tribune Foundation

The challenge was to create an identity that provides a sense of cohesion between the McCormick Tribune Foundation as an entity in its own right, and its three operations: the forthcoming Freedom Museum, Cantigny, the First Division Museum and the McCormick Conference Series. In addition, it needed to communicate a sense of discipline that originates from a military history, yet accessible and warm in tone. The main objective is to gain recognition not only in Chicago, but also on a national and international level. The identity is applied to all correspondence, mailers, advertisements, sponsorships, website, merchandise, environmental signage, wearable items, etc.

Logos

164 *Mushroom Records—new identity*
Design Firm: Frost Design
Designers: Anthony Donovan, Vince Frost
Client: Warner Music Australia

Mushroom Records started out in the late 1970s, signing acts such as Split Enz and Kylie Minogue to become Australia's leading independent music label. Warner Music Australia recently bought the label and approached Frost to create a new logo and identity. The brief was to stay true to the label's independent roots, while creating a new look that could carry it forward as the banner for Warner's Australian artists roster. The logo needed to work at a very small scale on CDs as well as in promotions such as ads. Our idea is based on mushrooms growing up to form the letter "m".

164 *PIT'R PAN PROD*
Design Firm: Creactis
Designer: Sebastien Canepa
Client: Priamo Pascal

This is a logo for an events and management agency which works mainly for regional companies. The client wanted an identity around the imagination and dreams of the Peter Pan universe. I chose to illustrate the idea by using the symbolism of the fairy, which gets ready to jump and evokes a festive spirit and little bit of magic. Four stars represented the four domains of the client's activity.

164 *Batteries*
Design Firm: HKLM
Designer: Darien Harris
Client: Dixon

Dixon Batteries is a 3rd generation local manufacturing operation, which produces and distributes SABS approved batteries for the South

African climate. Dixon briefed HKLM to refresh their brand in order for it to be perceived as a quality, cost effective product. On reviewing the competitive landscape, we decided to keep some of the colours from the previous identity, (red & blue) and simplify the identity, in order for it to have shelf presence. The use of the positive and negative battery symbols were incorporated into the bold typography allowing the name to be immediately associated with batteries.

164 *Dulcefina Identity*
Design Firm: Green Mantis Design
Designer: Hao (Eric) Shi
Client: Dulcefina

Dulcefina is a Latin American dessert company specializing in gourmet cakes filled with sweet, exotic fruit. The Dulcefina identity will be placed on all aspect of their company, from letterhead, business card, to packaging, etc.

164 *Mailer Magic logo*
Design Firm: RBMM
Designer: Brian Owens
Client: Williamson Printing Corporation

165 *Paint Specialists*
Design Firm: WXS
Designer: Karen Birnholz
Client: G de Ru

G de Ru is a small, family owned business, paint specialists since 1921, recognized as one of Holland's best. 'G' is the initial of the founder's first name. The family would like to keep this as a symbol in honor of their grandfather.

166 *Tatsumi Winery*
Design Firm: Graphics & Designing Inc.
Art Director: Toshihiro Onimaru
Creative Director/Designer: Takuro Tatsumi
Client: Takus Office

A title design for a television program. The title logo for a program about wine. The initials "T" and "W" of "Tatsumi Winery" in the form of a wine glass.

166 *Lyst—"Lillehammer Ysteri" cheese roducts*
Design Firm: Stromme Throndsen Design
Art Director: Morten Throndsen
Creative Director: Morten Throndsen
Designer: Stromme Throndsen Design
Client: Melkeveien

166 *555W23*
Design Firm: The ROC Company
Art Director/Creative Director: Mark Richardson
Designer: Marcie Kovac
Illustrators: Mark Richardson, Nicholai Buglaj
Photographer: Studio 7
Client: Douglaston Development

Real estate brochure for a new development in New York's gallery row, in West Chelsea.

166 *Identity System*
Design Firm: Meta4 Design
Art Director: Fred Biliter
Designer: Audrey Saberi
Client: McCormick Tribune Foundation

The challenge was to create an identity that provides a sense of cohesion between the McCormick Tribune Foundation as an entity in its own right, and its three operations; the forthcoming Freedom Museum, Cantigny, the First Division Museum and the McCormick Conference Series. The McCormick Tribune Foundation is an organization that focuses on advancing the ideals of a free and democratic society through children, communities and country. Our goal was to create a logo that is accessible and warm in tone, yet also communicates a sense of discipline that originates from a military history. The stripes that make up the "M" represent the military accolades awarded to those who have performed superior service.

166 *Lobo Tortilla Factory logo*
Design Firm: RBMM
Designer/Illustrator: Kevin Bailey
Client: Lobo Tortilla Factory

167 *Pinot Noir New Zealand 2007 brand*
Design Firm: Clemenger Design
Art Director/Designer: Tim Christie
Creative Director/Writer: Bruce Hamilton
Illustrator: Grant Reed
Client: Pinot Noir New Zealand 2007

Objective: Develop a brand for the 2007 NZ Pinot Noir Conference—an event that attracts wine delegates from all over the world as well as New Zealanders with a passion for producing and/or consuming pinot.

168 *Maia*
Design Firm: HKLM
Art Director: Gary Harwood
Creative Director/Designer: Bev Field
Client: Southern Sun

Maia is an exclusive luxury villa hotel in the Seychelles and is the most significant project undertaken by southern sun hotels to date.

HKLM created the brand essence of 'intuition' with supporting values of dignity, humility, spirituality and harmony. HKLM built the brand around the five senses, making every encounter, before, during and after a stay, a sensual delight. The primary logotype is created from the image of pink frangipanis and is reversed out of the image in white on the reverse of the format (see business cards). Each of the corporate identity elements uses a different expression of the logotype to fully capture the riot of colour and texture that is the Seychelles. A shoot was carried out on location to capture a variety of authentic textures from both Mahé and Maia itself.

169 *Alcatraz Ferry*
Design Firm: Michael Schwab Studio
Art Director: Tom Escher
Designer/Illustrator: Michael Schwab
Client: Red & White Fleet

169 *Tim Bieber Logo*
Design Firm: Liska + Associates
Art Director/Creative Director/Designer: Steve Liska
Client: Tim Bieber

Logo for a film and commercial director

169 *Corporate Logo*
Design Firm: Sukle Advertising & Design
Creative Director: Mike Sukle
Designer: Jamie Panzarella
Client: Deep Rock Water

169 *40th Anniversary Logo*
Design Firm: Barkley Evergreen & Partners
Creative Director: Craig Neuman
Designer: Eric Carver
Client: Barkley Evergreen & Partners

169 *Roadsmith Logo*
Design Firm: Initio Advertising
Art Directors: Joe Monnens, Randy Pierce
Creative Director: Paul Chapin
Designer: Joe Monnens
Client: The Trike Shop

Roadsmith is the result of a complete rebranding effort for a line of trikes, motorcycles converted into three-wheeled bikes, crafted by The Trike Shop. The Trike Shop has been converting bikes to trikes with a hands-on approach for over 30 years, so we positioned them as the experts in the field. The logo needed to communicate this expert positioning, including craftsmanship, attention to detail and strength. Simultaneously, it needed to exude the qualities of a motorcyclist: attitude and a desire for the open road. The Roadsmith logo will be placed on the back of the trikes, retail store signage, t-shirts, sales materials, advertising, vehicle graphics, and in other locations where the Roadsmith message needs to be conveyed.

170 *Goodies Logo for Target Stores*
Design Firm: Stand Advertising
Art Director/Creative Director: Michael Telesco
Photographer: Walter Colley
Writer: Crista Finn
Client: Rich Products

170 *Cook County Canines*
Design Firm: pfw design
Art Director/Creative Director/Designer:
Patience F Williams
Illustrator: Pat McDarby
Client: Monica Whang

With so many "owner gives up's" and overcrowding of the local animal shelters, Cook County Canines strives to educate and support families who adopt dogs who are sometimes overlooked and ignored at dog pounds. They offer training programs for canines and their humans geared towards developing a good positive foundation in obedience, handling, confidence, and patience. It is a serious organization with a soft side.

170 *Fotoj Logo*
Design Firm: ixo
Creative Director: Susan Cox
Designer/Illustrator: Frank Biancalana
Client: Jim Krantz

The Fotoj logo is an ambigram—reading the right way up and upside down. This demonstrates the diverse approach Jim Krantz takes to his photography. Hence what you see depends on where you stand.

170 *Kerzner Marine Foundation Identity*
Design Firm: Duffy & Partners
Creative Director: Dan Olson
Designer: Joseph Duffy
Client: Kerzner International Limited

Kerzner International Limited asked Duffy & Partners to create an identity for the Kerzner Marine Foundation, a private nonprofit foundation that fosters the preservation and enhancement of global marine ecosystems through scientific research, education, and community outreach. To stress the importance of their commitment to protect marine life, the identity creates an optical illusion of a human face and a dolphin tail. This design, along with the marine blue color of the mark, communicates the foundation's mission of defending the integrity of tropical marine ecosystems.

170 *STORY logo*
Design Firm: STORY
Designer: David Orr
Client: STORY

Logo created for STORY, a commercial production company based out of Chicago, IL. For application to all elements of corporate identity including stationary, website, and DVD covers for Directors' reels.

171 *Lyrics and Legacy Identity*
Design Firm: MBA
Creative Director: Mark Brinkman
Designers: Caroline Pledger, Mark Brinkman
Client: Hill Country Conservancy

A concert to raise funds towards preservation of the Hill Country featuring father/son acts.

172 *Mjolka*
Design Firm: O!
Art Director: Orn Smari Gislason
Designer: Orn Smari Gislason
Client: Mjolka

172 *Corporate Identity Package*
Design Firm: Goodby, Silverstein & Partners
Art Director/Creative Director: Rich Silverstein
Designer: Mark Rurka
Illustrator: Michael Schwab
Client: USA Cycling

172 *Dallas Legal Foundation logo*
Design Firm: RBMM
Designer/Illustrator: Kevin Bailey
Client: Dallas Legal Foundation

172 *Turn Corporate Identity*
Design Firm: Addis
Creative Director: John Creson
Designer: Rebecca Au-Williams
Client: Turn

172 *Brandtailor*
Design Firm: Michael Miller Yu
Art Director/Creative Director/
Designer/Illustrator: Michael Miller Yu
Client: Brandtailor ltd

A brand consulting company, tailor-made service to individual client.

173 *Synergy Signage*
Design Firm: Evenson Design Group
Art Director/Creative Director: Stan Evenson
Designer: Katja Loesch
Photographer: Emily Nelson
Client: Synergy Café

173 *Eos Airlines Corporate Identity Program*
Design Firm: Hornall Anderson Design Works
Art Directors: Mark Popich, David Bates
Creative Director: Jack Anderson
Designers: Mark Popich, Larry Anderson,
David Bates, Andrew Wicklund,
Leo Raymundo, Jacob Carter, Yuri Shvets
Client: Eos Airlines

Named for the Greek goddess of dawn, this new transatlantic airline offers a premium travel experience for business travelers, including 49 "suites"; not seats, in a plane that typically carries over 200.

173 *Bistro Boudin*
Design Firm: SF Pentagram
Art Director/ Creative Director: Kit Hinrichs
Designer: Kit Hinrichs, Laura Scott
Client: Boudin

174 *Weinig 100 Plus*
Design Firm: Jens Lattke
Art Director: Jens Lattke
Designer: Kerstin Hlava-Landeck
Client: Weinig AG

Key-Visual for the 100 Birthday year… The Weinig Group is the world leading company for industrial machines for the solid wood working industry. The Key-Visual quotes the Weinig-clients' material "wood": the number "100" (which should not be seen on the first view) is built of a wood chip (which results on Weinig's planing machines and moulders). The Key-Visual was used for banners on trade-fairs, invitation cards, and as Key-Visual for the birthday-event a.s.o.

175 *Ironhead Athletic*
Design Firm: Tim Frame Design
Art Director: Mike Regan
Designer/Illustrator: Tim Frame
Client: Ironhead Athletic

This is a logotype for Ironhead Athletic custom sports apparel.

175 *Crossroads Coffeehouse & Music Company Logo*
Design Firm: Peterson Ray & Company
Art Director/Designer/Illustrator: Scott Ray
Client: Crossroads Coffeehouse & Music Co.

175 *Entry 2006*
Design Firm: KMS Team GmbH
Art Directors: Patrick Märki,
Peta Kobrow, Bruno Marek
Creative Director: Knut Maierhofer
Writer: Axel Sanjosé
Client: Ausstellungsgesellschaft Zollverein

In summer 2006, Essen will host the first World Exposition for Design and Architecture: ENTRY2006. Visionary projects by leading designers and architects offer insights into the developments of the coming decades. For ENTRY, we created the name, the corporate design and the entire communication including website, trade show exhibit and merchandising ideas. The starting point of our conception is the distinctive symbol of a red Y (the final letter in ENTRY), which, rendered in three dimensions, appears as a system of coordinates. It connects the ideas of the graphic (plane) with that of the spatial, the respective original domains of design and architecture. The name refers to the underlying idea of providing access to relevant formal developments of the future.

175 *Scarecrow Wine Logo*
Design Firm: Vanderbyl Design
Art Director/Creative Director: Michael Vanderbyl
Designers: Michael Vanderbyl, Ellen Gould
Client: Scarecrow Wines

175 *Exomos Brand Identity*
Design Firm: FutureBrand
Creative Director: Avrom Tobias
Executive Director: Rina Plapler
Director: Tess Abraham
Director of Identity Systems: Carol Wolf
Senior Production Designer:
Sagayaraj Prasanna
Senior Designers: Tini Chen, Tom Li
Designers: Mike Williams, Brendan Oneill
Director of Visualization Team: Antonio Baglione
Visualization Associate Director:
Oliver de la Rama
Visualization Designers:
Walter Grant, Jeremy Yan, Arqum Ziauddin
Editor: Phil Tojas
Senior Multimedia Developer: Mike Sheehan
Illustrators: Antonio Baglione, Oliver de la Rama
Copywriter: Stephanie Carroll
Client: Exomos

With unprecedented developments built on water, it is not surprising that a revolutionary submarine and submersible company emerged out of Dubai. A company that offers a unique range of products for consumer, military and commercial audiences. We were hired to rename the company (initially called Palm Submarines), create an identity and provide full marketing support… The new name, based on the idea of "exo-skeletal" suggests the submersibles become like a second skin to users under the water and brand identity effectively captures the interplay and reflection of movement above and below water… we chose to highlight the submersibles as works of art and serious machines…using 3D programs, effectively communicating the scientific principles through diagrams and wireframes. A brochure reinforced the company's amazing achievements and advancements, while the use of neon and metallic inks and varnishes helped further suggest the unique boldness of the products.

Menus

176, 177 *Scott Howard*
Design Firm: Turner & Duckworth
Creative Directors:
Bruce Duckworth, David Turner
Designers: David Turner, Jonathan Warner
Photographer: Lloyd Hryciw
Client: Scott Howard Restaurant

The chef Scott Howard carefully selects the very best seasonal ingredients and—through a complex process of preparation and craftsmanship—extracts their essence to create dishes that are simply perfect. The logo for his restaurant reflects this precise method by creating an arrow out of a carrot. The menus, gift cards, and check presenters celebrate the ingredients with intense close-up photography, showing them at a scale most people never see.

Miscellaneous

178 *Phonebook Directory Covers*
Design Firm: Arih Advertising Agency
Art Director/Designer/Illustrator: Loni Jovanovic
Creative Director: Igor Arih
Writers: Sasa Iskric, Teo Krizmancic
Client: Telekom Slovenije, d.d

Seven covers of national phonebook directories (Telefonski imenik Slovenije 2006) for 6 code areas in Slovenia and Yellow Pages. Each cover features a typical protected flower of the area, while on the cover of Yellow Pages is the national protected flower.

179 *A Crack in the Edge of the World*
Art Director/Designer:
Roberto de Vicq de Cumptich
Design Firm: HarperCollins Publishers
Client: HarperCollins

A poster that serves as a book jacket for a trade book on the San Francisco earthquake of 1906.

Outdoor

180 *Black Truck, Blue Truck, Red Truck, Green Truck*
Design Firm: Sukle Advertising & Design
Creative Director: Mike Sukle
Designer: Jamie Panzarella
Client: Deep Rock Water

Vehicle wrap

181 *St. David's Imaging Services Vehicle*
Design Firm: The Bradford Lawton Design Group, Inc
Art Director/Creative Director: Bradford Lawton
Designer: Jason Limon
Client: St. David's MC Imaging Services

Packaging

182, 183 *Mario Batali The Italian Kitchen Packaging*
Design Firm: Bamboo
Art Director/Creative Director/Designer:
Kathy Soranno
Client: Copco

184 *Waitrose Cooks' Ingredients*
Design Firm: Lewis Moberly
Art Director: Mary Lewis
Designers: Mary Lewis, Christian Stacey
Client: Waitrose Ltd

Waitrose, the food shops of the John Lewis Partnership, has launched a new own-label range of Cooks' Ingredients, with everything that food lovers need, from oils to rice, herbs to vinegars. With the proliferation of celebrity chefs and food magazines, people are becoming increasingly interested in cooking. Waitrose has responded to this trend by a range that satisfies the enthusiasts' everyday needs. The range comprises lemon juice sourced especially from Sicily, sea salt from Anglesey and walnut oil from France; the products themselves are a far cry from "cupboard basics." And as any foodie worth their salt will tell you, even the most modest dishes require the right ingredients sourced with precision. Lewis Moberly has created the packaging for the range of over sixty products. Each of the packs introduces its contents with an energetic no-need-to-measure-it-out phrase.

185 *Panini*
Design Firm: Lewis Moberly
Art Director: Sonja Frick
Creative Director: Mary Lewis
Designers: Hideo Akiba, Fiona Verdon-Smith
Client: Panini-Grand Hyatt Dubai

One of the Middle East's largest and most exclusive hotels, the Grand Hyatt Dubai forms part of the expanding Grand Hyatt premium hotels portfolio, appealing to both business and leisure travellers. Lewis Moberly's brief was to create the identities for the 15 venues in the complex. The task included name generation, internal collateral and signage. Panini is the Hyatt's Italian café and bakery. Panini packaging was designed to reflect the fun, sophisticated nature of café culture. The design has a spontaneous free style illustration which reflects and extends the logo and animates across the numerous items on sale.

186 *Lynwood Preserves*
Design Firm: Harcus Design
Art Director: Annette Harcus
Designers: Stephanie Martin, Marianne Walter
Illustrator: Marianne Walter
Client: Lynwood Preserves

Packaging and branding for boutique preserves—jams, marmalades and chutneys.

187 *Harbor Sweets Packaging*
Design Firm: Tomlinson Inc
Creative Director: Bill Tomlinson
Designers: Danielle Rifkin, Lisa Sandbank
Writer: Karen Dawson
Client: Harbor Sweets

Redefine the Harbor Sweets brand as a more upscale, gourmet chocolatier to compete with well-known leaders, but also the keep the history and tradition of a 30-year-old company. It needed to appeal to its loyal customers, as well as attract new ones. This packaging system worked not only to unify the different lines of chocolate, it also made it more approachable and contemporary.

188 *Black Boy Premium Spices*
Design Firm: Stromme Throndsen Design
Art Director/Creative Director:
Morten Throndsen
Designer: Kjersti Benjaminsen
Client: Rieber & Son ASA

As leader in the Norwegian market, Black Boy was starting to be seen as a bit old fashioned and there were issues concerning the creation of growth in the category. Black Boy Gourmet was developed to encompass these issues and to fit better into the modern Norwegian kitchen. The result is a series of spices that are seen as different and more edgy, meeting the trends of today and making sure that Black Boy is no longer hidden behind closed kitchen doors.

189 *Caldo Packagaing*
Design Firm: Target
Art Director: Dan Weston
Creative Director: Minda Gralnek
Designer: Graham Hall
Client: Target

Caldo is an exclusive luxury product line designed by Target and imported from Italy. Caldo is a fragrance- and ingredient-based line for the modern man. Caldo was designed to encourage a new level in men's grooming.

190, 191 *Homebase Own Brand Packaging*
Design Firm: Turner Duckworth
Creative Directors:
David Turner & Bruce Duckworth
Designers: Christian Eager, Paula Talford,
Mike Harris, Charlotte Barres
Photographers: David Lidbetter,
Steve Baxter, Andy Grimshaw
Client: Homebase

Own label pack redesign for the entire Homebase portfolio of products (circa 44,000!). This has involved everything from creating the Pack Design Strategy to the creation of brand guidelines for implementation in the UK and Far East. Ranges launched so far include: Lighting, BBQ's, Garden Furniture, Paint Preparation (everything from paintbrushes to paint stripper to dust sheets and sealants), The White Room paint range and Cook Shop.

192 *Soil that works wonders*
Design Firm: Kostym
Art Director: Olle Olsson
Designers: Robert Hammar, Olle Olsson
Photographer: Anders Lipkin
Client: Hasselfors Garden

Packaging design for soil and a variety of garden products. Hasselfors Garden offers customers a wide range of quality products for the care of plants and soil. Soil that works wonders.

193 *Target ClearRx Prescription System*
Design Firm: Target
Designer: Target in partnership with
Deborah Adler and Klaus Rosburg
Client: Target

Target ClearRx prescription system is a new family of smart safe innovations in pharmacy: A new label design that helps make information about your medicine easier to read and easier to understand; A new shape bottle that puts all the vital information in the palm of your hand; New color-coded rings to personalize and easily identify your medicine; A place for your patient information card right on the bottle, right where you need it.

What makes it different or better? Easy-to-read label; Color-coded rings; Patient info card

tucked into the back label; Spill-resistant bottle & syringe for liquid medication; Top label with name of prescription.

194 *Bootleg*
Design Firm: Turner Duckworth
Creative Directors:
Bruce Duckworth, David Turner
Designer: Shawn Rosenberger
Client: Click Wine Group

Bootleg celebrates the creativity and style of a new generation of Italian winemakers by offering a collection of daring interpretations of classic Italian wines. Many Italian wine labels follow the usual formula of a hard to pronounce name and an illustration of the winery. We wanted to give a new twist to the tired cliché of the shape of Italy as a boot. The result is a sexy expression of contemporary Italian style that appears to wrap the bottle in skin-tight zippered leather.

195 *Pescaia Wine Label*
Design Firm: Giorgio Davanzo Design
Art Director/Designer: Giorgio Davanzo
Client: Facelli Winery

The Pescaia wines are produced by a family-run winery where everyone is directly involved in the process of winemaking. When asked to describe their style of winemaking each member of the family used words such as hand-picked, hand-crafted and hand-sorted. I immediately thought of letterpress as a way to communicate these values on the bottle.

196 *Beer Packaging Family*
Design Firm: tbdadvertising
Creative Director: Paul Evers
Designer: David Carlson—Gearbox
Illustrator: Mona Caron
Writer: Angela Reid and Frank Gjata
Client: Odell Brewing Co.

With its "rubber stamp" design technique, landscape features and fun, lighthearted personality, this packaging reflects the handcrafted nature of Odell Brewing Company's product, down-to-earth personality and the outdoorsy setting of the company's Colorado headquarters.

197 *Oatmeal Stout*
Design Firm: Shine Advertising
Art Director: Peter Bell
Client: Gray's Brewing Company

197 *Honey Ale*
Design Firm: Shine Advertising
Art Director: Peter Bell
Client: Gray's Brewing Company

198 *Monkey Shoulder Whisky*
Design Firm: Lewis Moberly
Designers: Mary Lewis, Joanne Smith
Client: William Grant & Sons

Rooted in whisky lore, Monkey Shoulder is inspired by, and named in honour of, the malt men who are among the few still to turn the barley by hand, using the traditional shiel. Monkey Shoulder is the nickname given to the stoop malt men often develop after repeatedly bending over to turn the malt. The iconic bottle design, branded by three monkeys, cast in pewter, each represent one of the three single malts used to create the whisky.

199 *75 South Whiskey*
Design Firm: Anthem
Creative Director: Brian Lovell
Designer/Illustrator: Kevin Sams
Client: Safeway

Anthem helped Safeway reposition their private label offering for the spirits category to compete at the national brand level. 75 South Whiskey was strategically named to reflect its Southern American origins, while the design expressed a classic masculinity.

200 *Auchentoshan 1962*
Design Firm: Breeze Creative
Design Consultants
Art Director/Designer: Craig Mackinlay

Photographer: Colin Bell
Client: Morrison Bowmore Distillers Ltd.

A Limited Edition Vintage Malt Whisky from Glasgow's distillery, Auchentoshan, designed to reflect Glasgow as it is now—stylish, cosmopolitan, and very individual. This fine whisky is the oldest and most expensive lowland malt ever. The spirit is so rare that only 104 bottles will be made available across the entire globe.

201 *Riedel Packaging*
Design Firm: Target
Art Director: KNOCK, Inc
Creative Director: Eric Erickson
Client: Target

Paper Companies

202 *Beauty and Nuance*
Design Firm: Vanderbyl Design
Art Director/Creative Director: Michael Vanderbyl
Designers: Ellen Gould, Michael Vanderbyl
Client: Mohawk Fine Papers, Inc.

This was a perfect opportunity to explore ideas about beauty and nuance and to gather examples of design that embody those qualities. The most lasting and significant designs are imbued with elegance, clarity and beauty. These are ideals that seem to have always existed and for good reason. Beauty enriches life, making it more pleasurable and links us to the past. Beauty has a universal attraction, despite recent trends that push it aside.

203 *Cougar/Lynx/Husky Swatch Books*
Design Firm: Squires & Company
Creative Director: Brandon Murphy
Designer: Bret Sano
Illustrator: Ernesto Pacheco
Photographers: Various
Writers: Wayne Geyer, Bret Sano
Client: Wyerhaeuser

Swatchbooks for Cougar, Lynx and Husky papers.

204 *The Standard*
Design Firm: Pentagram San Francisco
Art Director/Creative Director: Kit Hinrichs
Designers: Kit Hinrichs,
Belle How, Jessica Siegel
Client: Sappi

205 *Utopia Book*
Design Firm: Carmichael Lynch Thorburn
Creative Director: Bill Thorburn
Designers: Terese Corredato,
Jesse Kaczmarek
Writer: Riley Kane
Client: Appleton Coated Papers

The purpose was to educate designers and specifiers about the exceptional quality of Utopia. The book was used as a direct mail and was also used in sales presentations.

Posters

206 *30 Anschlaege (30 Assaults)*
Design Firm: gggrafik-design
Art Director/Creative Director/
Designer/Illustrator: Goetz Gramlich
Client: 30 Anschlaege

This was a poster for a poster exhibition. 30 artists/designers were invited to create a visual assault-show in the public. For more information, please visit www.30anschlaege.de.

207 *Takenobu Igarashi Exhibition Series*
Design Firm: Rubberbandland
Creative Director/Designer: Kayoko Takeo
Client: Takenobu Igarashi
Exhibition Series Committee

As promotional items for a series of exhibitions and events of the artist Takenobu Igarashi, this was created by layering strips of Igarashi's diverse graphic, product and sculptural work. The typography displays information about the 15 exhibitions. The poster pays homage to his sculptural work, "Horizontal feeling"—a work comprised of layered strips of wood in varying color and texture.

208 *Launch Poster*
Design Firm: Graphic Design, Apple Computer
Art Director/Designer: Apple Graphic Design
Client: Apple Computer

209 *Peet's Coffee and Tea*
Design Firm: Michael Schwab Studio
Art Director: Elisabeth Settimi
Designer/Illustrator: Michael Schwab
Client: Peet's Coffee & Tea
Poster created for the 40th Anniversary.

210 *Exhibitor Show 2006*
Design Firm: Vanderbyl Design
Art Director/Creative Director/Illustrator:
Michael Vanderbyl
Designers: Ellen Gould, Michael Vanderbyl
Client: Exhibitor Magazine

211 *Rosey Call to Entry*
Design Firm: Sandstrom Design
Art Director: Jon Olsen
Creative Directors: Austin Howe (Four Stories),
Jon Olsen (Sandstrom Design)
Designers: Jason Chmielewski, Jon Olsen
Photographer: David Emmite
Writer: Austin Howe (Four Stories)
Client: Portland Advertising Federation

212 *Velocity-Ecopolis Poster*
Design Firm: Communication Arts Inc.
Creative Director: Bryan Gough
Designer: Zach Lee
Client: Value Retail

This poster was created to illustrate the spirit of the Velocity project in Maasmechelen, Belgium. The poster is used as a tool to approach the local government and surrounding community about the project and give an idea of what the overall goal is. It is not used as a promotional tool, but is used to inspire designers and architects working on the project. This poster's intended audience is the local community, government officials, and project designers. This poster is used as part of presentations, and is circulated internally to Velocity team members via email and postings in common areas of the team.

213 *Alberta Scene*
Design Firm: MacLaren McCann
Art Directors/Designers: Brad Connell,
Kelsey Horne, Mike Meadus
Creative Director/Writer: Paul Long
Photographer: Ken Woo
Client: EPCOR

214 *Kendrick Revealing Character Campaign*
Design Firm: McGarrah/Jessee, CHAOS
Creative Director: Bryan Jessee
Designers: Derrit DeRouen, Ryan Rhodes
Photographer: Robb Kendrick
Client: Robb Kendrick

The mission of this project is to preserve the character of Texas in a collection of photographic art to inspire citizens of Texas. In 2004, Frost Bank, in partnership with Texas Monthly asked renowned Robb Kendrick to document today's Texas Cowboy in an effort to not only rekindle our heritage but also to remind us all that character is alive, well and just as important today.

215 *University of San Francisco*
Design Firm: Saint Hieronymus Press
Art Director/Creative Director/
Designer/Illustrator: David Lance Goines
Client: University of San Francisco

University of San Francisco 150th Anniversary.

Products

216, 217 *Pushpin Olive Picks*
Design Firm: Gabrielle Lewin Design
Designer: Gabrielle Lewin
Photographer: Anatole Shaw
Client: Kikkerland, Inc.

The Pushpin Olive Picks bring much-needed humor to traditional bar accessories by taking a familiar and iconic object, the push pin, and giving it a fresh, unexpected twist. These stylish

olive picks are designed to allow one to spear crudités or martini olives with the same elegance as a bulletin board to-do list. The Pushpin Olive Picks are available in a pack of six different colors: white, yellow, blue, red, orange, and green.

Promotions

218 *Direct Mail*
Design Firm: Thomas Manss & Company
Art Director: Thomas Manss
Designer: Damian Schober
Photographer: Nick Veasey
Writer: Stephan Platt
Client: Vertixx

Vertixx is a subsidiary of Deutsche Telekom AG, founded in 2005 primarily for the online sale and distribution of office and consumer electronics. The direct mail campaign was used to launch the company, promote the range of services and raise the profile of the Vertixx brand. At the centre of the design of the targeted direct mailing are x-ray photographs of consumer electronics. These are used to communicate the fact that Vertixx is the safe choice when trading online. All products are vetted to Vertixx before auction. The X-rays have the added advantage of showing a product without identifying a specific manufacturer or brand. The first step of the direct mailing campaign, sent to 500 decision makers in targeted businesses, is an A3 radiogram/X-ray showing an image combining a graph with increased sales. The headlines: From non-seller to cash cow, From shelf-warmer to growth miracle, From surplus stock to profit maker and From left overs to hot cakes emphasise that message.

219 *NB Studio Christmas Card*
Design Firm: NB Studio
Art Directors: Alan Dye, Nick Finney, Ben Scott
Designer: Jodie Wightman
Writer: Howard Fletcher
Client: NB Studio

A Christmas Card for all occasions!

220 *Central Market Print "Happy New Year"*
Design Firm: McGarrah/Jessee, CHAOS
Art Director: Michael Anderson
Creative Directors: Cameron Day, James Mikus
Writer: Brian Jordan
Client: Central Market

221 *Central Market Seasonal Poster Campaign*
Design Firm: McGarrah/Jessee, CHAOS
Designers: Craig Crutchfield,
Derrit DeRouen, Ryan Rhodes
Client: Central Market

222 *Cubanisimo*
Design Firm: TAXI
Art Director/Designer/Illustrator: Stephanie Yung
Creative Director: Steve Mykolyn
Writer: Alexis Gropper
Client: Canadian Film Centre

223 *New York: Let The Dreams Begin*
Designer: Kristin Johnson
Art Director: Jennifer Kinon
Client: NYC2012

This poster was created for an extravaganza put on at the Jazz at Lincoln Center by NYC2012 (New York's bid for the 2012 Olympics). The event was intended to show the International Olympic Committee members what an exciting and vibrant city New York is. This abstract rendition of the city uses typography and the NYC2012 branding to communicate the spirit of New York City.

224 *Happy…and heavy 06*
Design Firm: Design Center Ltd.
Art Director/Creative Director/Designer:
Eduard Cehovin
Photographer: Janez Vlachy
Client: Eduard Cehovin

Starting (building) from the very beginning "New Life", in new house and new job, was my main idea for using a brick as a Christmas card.

225 *Gavin Martin Associates Moving Card*
Design Firm: NB Studio
Art Directors: Alan Dye, Nick Finney, Ben Stott
Designer: Daniel Lock
Client: Gavin Martin Associates

We were asked to design a piece of direct mail to announce printer Gavin Martin Associates' move to new offices. Taking cue from their new location, The Tea Building in Shoreditch, we decided to lavishly letterpress the typography onto GF Smith card and then painstakingly stain all 1000 cards with a tea ring to reflect the idea of removal and removal men leaving tea stains all over the office. Four different version were created using Earl Grey, Darjeeling, Roiboos and English Breakfast teas, instead of cyan, magenta, yellow and black inks. This alternative printing method reflected Gavin Martin's own experimental approach and made every card individual.

Shopping Bags

226 *Target Vintage Bag*
Design Firm: Target
Art Director: Ron Anderson
Creative Director: Minda Gralnek
Designer: Jason Miller
Client: Target

The bag was given away at Target sponsored events as well as sold to Target team members in our Brand Shop located at our headquarters building. Iconic images were chosen from original Target advertising dating back to the 1960s using a colorful collage design. The design highlights the Target brand with a vintage twist.

Signage

227 *Coffee Darling*
Design Firm: Hoyne Design Pty Ltd.
Art Director/Creative Director: Andrew Hoyne
Designers: Andrew Hoyne, James West
Illustrator: Karen Oppatt
Photographer: Marcus Struzina
Client: Coffee Darling

The task was to develop the brand identity for a stylish cafe in an upmarket Melbourne neighborhood just off Toorak Road in Darling Street, South Yarra (Victoria, Australia). Graphic symbolism was used to depict the Coffee Darling experience a flight of fancy, an escape from the hubbub of the outside world. This was interpreted as a flamboyant illustration of a fanciful bird taking to the sky, extending to a textural mural featuring an entire flock of birds taking flight. Coffee Darling is aptly named both for the street it's in and its clientele's frequent use of dahling.

228, 229 *City Museum*
Design Firm: emerystudio
Art Director: Garry Emery
Designer: Mark Janetzki
Client: City Museum at Old Treasury

The City Museum is housed in a prominent building located at the end of a primary axis in the city. However, the main entry to the museum is through an insignificant door that is found only after climbing a grand stair and crossing a windswept podium. The task for emerystudio is to signal the presence of the museum, to encourage visitation and to announce temporary exhibitions and operating hours. The brightly coloured, folded monumental signage elements are designed as contemporary insertions into the historic setting. These sign-objects are located to subtly guide people upwards to discover the museum entry and the exhibitions. The aim of the sign system is to enhance the operational requirements of the museum while respecting the historic building fabric. Some more conservative members of the public do not appreciate this approach.

230 *Collins Place*
Design Firm: emerystudio
Art Director: Garry Emery
Designer: Ben Kluger
Client: Collins Place

Collins Place consists of two office towers linked by a retail complex. The building, designed in the 1970s by American architect I M Pei, turned its back on Flinders Lane, which was then a lifeless part of the city but has since become a vibrant retail precinct. The building owners have refurbished Collins Place to address the evolving opportunity of a rejuvenated Flinders Lane. emerystudio has developed a new wayfinding system as well as graphics and signage to enhance the experience of the retail offer. Of particular significance is a signage element fixed to a monumental, reflective metal column located on the central retail axis between the two towers. The column terminates at the ground at the centre of the radius, forming a large water feature. The bright orange sign attracts attention to the name of the place and its street number. The distinctive sculptural sign also has a relationship with other signs in the system, which share a common visual language—a volume based on a square section—and are also orange to stand out in a competitive, cluttered retail environment.

231 *Arte & Frank Hair Dressing Salon— Interior graphics and exterior identification*
Design Firm: Frost Design
Creative Director: Vince Frost
Designers: Bridget Atkinson,
Anthony Donovan, Vince Frost
Client: Arte & Frank

The design solution for this boutique Melbourne hairdressing salon is deceptively simple. Working to a small budget, our idea was to unify the long, tunnel-like interior space by wrapping the salon's name diagonally up the walls and across the ceiling. The letters travel around the narrow walls—this treatment encourages the type to react with the added dimension. The concept also takes advantage of the salon's expanse of mirrors that constantly shift viewer perceptions of the type. The type changes direction at the halfway point marked by the ampersand, so that it can be read from both directions. Seen from outside, the letters draw you in as they spiral back into the space. The 4 ft high lettering was hand-painted on to the walls and ceiling—our choice of signwriting ties in to the craft of hairdressing.

232, 233 *Biopolis*
Design Firm: Epigram
Art Director: Kelvin Lok
Creative Director: Edmund Wee
Designers: Kelvin Lok, Quek Hong Shin
Client: JTC Corporation

At one-north, leading scientists, researchers and technopreneurs from around the world come to live, work and play. Within the vibrant premises, three towering structures—Biodroids—capture the imagination. The four-metre aluminium structures are formed by seven different geometric shapes and colours, echoing the top elevation of each building in Biopolis, a biomedical centre. They also support life load, in case intrepid visitors climb up for a closer look or a better snapshot. Inspired by the peculiar shapes of the buildings, the Biodroids are the 'Building Blocks of Life', an allusion to the biochemistry industry. Put together in a fun way, the Biodroids actually point to the main entrance of Bioplois. The various shapes and colours that make up the Droids also help people find their way around, guided by specific colour schemes and directional angles.

Stamps

234 *Constellations*
Art Director: Carl Herrman
Designer/Artist: McRay Magloby
Client: United States Postal Service

Starry patterns in the night sky adorn a block of four stamps issued by the U.S. Postal Service. Each stamp features one of the following constellations as seen from the Northern Hemisphere: Leo, Lyra, Pegasus, and Orion. The stamp designs are original artwork created by well-known illustrator, graphic designer, and educator McRay Magleby of Provo, Utah.Magleby used star maps by Wil Tirion as reference for the placement and size of the stars depicted in the stamp art. Tirion, who lives in the Netherlands, has been called "this generation's foremost celestial cartographer."

235 *Sports Treasures*
Design Firm: Spark Studio
Art Director/Designer: Adam Pugh
Creative Director: Sean Pethick
Photographer: Lynton Crabb
Client: Australia Post
Stamp image reproduced with permission from Australian Post. © Australia Post.

Iconic objects transcend from everyday items through their relationship with a great person or event. Spark was commissioned by Australia Post to design four stamps that featured items that evoke the legend of four great Australian sporting champions—Sir Donald Bradman, Lionel Rose, Phar Lap and Marjorie Jackson.

236 *Animal Tales*
Design Firm: Rose Design Associates Ltd.
Art Director: Simon Elliot
Creative Director: Garry Blackburn
Designer: Terry Stephens
Illustrator: Eric Carle
Client: Royal Mail

237 *Australian Legends 2005*
Design Firm: Spark Studio
Art Director/Designer: Adam Pugh
Creative Director: Sean Pethick
Photographer: Lucas Allen
Client: Australia Post
Stamp image reproduced with permission from Australian Post. © Australia Post.

The Australia Post Legend awards were initiated in 1997 to honour living Australians who have made a unique contribution to our way of life. Spark Studio was honoured to be the first studio outside of Australia Post to design this iconic collection. The 2005 Australian Legends are Australian fashion designers Prue Acton OBE, Jenny Bannister, Collette Dinnigan, Akira Isogawa, Joe Saba and Carla Zampatti.

238 *Postcollants*
Design Firm: Vidale-Gloesener
Creative Director: Tom Gloesener
Designers: Silvano Vidale, Miguel Pereira
Photographer: Christian Mosar
Writer: Gioia Bertemes
Client: P&T Luxembourg

The Luxembourg Post Office commissioned us to brand their new product of adhesive stamps. It had to stand out visually from previous products and existing stamps. To emphasize the novelty of the product, we came up with the idea of showing a finger peeling off an adhesive stamp on the product itself, giving it a surreal appearance. The packaging design was based on that same visual. For the two editions (0,25 and 0,50 EUR), we chose different colour palettes, with each of the colours represented in four different shades, from light to dark. This extra detail gives the product an aspect of motion. To give the stamp a timeless feeling, we kept the typography very simple, using a DIN Engschrift. By giving the product a specific yet fun name, we underlined the novelty and the easy, practical side of this product for the consumer.

239 *Big Cats*
Designer: Keith Martin
Printer: Lowe-Martin

239 *Search and Rescue*
Designer: François Dallaire
Illustration: Paul Home
Photography: Guy Lavigeur, Reuters/Corbis, Canadian Coast Guard Maritime Search and Rescue, Newfoundland and Labrador Region, Space Imaging

239 *XI FINA World Championships*
Designers: François Martin, Réjean Myette
Printer: Lowe- Martin

239 *Ellen Fairclough*
Designer: Katalin Kovats
Photography: LAC- Roy Arthur, Duncan Cameron, Murray Mosher
Printer: Canadian Bank Note

239 *High Value Definitive—White-tailed Deer and Atlantic Walrus*
Designer: David Craib
Illustration (walrus): Pierre Leduc, Jorge Peral
Illustration (deer): Xerxes Irani
Engraving: Jorge Peral
Photographers:
Jack Hollingsworth, James Gritz
Printer: Canadian Bank Note

Stamps on this page found in the following book:

Collection Canada 2005
Design Firm: q30design inc.
Art Director: Glenda Rissman
Creative Director: Peter Scott
Designer: Jeremy Linskill
Illustrator: Various
Photographer: Various
Writers: Michael Erkelenz, Fine Line Writers
Client: Canada Post Corporation

Collection Canada 2005 is an annual premium product directed towards the serious and casual collector. Stamp subjects are grouped into chapters, and interesting and unusual connections are uncovered between them. This approach allows for storytelling and visuals beyond the stamp content making for a more dynamic presentation.

T-Shirts

240, 241 *Envelope*
Design Firm: BBDO/NY
Art Directors: Eric Shutte, Chuck Tso
Creative Director: Eric Silver
Client: FedEx

Its wraparound design gives the impression that a FedEx package is being carried by its wearer.

242, 243 *2006 Shirts*
Design Firm: BVK/Serve
Art Director/Designer: Giho Lee
Creative Director: Mitch Markussen
Writer: Percy Spunkmier
Client: United Adworkers

Typography

244, 245 *Carclew*
Design Firm: IKD Design Solutions
Art Director/Creative Director: Ian Kidd
Designers: Dinah Edwards, Anna Rogers
Client: Carclew Youth Arts Centre

Carclew Youth Arts Centre provides programs of excellence for four to 26 year olds. The re-branding includes a specially designed playful grunge typeface which is used throughout the identity and communications program.

246 *Magneto Motivity*
Design Firm: Les Cheneaux Design
Designer: Lori Young
Client: Les Cheneaux Design

This typography is designed to promote ornamentation based on cultural constructs.

Index

253 *Nike iD Reuters Sign*
Creative Director: Richard Ting
Art Director: Marlon Hernandez
Interaction Designer: Aya Karpinska
Visual Designers: Brian Votaw, Laura Pence, Matthew Garton, Troy Kooper, David Alcorn
Copywriters: Michael Spiegel, Josh Bletterman, Scott Tufts
Programmers: John Mayo-Smith, Ephraim Cohen, Sean Lyons, Scott Prindle, Chuck Genco
Q: Michael Shagalov
QA: Todd Kovner
Producers: Andy Bhatt, Matt Howell
Analytics: Briggs Davidson

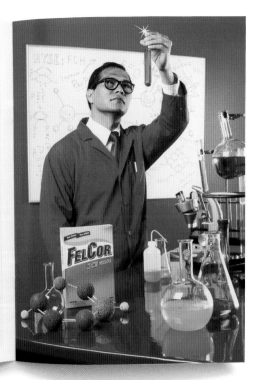

WE'VE CREATED A NEW FELCOR—
And it's Better than Ever!

?

HOW DOES THE
IHG DEAL
MAKE IT
BETTER?

NEW FELCOR HAS MADE AN INCREDIBLE BREAKTHROUGH! WE ARE FOCUSED ON OUR CORE HOTELS AND ON FINDING WAYS TO MAKE OUR PORTFOLIO MORE VALUABLE.

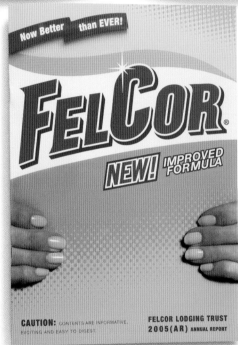

Now Better than EVER!

FELCOR®
NEW! IMPROVED FORMULA

CAUTION: CONTENTS ARE INFORMATIVE, EXCITING AND EASY TO DIGEST.

FELCOR LODGING TRUST
2005(AR) ANNUAL REPORT

With New FelCor,
OUR SHAREHOLDERS WILL
REST EASY.

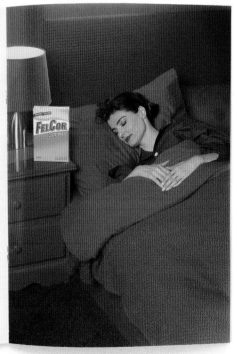

GO WEST

IN BLACK AND WHITE

AMERISTAR CASINOS, INC.

WHAT'S THE RUSH TO EAT?

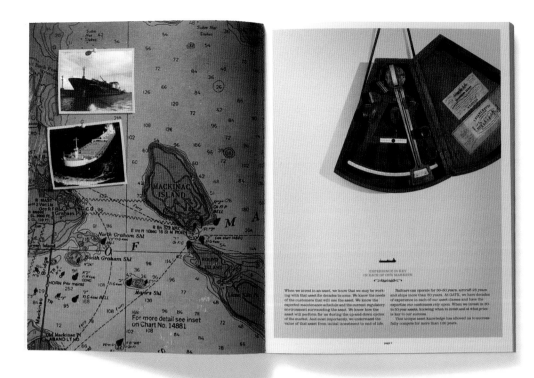

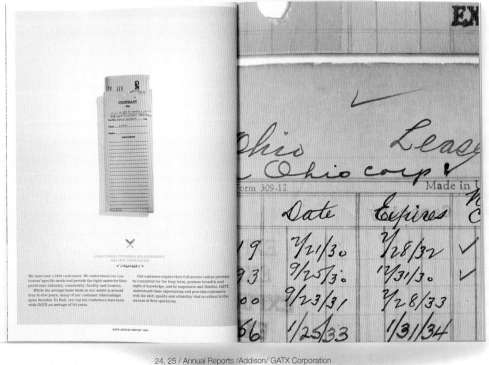

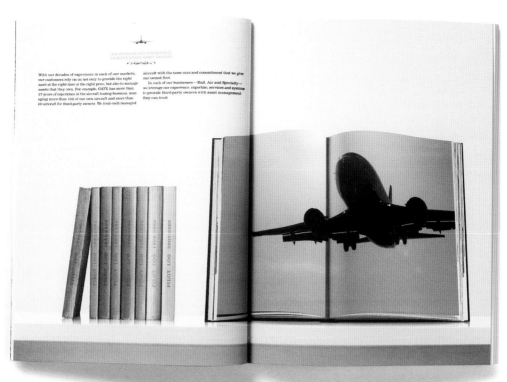

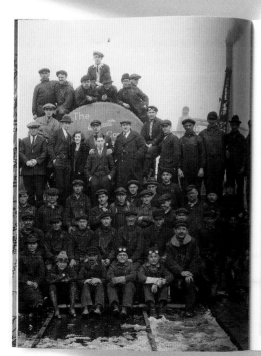

BERICHT DER GESCHÄFTSLEITUNG

LISA MARIA FRANKE, GESCHÄFTSFÜHRERIN
WERNER GEISSLER, GESCHÄFTSFÜHRER AB 01/2006

DESIGN IST WICHTIG (91%). DARÜBER SIND SICH FAST ALLE UNTERNEHMEN EINIG. INNERHALB EINES JAHRZEHNTS HAT SICH DAMIT IN BAYERN DAS VERSTÄNDNIS FÜR UND DIE ZUSTIMMUNG ZU DESIGN DEUTLICH VERSTÄRKT.

AUSZUG AUS DER STUDIE „DESIGN: JA, ABER ... – DER RANG DES DESIGNS IN BAYERN 2004 – STRUKTURANALYSE UND HANDLUNGSEMPFEHLUNGEN", BEAUFTRAGT VOM BAYERISCHEN STAATSMINISTERIUM FÜR WIRTSCHAFT, INFRASTRUKTUR, VERKEHR UND TECHNOLOGIE.

12 * 13

DESIGNBERICHT BAYERN
2003–2005

bayern
design

40 * 41

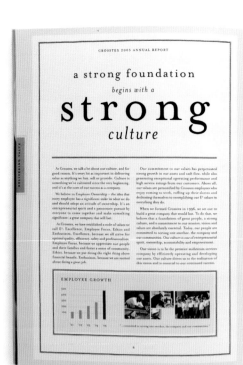

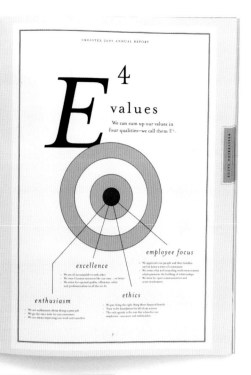

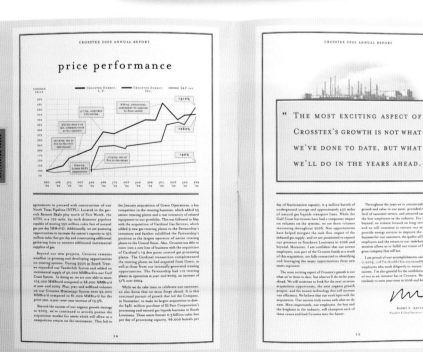

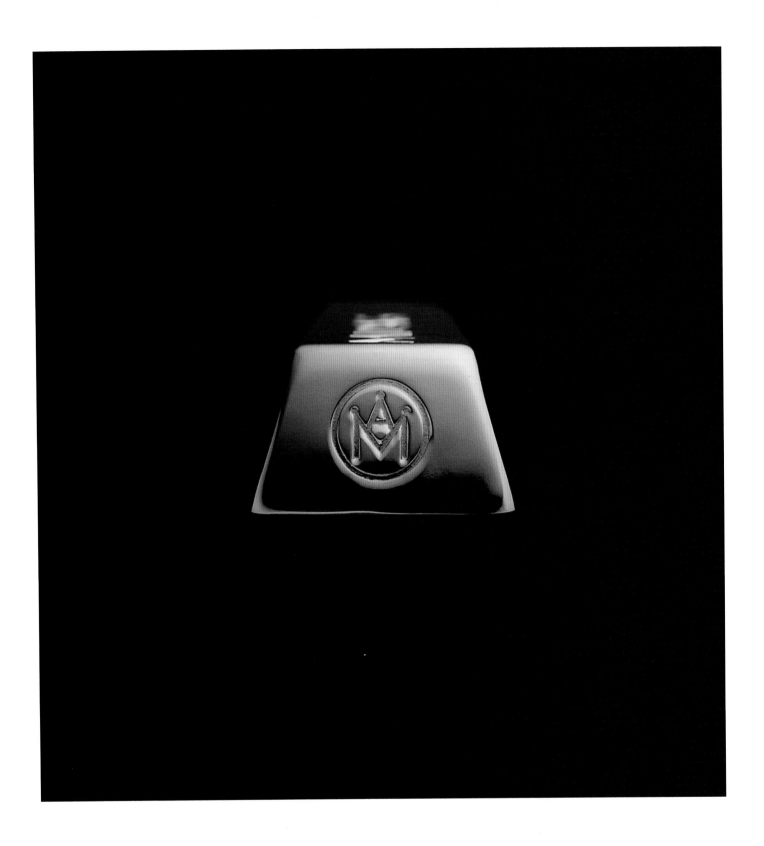

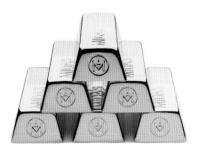

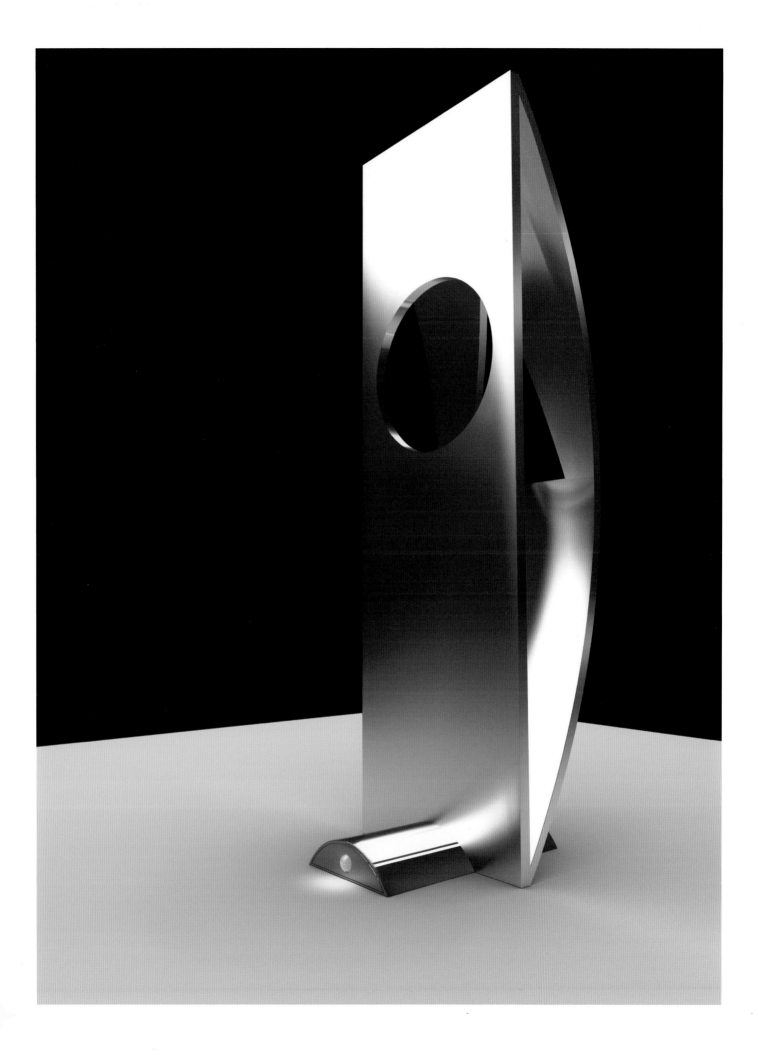

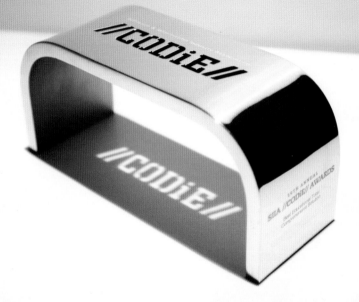

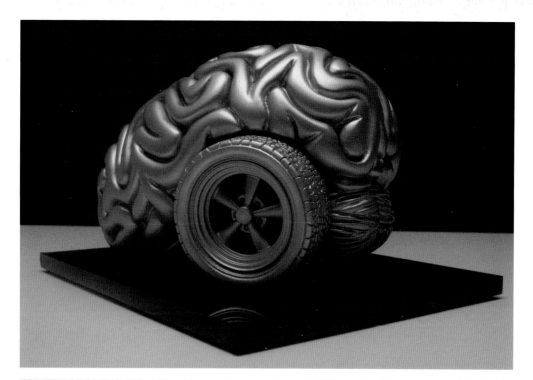

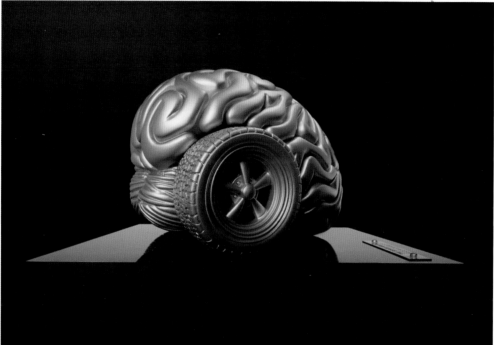

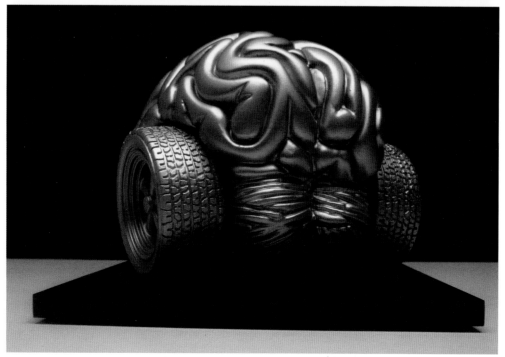

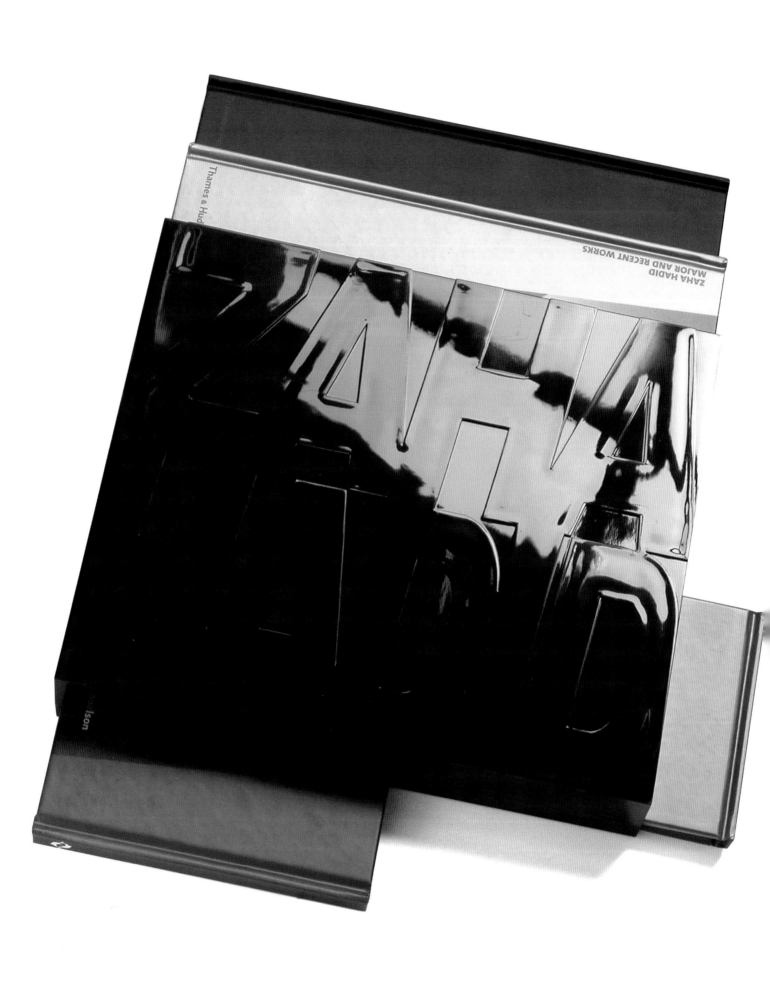

ZAHA HADID
MAJOR AND RECENT WORKS

Thames & Hud

Thames & Hudson

Extension to the Reina Sofia Museum
Madrid, 1999

The primary intention was to create a new building for the museum that is as instantly recognizable as the objects it will contain, vivid in its individuality. Flexibility of space was one of the main objectives within the temporary gallery enabling artists to interact with their surroundings and to have a degree of choice. Spaces could be used together or individually, depending on the exhibition and the artist's demands. The galleries are linked by an immediately identifiable route that creates a unique journey and maximizes the potential of each gallery. Within each gallery, an allowance has been made for ancillary space for educational purposes. Natural overhead light is maximized through the use of **INTERWOVEN LAYERS** that **SPLAY** and **SPLIT**. Public access is via the east façade, dividing the building clearly into public and private zones and allowing the west façade to be used for deliveries.

'Wishmachine – World Invention'
Kunsthalle, Vienna, 1996

The exhibition follows various historical threads into a knot of technological exploration and utopian fantasy. Serious achievements are placed next to their forgotten ancestors and abandoned sidelines. Between curiosities, monstrosities and exhilarating flights of fancy one can see progress stumble ahead. Fantasy and desire are the protagonists of this alternative history of modern technological civilization, where each technological idea implies the reinvention of mankind. The architecture of this multiple reinvention of the human world through the tangle of fact and fiction cannot be reduced to Platonic forms. Nothing is conceived a priori. The genealogical tree mutates into a knot of loose ends thrusting across the space, following non-confinable lines of flight that inflect each other as they interpenetrate. The spaces thus created are not exclusive thematic compartments but ambiguous perspectival effects created by the **BUNDLE OF WALLS**. The walls emerge at the point of entry and traverse the box – which barely contains them – in all directions. Without a given route, surprises become inevitable.

34 Cathcart Road (Bitar Furniture)
London, 1985–86

This International Style residence provided a backdrop for the first material display of Zaha Hadid's **SUPREMATIST ECOLOGY**, an extension of her explorations at 59 Eaton Place (p.1). The ensemble included Bitar furniture, extra-large pieces that did not act as sculptural objects in a neutral container but rather created a dynamic space of their own. Pivoting, sliding and swivelling, a storage wall further animated the space with the physical movements of its doors and cabinets.

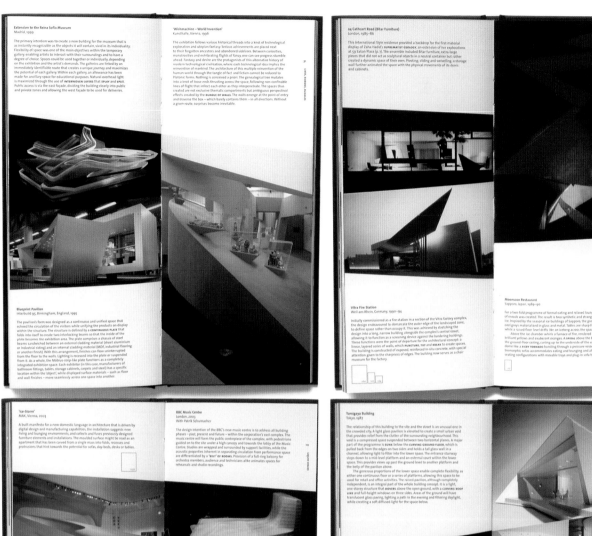

Blueprint Pavilion
Interbuild 95, Birmingham, England, 1995

The pavilion's form was designed as a continuous and unified space that echoed the circulation of the visitors while unifying the products on display within the structure. The structure is defined by **A CONTINUOUS PLATE** that folds into itself to create two interlocking beams so that the inside of the plate becomes the exhibition area. The plate comprises a chassis of steel beams sandwiched between an external cladding material (sheet aluminium or industrial siding) and an internal cladding material (MDF, industrial flooring or another finish). With this arrangement, finishes can flow uninterrupted from the floor to the walls. Lighting is recessed into the plate or suspended from it. As a whole, the Möbius-strip-like plate functions as a completely integrated exhibition space. Each exhibitor (in this case, manufacturers of bathroom fittings, tables, storage cabinets, carpets and steel) has a specific location within the 'object', while displayed surface materials – such as floor and wall finishes – move seamlessly across one space into another.

Vitra Fire Station
Weil am Rhein, Germany, 1990–94

Initially commissioned as a fire station in a section of the Vitra factory complex, the design endeavoured to demarcate the outer edge of the landscaped zone, to define space rather than occupy it. This was achieved by stretching the design into a long, narrow building alongside the complex's central street, allowing it to function as a screening device against the bordering buildings. These functions were the point of departure for the architectural concept: a linear, layered series of walls, which **PUNCTURE, TILT** and **BREAK** to create spaces. The building is constructed of exposed, reinforced in-situ concrete, with special attention given to the sharpness of edges. The building now serves as a chair museum for the factory.

Moonsoon Restaurant
Sapporo, Japan, 1989–90

For a two-fold programme of formal eating and relaxed lounging, an opposition of moods was created. A light glass pavilion is elevated to create a small urban void. The result is two synthetic and strange worlds: fire and ice, inspired by the seasonal ice buildings of Sapporo, the ground floor features cool greys materialized in glass and metal. Tables are sharp fragments of ice, while a raised floor level drifts like an iceberg above the space.

Above the ice chamber whirls a furnace of fire, rendered in searing reds, brilliant yellows and exuberant oranges. A **SPIRAL** above the bar leans through the ground-floor ceiling, curling up to the underside of the upper level dome like a **FIERY TORNADO** bursting through a pressure vessel. A plasma of biomorphic sofas accommodates eating and lounging and allows multiple seating configurations with movable trays and plug-in sofa racks.

'Ice-Storm'
MAK, Vienna, 2003

A built manifesto for a new domestic language in architecture that is driven by digital design and manufacturing capabilities, the installation suggests new living and lounging environments, and collects and fuses previously designed furniture elements and installations. The moulded surface might be read as an apartment that has been carved from a single mass into folds, recesses and protrusions that hint towards the potential for sofas, day-beds, desks or tables.

BBC Music Centre
London, 2003
With Patrik Schumacher

The design intention of the BBC's new music centre is to address all building phases – past, present and future – within the corporation's vast complex. The music centre will form the public centrepiece of the complex, with pedestrians guided on to the site under a high canopy and towards the lobby of the Music Centre. Studios are wrapped and surrounded by support facilities, while the acoustic properties inherent in separating circulation from performance space are differentiated by a 'BELT' OF ROOMS. Provision of a full-ring balcony for orchestra members, audience and technicians alike animates spaces for rehearsals and studio recordings.

Tomigaya Building
Tokyo, 1987

The relationship of this building to the site and the street is an unusual one in the crowded city. A light glass pavilion is elevated to create a small urban void above the clutter of the surrounding neighbourhood. This void is a compressed space suspended between two horizontal planes. A major part of the programme is **SUNK** below the **CURVING GROUND FLOOR**, which is pulled back from the edges on two sides and holds a tall glass wall in a channel, allowing light to filter into the lower space. The entrance stairway steps down to a mid-level platform and an external court within the lower space. This provides views up past the ground level to another platform and the belly of the pavilion above.

The generous proportions of the lower space enable complete flexibility, as either one continuous floor or a series of platforms, allowing this space to be used for retail and office activities. The raised pavilion, although completely independent, is an integral part of the whole building concept. It is a light, one-storey structure that **HOVERS** above the open ground, with a **CURVING ROOF LINE** and full-height windows on three sides. Areas of the ground will have translucent glass paving, lighting a path in the evening and filtering daylight, while creating a soft diffused light for the space below.

Tea and Coffee Piazza
Limited edition for Alessi, 2003

Four elements – teapot, coffee pot, milk jug and sugar pot – fit together to form a mutating whole that changes according to whether or not the set is in use. When not in use, the piece is unified and portable. When in use, the fluid forms are flipped and turned, facilitated by the tray's template. Tea time becomes a sculptural riddle, and the tea set a transformable table sculpture.

Iceberg
Seating, 2003

A liquid form for a domestic setting, the iceberg sofa/lounger allows sitters to assume a variety of orientations, positions and postures. Two icicle prongs appear to dart out in opposing directions, but in fact they morph together into a harmonious whole, a melting of formal inclination into a frozen state. The entity can be divided into two parts, one of which takes on a more vertical, threelike orientation, while the other suggests a more horizontal, lounging posture. Constructed of steel and wood, with a shiny pearl-white car-paint finish, the structure is moulded to provide the most ergonomic contours.

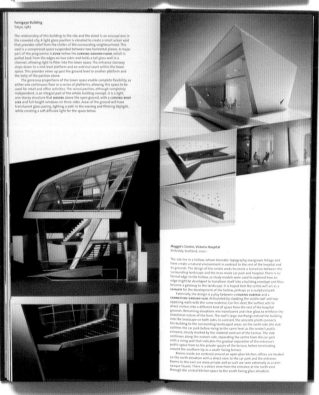

Maggie's Centre, Victoria Hospital
Kirkcaldy, Scotland, 2001–

The site lies in a hollow whose dramatic topography, overgrown foliage and trees create a natural environment in contrast to the rest of the hospital and its grounds. The design of the centre seeks to create a transition between the surrounding landscape and the main made car park and hospital. There is no formal edge to the hollow, so study models were used to explored how an edge might be developed to transform itself into a building envelope and thus become a gateway to the landscape. It is hoped that the centre will act as a **CATALYST** for the development of the hollow, perhaps as a sculptural park.

Externally, the design is a play between a **FOLDING SURFACE** and a **CONNECTING GROUND SLAB**. Articulated by cladding the visible roof and two opposing walls with the same material. Cor-ten steel, the surface acts to direct visitors into a different kind of space from the rest of the hospital grounds. Remaining elevations mix translucent and clear glass to reinforce the directional nature of the form. The roof's large overhangs extend the building into the landscape on both sides. In contrast, the concrete plinth connects the building to the surrounding landscaped areas on the north side, the slab outlines the car park before rising to the same level as the centre's public entrance, clearly marked by the material contrast of the tarmac. The slab continues along the eastern side, separating the centre from the car park with a rising wall that indicates the gradual separation of the entrance's public space from to the private spaces of the terrace, before terminating around the southern tip as a south-facing terrace.

Rooms inside are centred around an open-plan kitchen; offices are located on the north elevation with a direct view to the car park and the entrance. Rooms to the east are more private and as such are seen externally as a semi-opaque façade. There is a direct view from the entrance at the north end through the central kitchen space to the south-facing glass elevation.

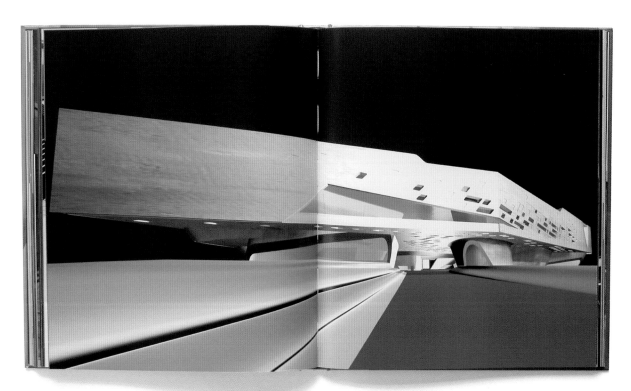

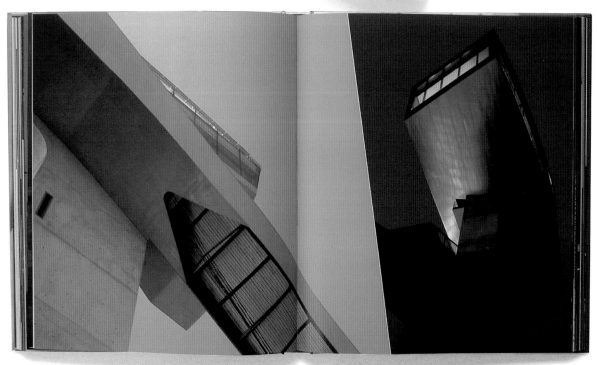

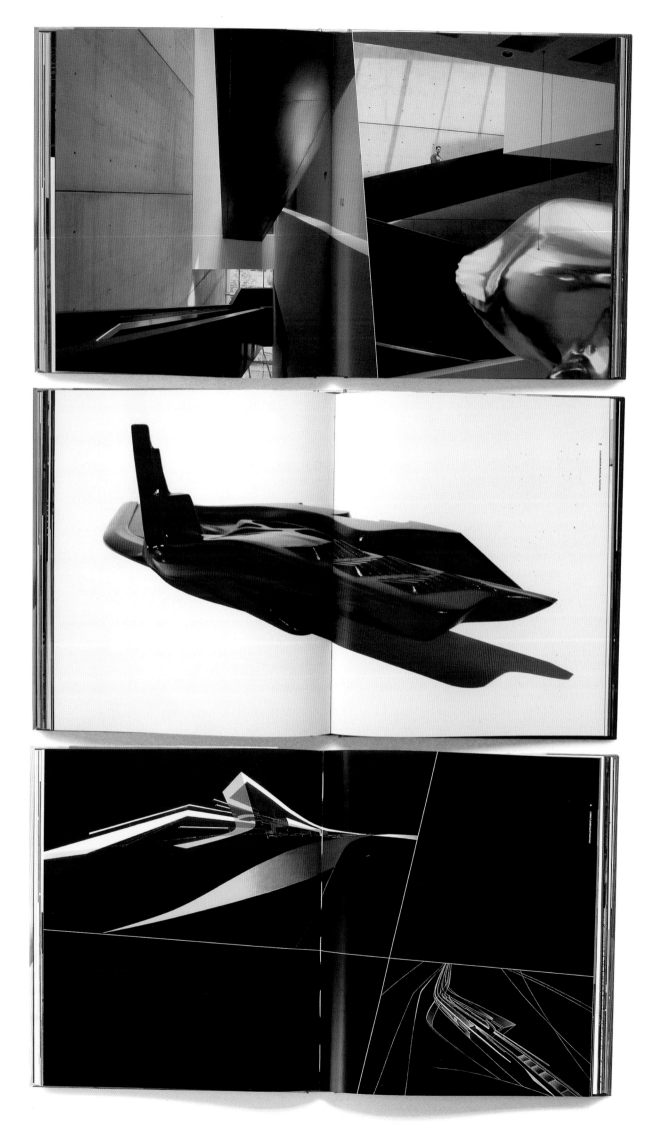

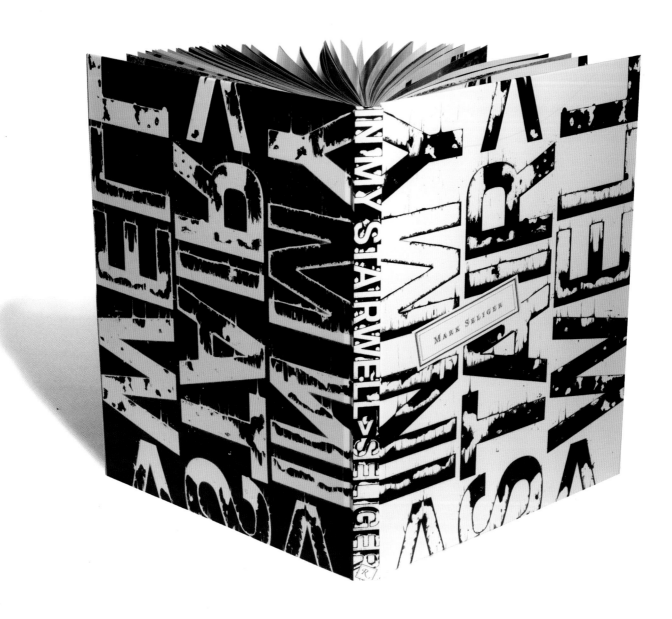

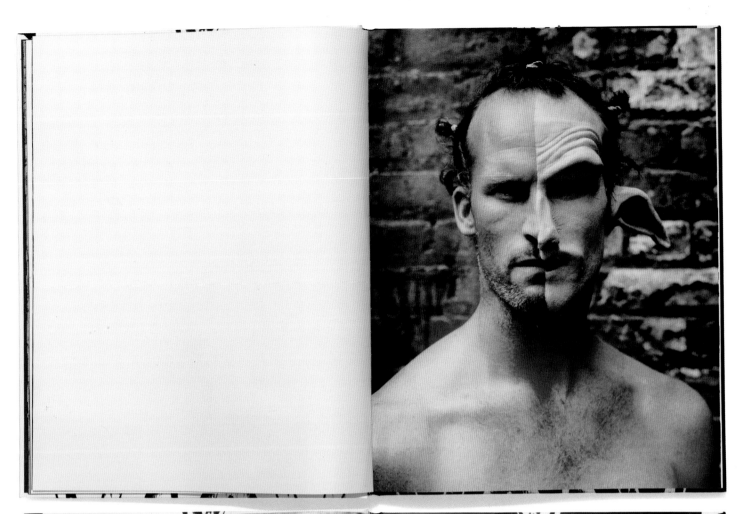

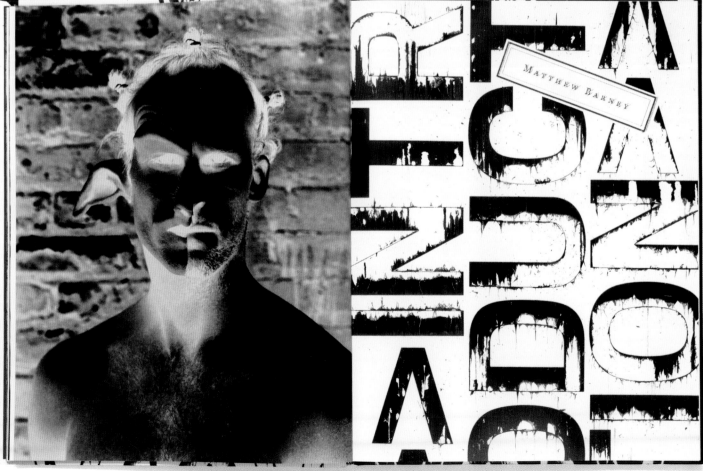

Matthew Barney

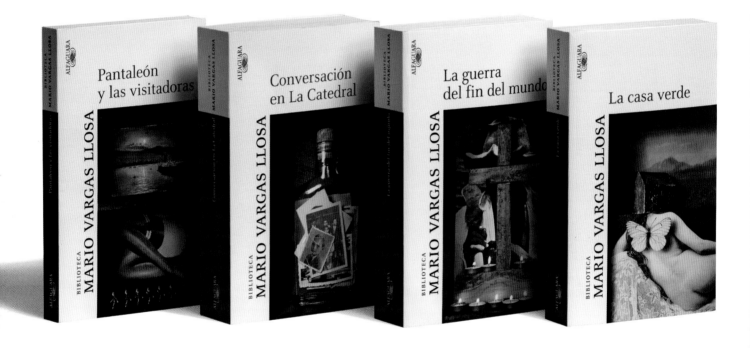

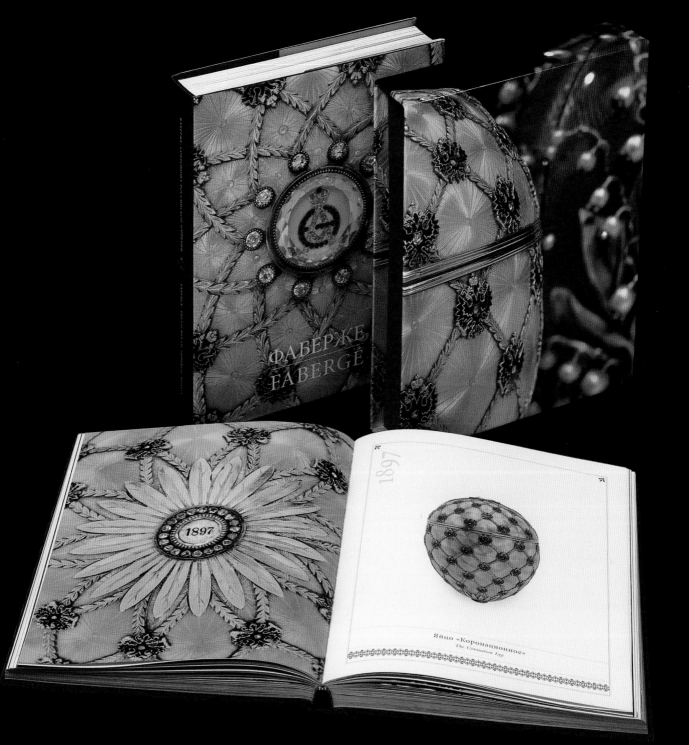

ФАБЕРЖЕ
FABERGÉ

1897

Яйцо «Коронационное»
The Coronation Egg

Norman Foster Works 4

New

Dragan Sakan

THE LAST PLACE ON EARTH

THE LAST
PLACE
ON EARTH

WITH MIKE FAY'S
MEGATRANSECT JOURNALS

PHOTOGRAPHS BY MICHAEL NICHOLS

macromedia

STUDIO MX
2004

入門快易通

涵蓋 Macromedia Flash MX 2004,
Dreamweaver MX 2004,
Fireworks MX 2004
與 Freehand MX 專案

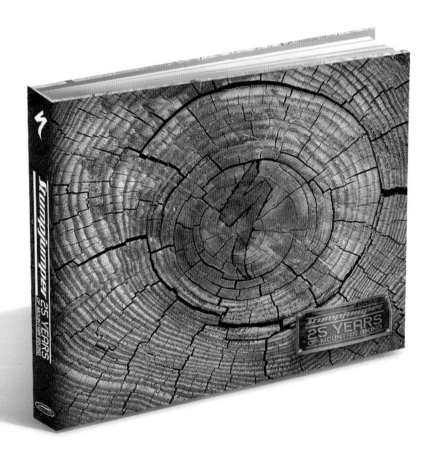

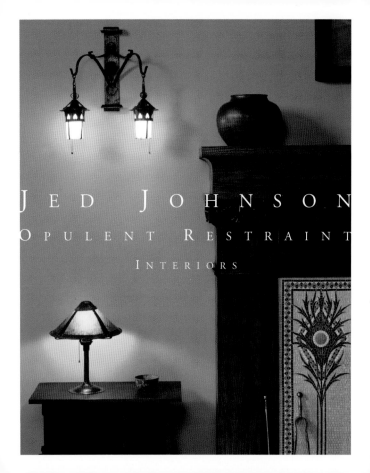

JED JOHNSON

OPULENT RESTRAINT

INTERIORS

JED JOHNSON: OPULENT RESTRAINT

INTERIORS

EDITED BY TEMO CALLAHAN AND TOM CASHIN

Rizzoli
NEW YORK

TWIN FARMS
BARNARD, VERMONT
1995

In June of that year, Andy was shot and nearly killed by Valerie Solanas, a deranged Factory hanger-on who told the press that he "controlled her life." Jed rode in the ambulance with Andy, who would require a five-hour operation by a team of five surgeons because his would-be assassin's three bullets, fired at close range, had pierced every vital organ except his heart. After Andy was released from the hospital, Jed moved into his house on Lexington Avenue, near Eighty-ninth Street, to help his mother, Julia, a Czechoslovak immigrant who barely spoke English, care for him. During the long months of Andy's recuperation, he and Jed fell in love.

Jed would become Andy's interior decorator-in-residence at the East Sixty-sixth Street townhouse he bought in 1975, and eventually the director of *Andy Warhol's Bad*, the first Factory film not directed by Paul Morrissey. His best friend at the factory, Pat Hackett, wrote the script for *Bad*, which, among other things, was supposed to be a comeback vehicle for Carroll Baker, but it instead turned out to be a swan song for pretty much everyone involved. Fours years after it was released, Jed and Andy separated, and Jed left the home he had so beautifully arranged to start a new life and business with the architect Alan Wanzenberg on the other side of Central Park.

In 1971, I moved up to managing editor and art director of the fledgling *Interview*—print run five thousand—at a salary of fifty dollars a week. For a middle-class twenty-two-year-old from Long Island, the Factory was exciting but frightening: the Warhol gang had a reputation for both wildness and exclusivity. Its habitués seemed to come from either the tough streets of the East Village or the plush co-ops of Fifth and Park Avenues, and while Andy and Paul gave me their full support, I spent many months enduring Joe Dallesandro's scowls and Brigid Berlin's sneers. Andy's business manager, Fred Hughes, with his hand-tailored suits and high-society flourishes, blew hot and cold, embracing me after a few glasses of champagne at some fancy party that Andy had dragged me to, whispering behind my back about how "bourgeois" I was the next day at work. Then there were the times when Solanas, who served a mere three years in a mental institution because a terrified Andy had refused to press charges, called and growled to whomever answered the telephone, "Is Warhol there?" (Andy would lock himself in the editing room with Jed, while Joe stood guard at the bulletproof steel door that separated the Factory's front room from the vestibule and elevator, and Vincent Fremont, Warhol's bookkeeper-cum–video director, went downstairs to make sure that the coast was clear for "the boss" to escape uptown in a taxi.)

It would be an exaggeration to say that Jed became my protector—he had his hands full pleasing Paul and taking care of Andy—but at least he was nice. He smiled and asked me how I was doing. He invited me to have lunch with him and Pat at Brownie's, the health-food restaurant just off Union Square where they went every day—but only occasionally, because Pat was very possessive of Jed and probably a little in love with him. But then, I think nearly everyone at the Factory was a little in love with Jed, including my straight assistant editor, Glenn O'Brien, and his first wife, Judy (aka Jude Jade). There was something so appealing about Jed's shyness and calm. He spoke so softly you had to lean in close to hear what he was saying; he often said nothing at all while the rest of us babbled on, competing to be the wittiest for Andy and his tape recorder. Jed didn't try to be smart or funny or anything at all; he was incapable of showing off; he just was what he was: a slim, silent beauty in perfectly pressed jeans and neatly checked shirts, as handsome and intriguing as the young Gary Cooper, a sweet, innocent fawn among the tigresses and hyenas.

Jed Johnson with Jane Forth at the opening of the Whitney Museum of American Art exhibition of Andy Warhol works, 1971. Forth would later appear in Johnson's movie *Andy Warhol's Bad*.

Photograph Andy Warhol © 2005 Andy Warhol Foundation for the Visual Arts/ARS, New York.

Chanel

THE METROPOLITAN MUSEUM OF ART

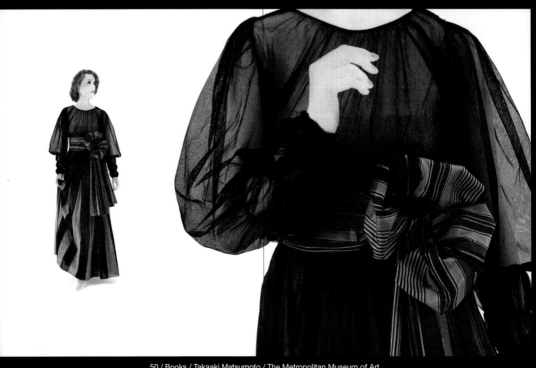

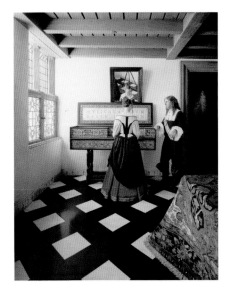

A MUSIC LESSON, 1999

Love, all alike, no season knowes, nor clyme,
Nor houres, dayes, months, which are the rags of time.
—John Donne [1]

TYRRHENIAN SEA, CONCA, 1994

BALTIC SEA, RÜGEN, 1996

Artists and Their Materials
1942–1946

Like most prison art, the things produced in the Japanese American concentration camps were made from scrap, discards, and found materials such as those shown at right. Later, the remote locations of the camps and the authorities' realization that internees presented no danger caused rules to be relaxed so that internees could roam the vast empty spaces outside the barbed wire fences to search for interesting rocks, vegetation, and other indigenous materials. When money allowed, internees could also order art supplies by mail. And, as time wore on, the WRA sent in surplus shop equipment and tools.

Most of the work shown on the following pages was created by Issei. With rare exceptions, few had any formal art training. Before entering the camps, more than half of the men had been farmers, with a large number of others working as shopkeepers, commercial fishermen, and gardeners. As amateur artists, they tended not to think of what they produced as "art," but merely as a way to pass the hours of confinement. Because they undervalued their skill and imagination, they freely gave their work away, and with the passage of time, their names have been forgotten. This made giving appropriate credit very difficult. The problem was compounded because Issei never called even their closest friends by their first name, but attached the honorific "san" to the surname. That is how most people remembered them. Rather than leave their names out completely, that is how several are identified here.

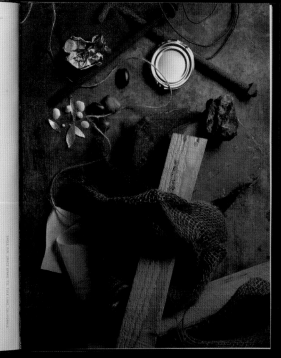

The Art of Gaman

Arts and Crafts from the Japanese American
Internment Camps 1942–1946

Delphine Hirasuna

OBJECT **Painted Geta**
SIZE **9" x 3" x 4"**
ARTIST **Fumi Okuno**
CAMP **Amache, Colorado**

An indelible memory for most former internees is the sound of wooden clogs, called geta, clattering toward the latrine, public baths, and laundry rooms every morning and evening. The abrasive sand of the deserts where most of the camps were located and the swampy mud of the camps in Arkansas wreaked havoc on shoes and boots, so handmade geta became essential footwear. The demand for these wooden sandals turned geta making into a cottage industry.

OBJECT **Unpainted Geta**
SIZES **9" x 3" x 4" (left)**
9" x 3.5" x 2.5" (right)
ARTIST **Masataro Umeda**
CAMP **Jerome, Arkansas**

SURF BOOK

Michael Halsband
Joel Tudor

Big
Magazine design (Location Printing) Madrid/London, 1994-1997

Presented with a box full of battered photos, some
Spanish text and a request to design "the best
magazine in the world", Frost was seduced by the
rawness and confidence of bilingual Madrid-based
Big Magazine from the start. With no brief to speak
of – the only parameters being the size of the
magazine (A3) and its colour (black and white)
– and a limited budget, he called upon his strength
as a typographer to direct the design. Frost also
had to come up with headlines for all the stories
himself. Working on the New York issue – his first
as art director – Frost was immediately drawn to
letterpress typography as the perfect way to reflect
the gritty, bold realism of the city. A visit to Alan
Kitching's Clerkenwell studio to 'play' followed.
For the cover, Frost took the letters NYC – finding
as many of each as he could. He then turned over
all the letter N's except one and fashioned them into
the letter B, repeating this process with the letters
Y and C to create the word BIG with the letters NYC
revealed within. In total, Frost designed seven issues
of Big Magazine over four years.

2

"I had no idea what I was doing when I did this project"

"a kid bullied in front of Ezra at the top of this slide and he wouldn't come down"

TOM MOORHOUSE
MOORHOUSE RANCH

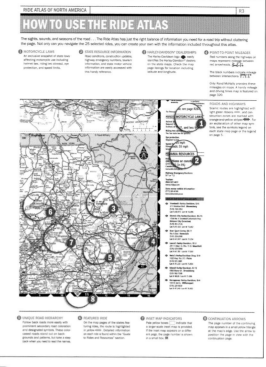
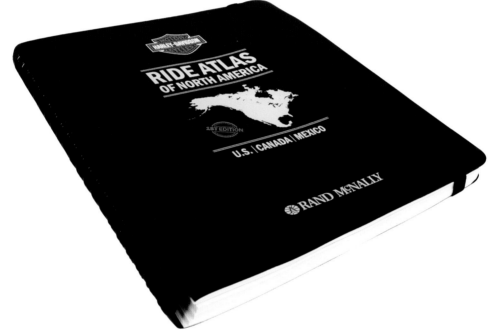

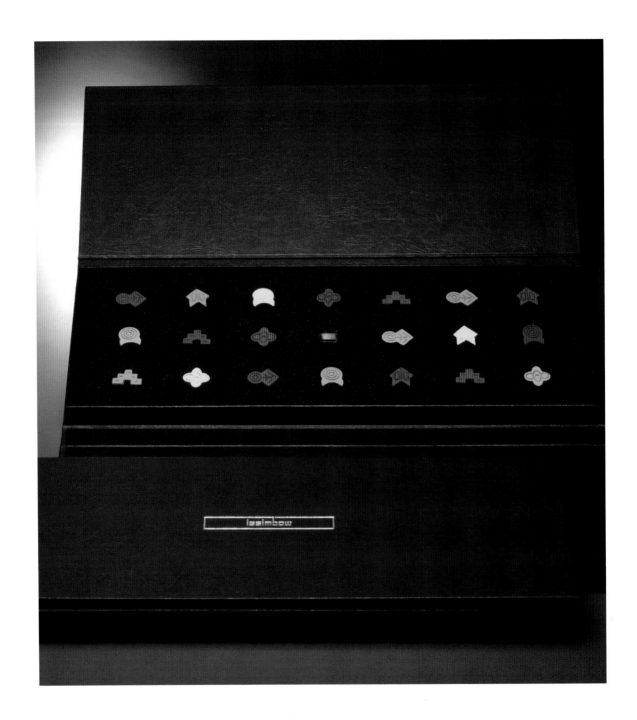

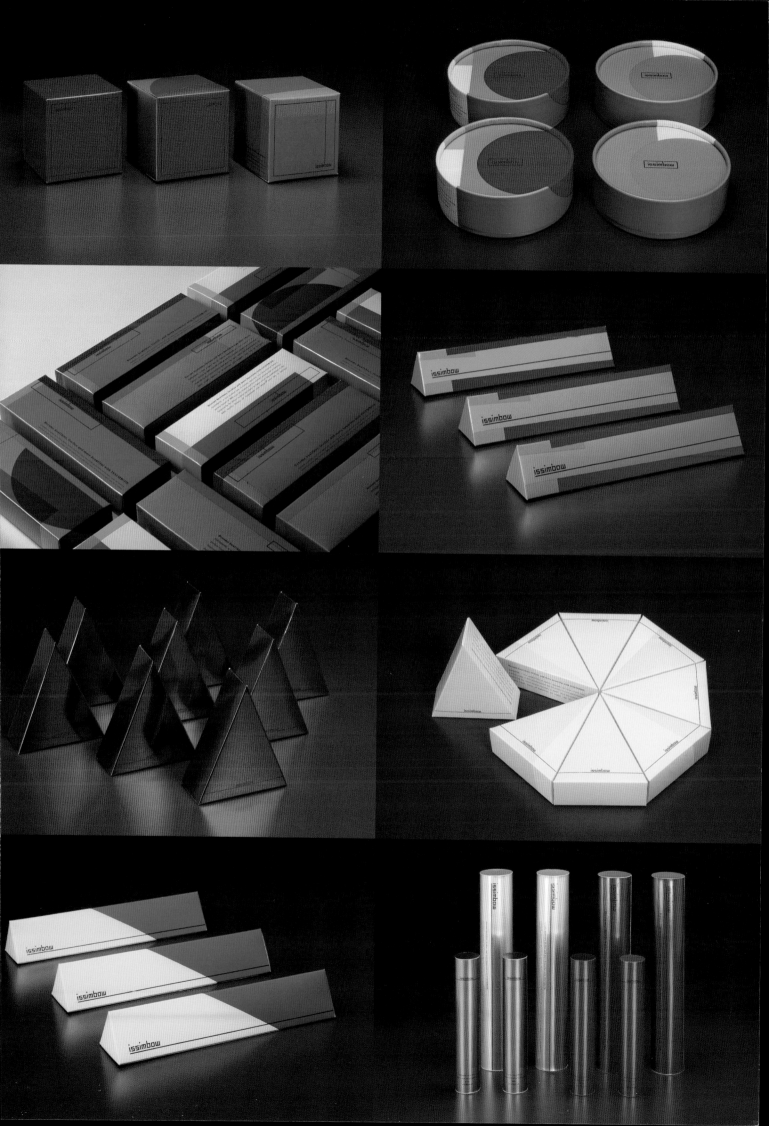

Become healthier, livelier and more beautiful with ISSIMBOW.

ISSIMBOW, a new product line of holistic approach, has been created from
a perfect fusion of 800-year old wisdom and 21st century science and technology.
Devoted to the utmost medical disclosure in Japan, which has contributed to
the daily health, beauty of humankind and support your life of wellness.

issimbow

Become healthier, livelier and more beautiful with ISSIMBOW.

ISSIMBOW, a new product line of holistic approach, has been created from
a perfect fusion of 800-year old wisdom and 21st century science and technology.
Devoted to the utmost medical disclosure in Japan, which has contributed to
the daily health, beauty of humankind and support your life of wellness.

issimbow

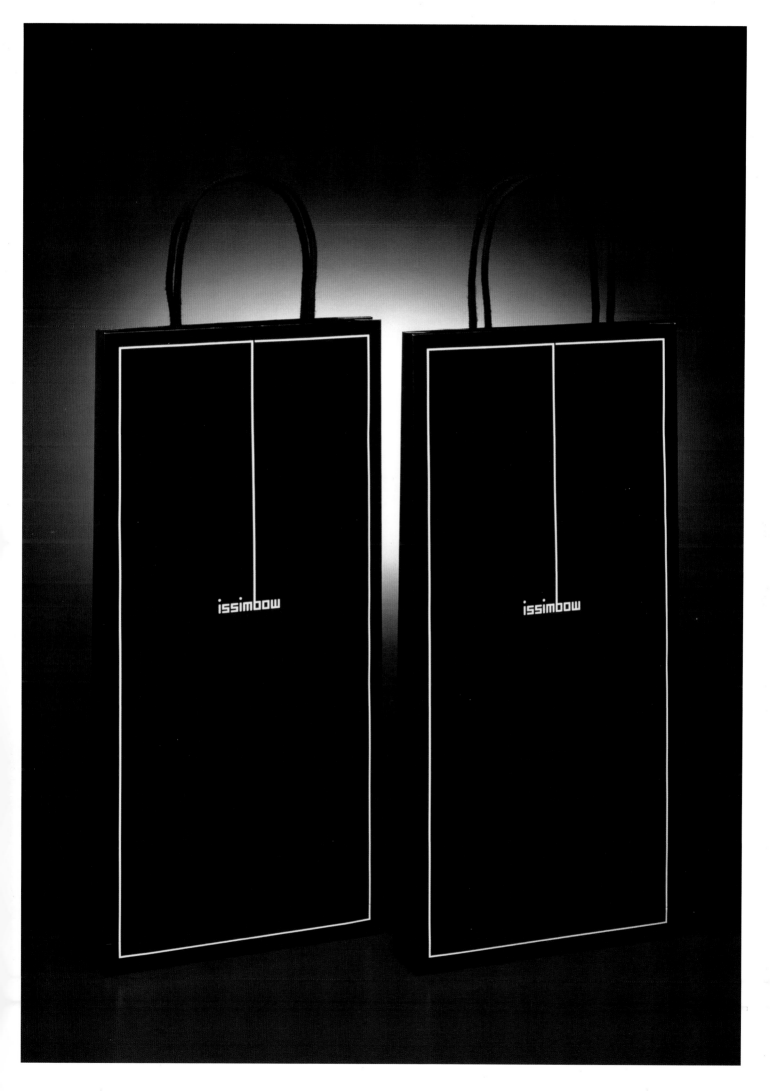

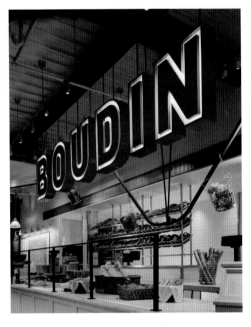 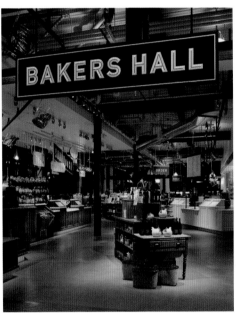

BOUDIN AT THE WHARF

PEET'S COFFEE & TEA

Rich mochas, creamy lattes, soothing teas, icy freddos...our espresso bar, featuring Peet's coffee and tea, has it all, including oven-fresh cookies, French pastries and other bakery treats.

BAKERS HALL

An ideal place for a sandwich, salad, or soup-in-a-bread-bowl. Find locally crafted gifts and picnic-perfect food and drink, including regional wine and cheese, California olive oils, specialty chocolates and fresh-baked bread.

BISTRO BOUDIN

Relax and enjoy a dazzling view of the Bay and Wharf at our full-service restaurant and bar, open every day for lunch and dinner. Featuring seasonal fresh foods and traditional local favorites.

BOUDIN MUSEUM & BAKERY TOUR

Through a fascinating collection of exhibits and interactive displays, explore the origins, art and science of our bakery against the background of San Francisco's history and culture, from the Gold Rush to modern times.

BAKERY & BAKESHOP

Sample oven-fresh sourdough, French and European hearth breads at our Bakeshop, located just steps away from the Demonstration Bakery where you can watch the entire baking process from start to finish.

ESTABLISHED 1849

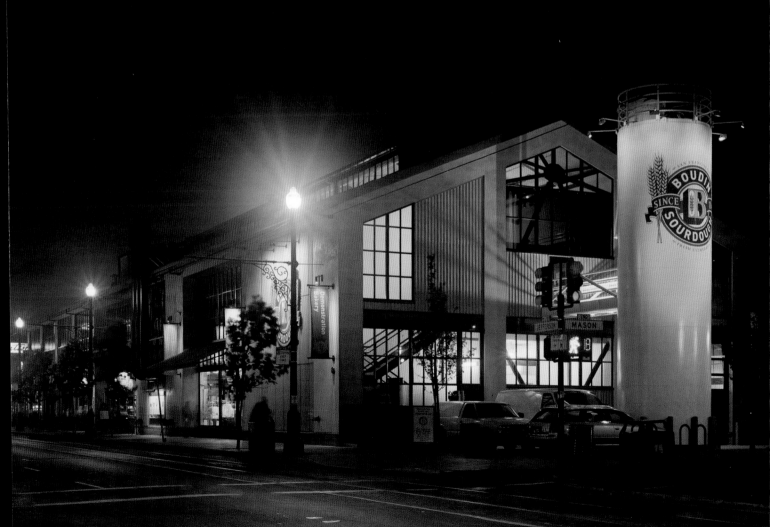

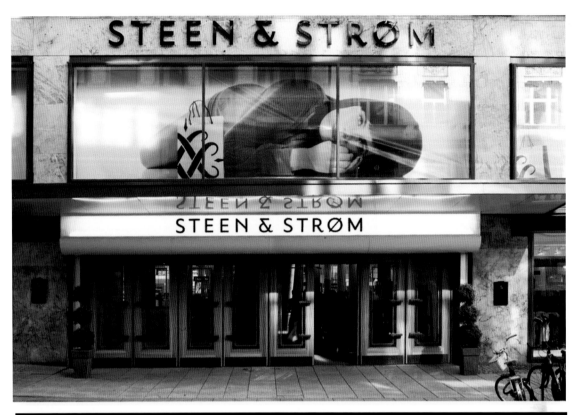

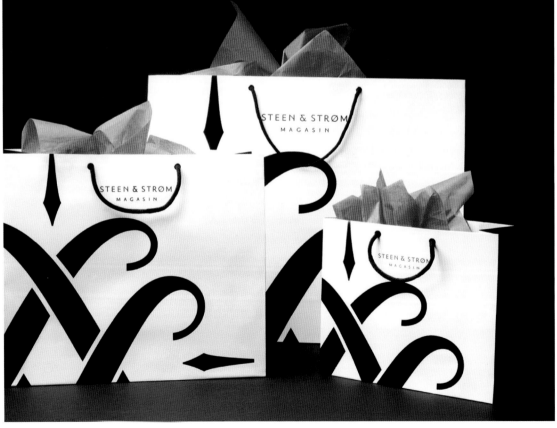

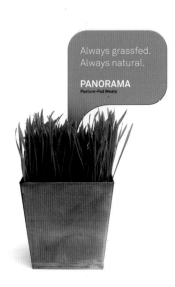
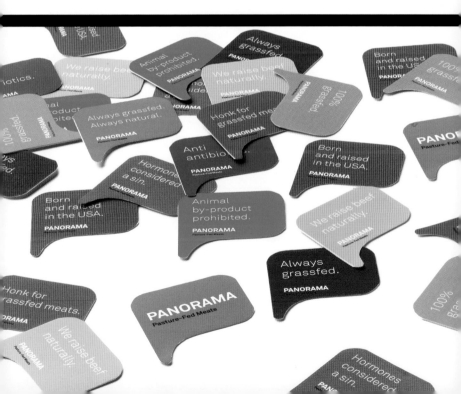

visionary

immediate

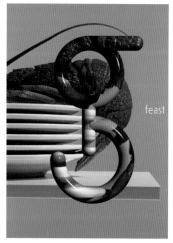
feast

calm

inspired

indulge

social

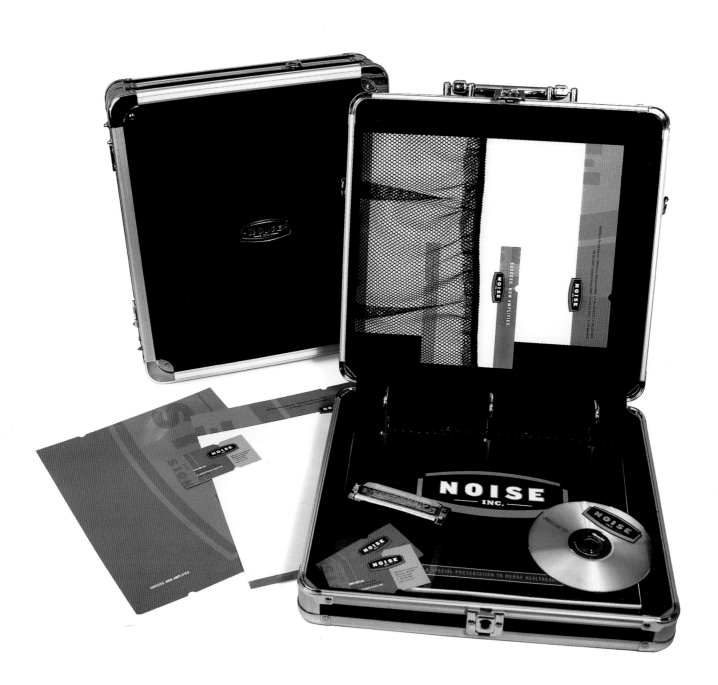

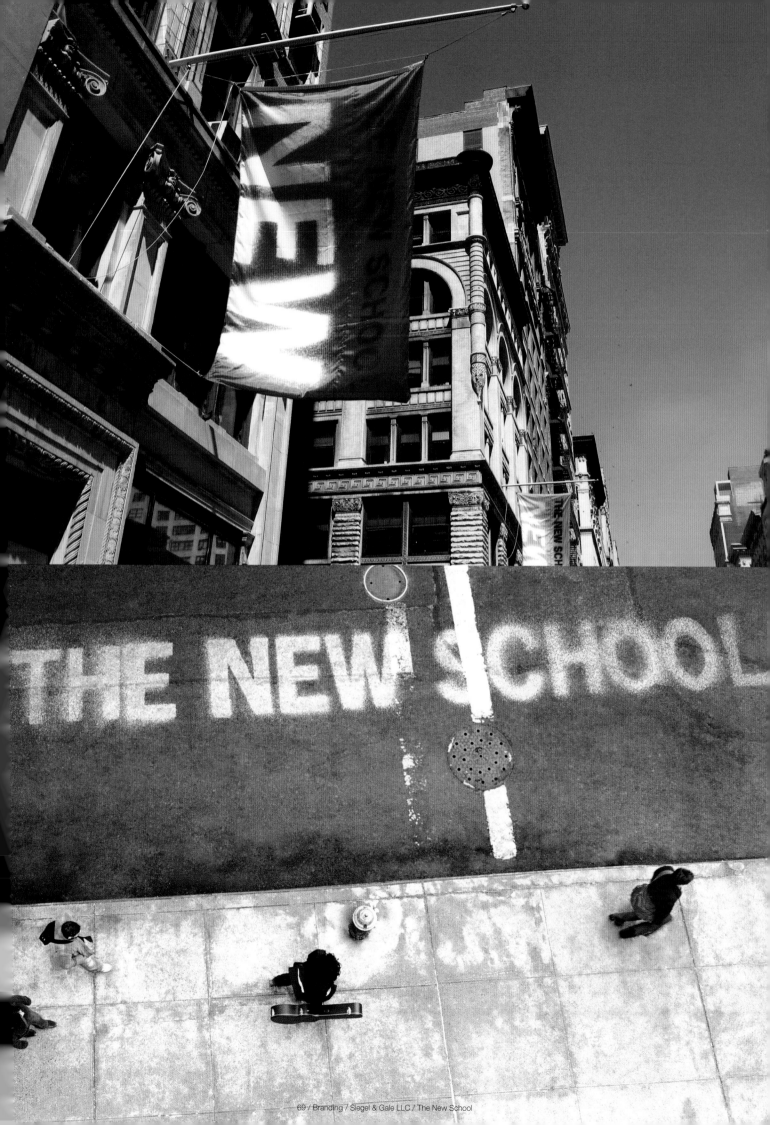

in

The end is nigh. Burn all the books. Words are done for. Pictures are the future. If you believe everything you read, you wouldn't be reading. Books would be doorstops and brochures would be shelved. And as for direct mail and magazines, the less said about them the better. But the truth is different.

ink! is a team of copywriters, journalists and communication strategists who believe words can still have a huge impact. We work with design agencies and businesses offering strategic advice for their literature, writing words that jump off the page and making every letter count. Starting here.

k!

Words are a little like icebergs.
Beneath the elegant bits on the surface is an unseen force holding everything together. In writing, this is the thought behind the words; the strategy that makes your communication stand out.
So before we put pen to paper, we pause for a while.

And take a moment to fully understand your aims and challenges, your company's brand values and tone of voice, your audience's attitudes and behaviour. At these opening stages, our strategic thought can really add value. Then, when everything's in place, we start to write.

think

We'd all love the luxury of a lazy deadline, some time to put our feet up. But at ink, we know the clock is always ticking...

So we work fast:
Teaming up to meet tight deadlines.
Putting two, three or more writers onto large projects.
Using our team to handle sets of marketing literature.
Pooling talents for magazines, ads or branding exercises.
Conducting interviews around the country.
Providing you with your own, dedicated account manager.
And always being available when you need us.

But there's no point in a speedy service if quality slips. Which is why everything we write is checked by at least one other member of our team. So the end result is not just fast, but also flaw-free.

blink

What else do we do?
It's a tough world for words.
For starters there's a lot of them about, jostling for our attention every day in press, posters, packaging and online. So we offer a wide range of services – all linked to our writing expertise – that make words work that bit harder. Each service is designed to help build your brand consistency through language and make sure your marketing's filled with meaning, not empty promises.

More than you'd expect:
Copy strategy: developing and implementing a language that reflects your brand.
Training: helping organisations improve writing skills and express their brand in communications.
Translation: adapting copy for most international languages using only the best mother-tongue writers.
Editing and proofing: providing a complete editorial service, from magazine content plans to fully proofing every item for printing.

link

Clients:
[client list]

Experience:
[experience list]

Financial newsletters, pub games, bread packaging and brand guidelines: you name it, there's a good chance we'll have written something like it. To find out more about what we do, or to join our band of happy clients, call us on 01225 731 373, email info@inkcopywriters.com or visit **www.inkcopywriters.com**

ww.ink

ink!
+44 (0)1225 731 373
info@inkcopywriters.com
www.inkcopywriters.com

!

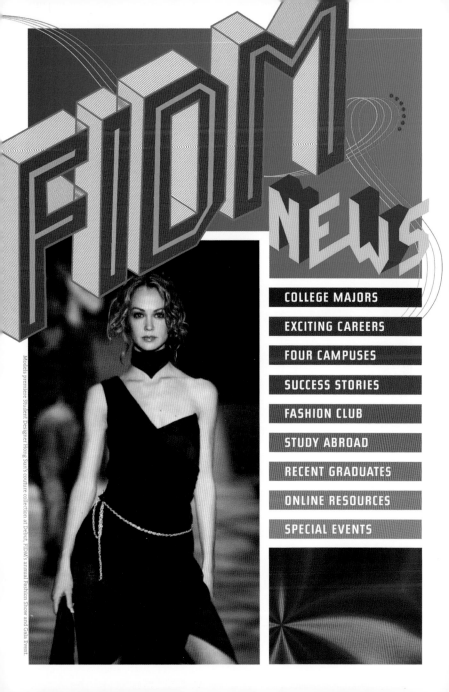

FIDM NEWS

- COLLEGE MAJORS
- EXCITING CAREERS
- FOUR CAMPUSES
- SUCCESS STORIES
- FASHION CLUB
- STUDY ABROAD
- RECENT GRADUATES
- ONLINE RESOURCES
- SPECIAL EVENTS

Models premiere Student Designer Hong Sun's couture collection at Debut, FIDM's annual Fashion Show and Gala Event.

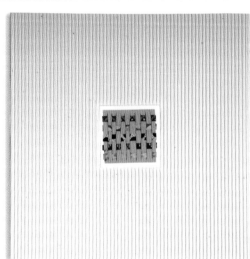

Savoring Paper Route Laurene Krasny Brown offers in these essays, dreamlike assemblages of playful aerial civilizations that draw on art and culture history. As a self-taught artist, she has been influenced by American art and architecture, and classical music among other sources. Her work is lively and intricate, captivating and tantalizing the eye with a complex metamorphosis of color, juxtaposition, scale. These intelligent organizations of paper and pigment emerge and fold, inviting conversations that feel to us, when once immersed, like visual symphonies.

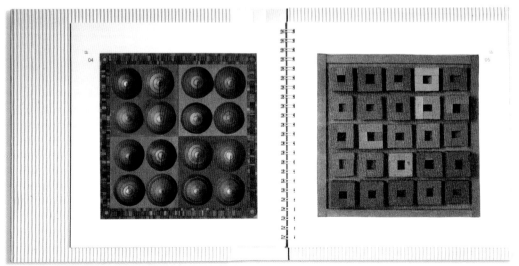

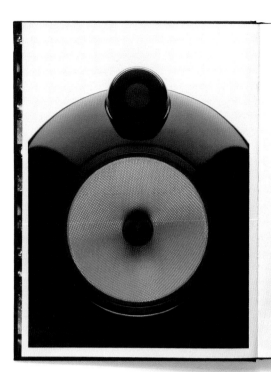

Celebrating the 800 Series Everything moves on. Our enjoyment of music, for example, has undergone a revolution in the last few years. That album you thought you'd never hear again after the kids played Frisbee with it? It can now be downloaded in a full, stereo, scratch-free, digital format, within a few clicks of a button. Technology has made music more accessible. It's also made it more enjoyable. B&W's pursuit of the perfect loudspeaker has led to continuous improvements in the listening experience. A few years ago, our Nautilus™ 800 Series introduced advances in acoustic engineering that revealed music in a new light. But we didn't stop there. We kept moving on. We continued to refine and experiment, and now we've raised the standard again. We discovered the incredible difference made by a diamond tweeter dome. We've simplified the crossover to the purest, subtlest and most harmonious group of components. Improvements have been made to all the drive units. Subwoofers now include a room optimisation system that tailors their output to the acoustic of the surroundings. And we've widened the range to better encompass home theatre. You'll find much more on these advances on the following pages plus interviews with well-known B&W enthusiasts and some stunning images of our latest creations. Finally, take a look at the DVD we've put together for the full story on how we keep everything moving on at B&W.

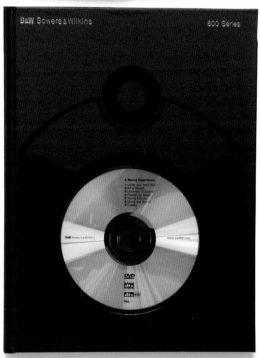

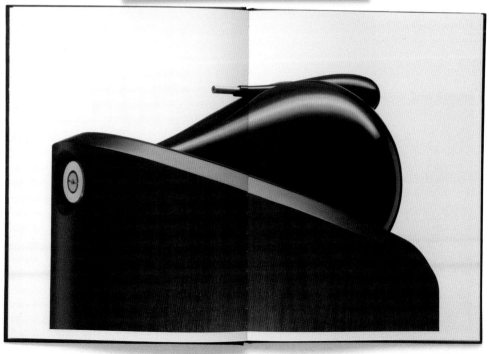

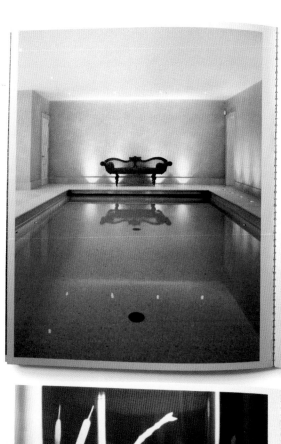
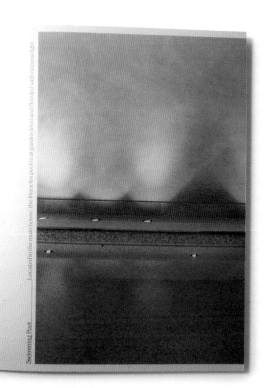

Swimming Pool Located in the main house, the 18m x 4m pool is at garden level and flooded with natural light.

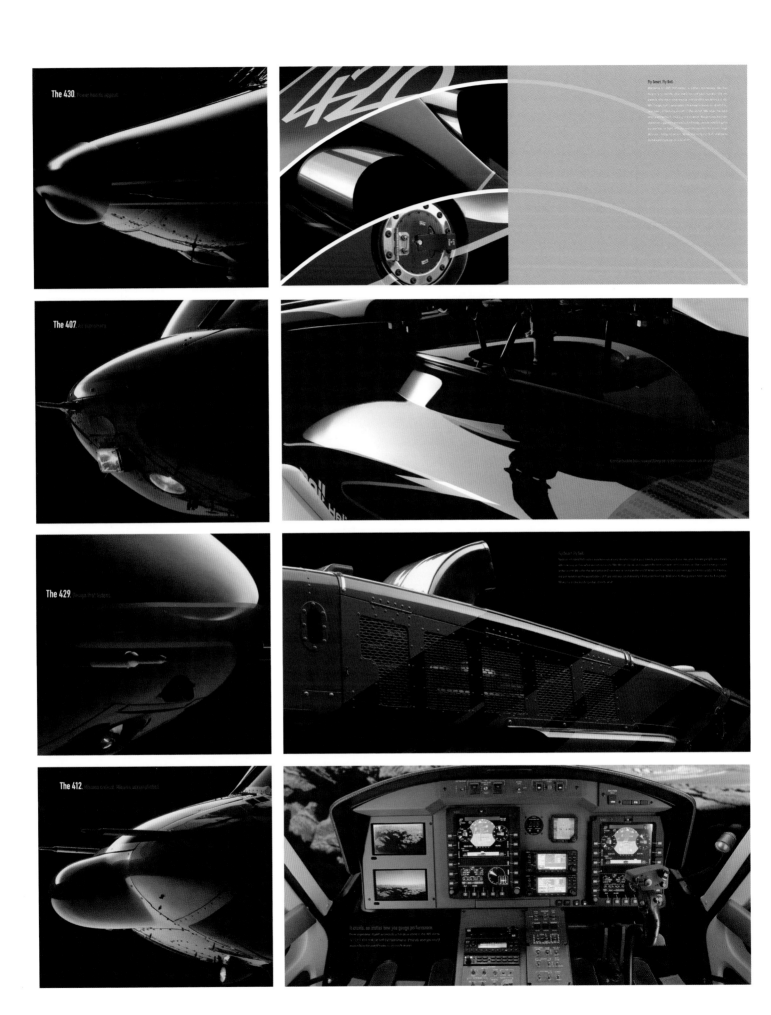

The 430. Power has its appeal.

The 407. An experience.

The 429. Design that matters.

The 412. Mission critical. Reliable accomplished.

Fly Smart. Fly Bell.

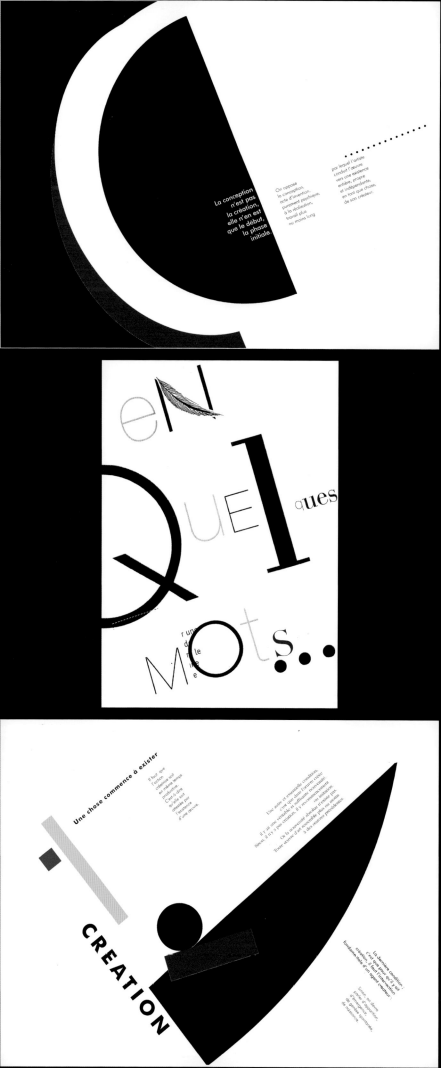

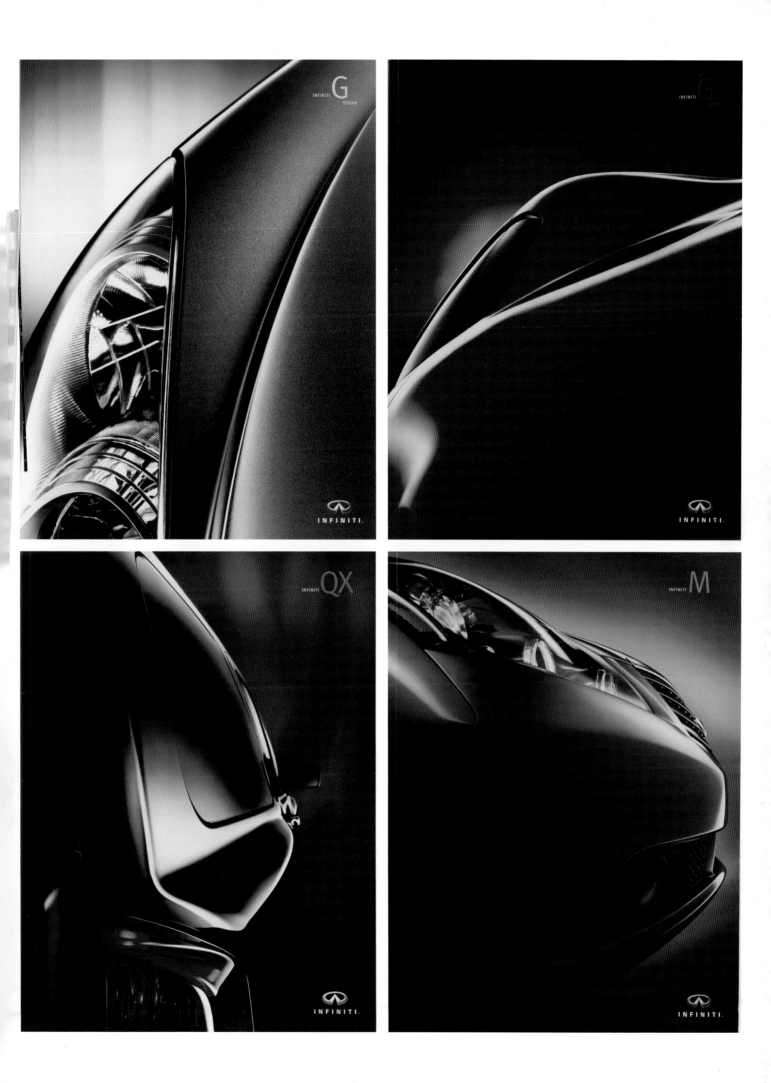

Double Church
for Two Faiths

Freiburg
Germany

kister
scheithauer
gross
koln/dessau

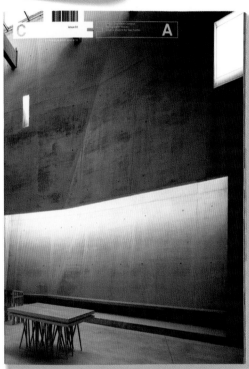

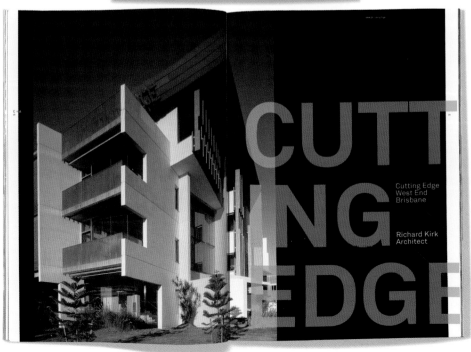

Cutting Edge
West End
Brisbane

Richard Kirk
Architect

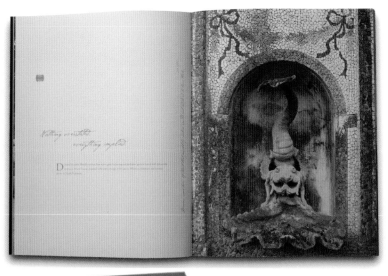

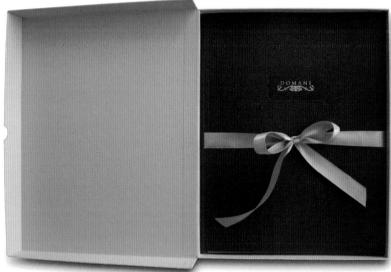

In 2002, deeply in love, an elderly French couple (ages 96 and 94) were married in the town of Clapier, France.

How do we imagine the future from here? At Teknion, we remain optimists. We envision an opportunity to create a prosperous and sustainable world; to serve the process of renewal and recovery through business solutions that harness creativity; that create smart, human-centered spaces that spark ideas and set new worlds in motion. Teknion's integrated portfolio of products is designed to enlarge the compass of planning possibilities; to serve the multiplicity of human needs from the mobile wireless workplace to a suite of private offices and everything in between. Teknion designs for the future with confidence; for the many potential forms of work as they unfold today, tomorrow and the day after.

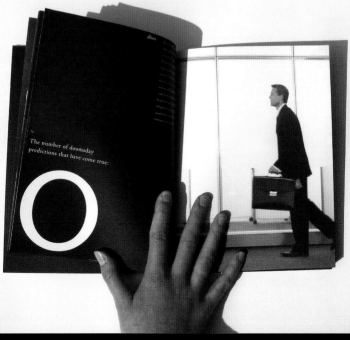

The number of doomsday predictions that have come true:

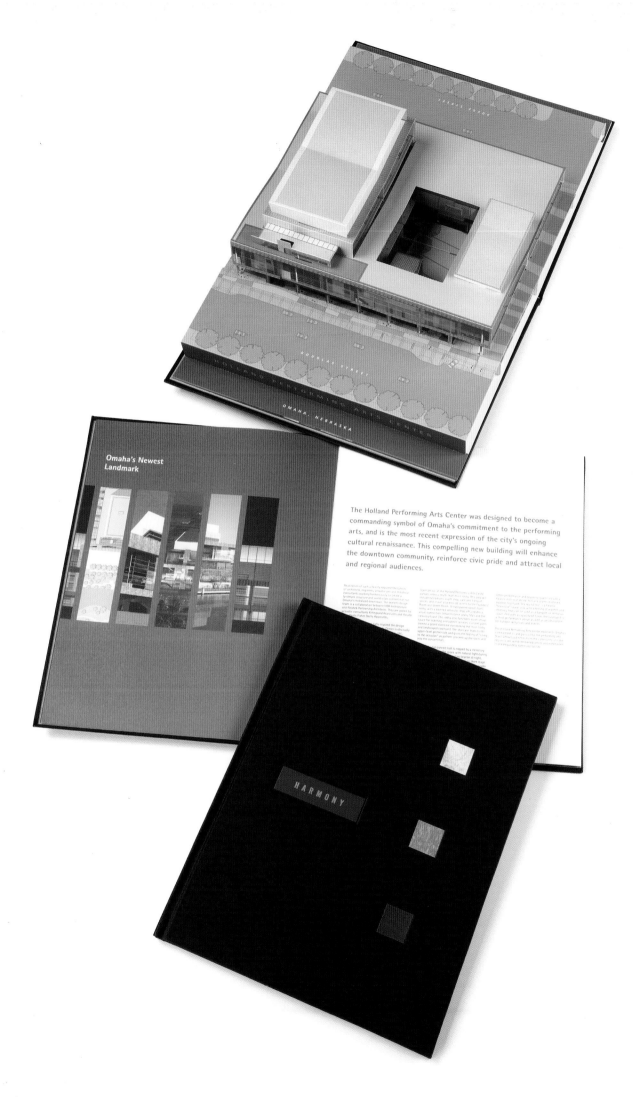

Omaha's Newest Landmark

The Holland Performing Arts Center was designed to become a commanding symbol of Omaha's commitment to the performing arts, and is the most recent expression of the city's ongoing cultural renaissance. This compelling new building will enhance the downtown community, reinforce civic pride and attract local and regional audiences.

HARMONY

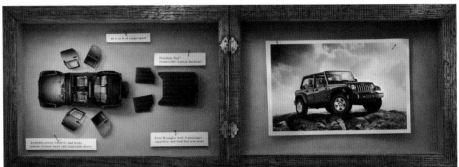

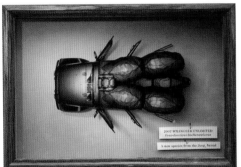

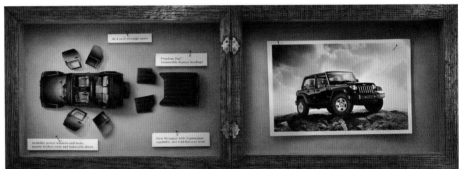

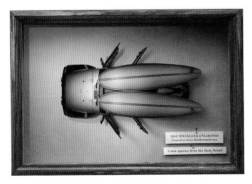

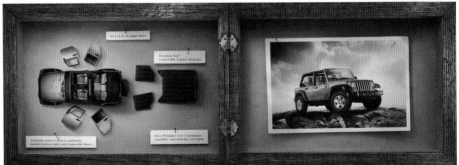

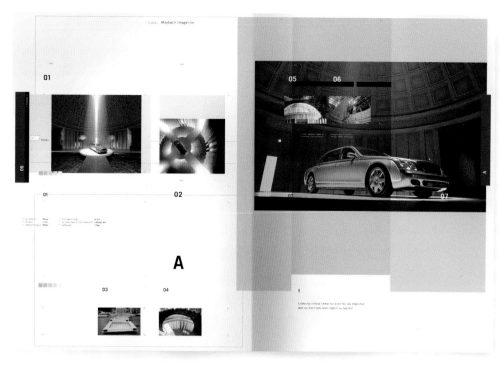

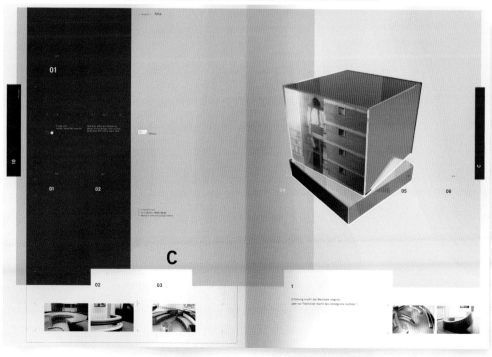

Unbound
3
*IMAGES
REAL AND IMPLIED*

*RIGHTS-MANAGED
AND
ROYALTY-FREE
IMAGES*

masterfile.com
1 800 387 9010

unbound3@masterfile.com

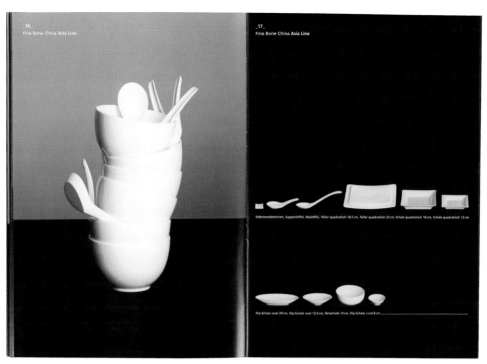

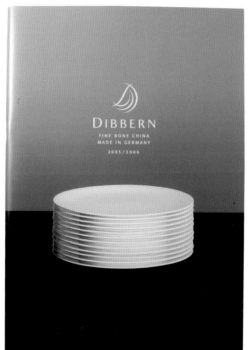

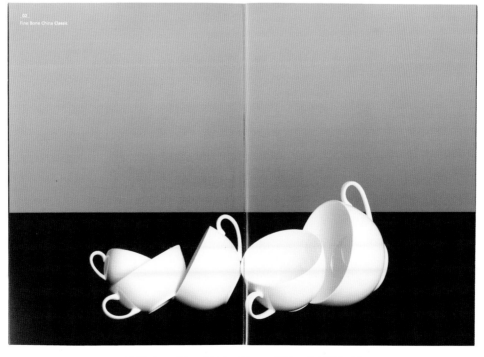

Overzicht van je nieuwjaars voornemens

...3 van de 7 dagen biologisch koken

J F M A M J J A S O N D

...al het drukwerk naar Ando sturen

J F M A M J J A S O N D

...solliciteren naar een interessante baan

J F M A M J J A S O N D

...me meer inzetten voor liefdadigheid

J F M A M J J A S O N D

...niet meer roken in bed

J F M A M J J A S O N D

...mijn fitnessvideo een paar keer per week bekijken

J F M A M J J A S O N D

...niet meer liegen over mijn leeftijd

J F M A M J J A S O N D

...meer kleur dragen

J F M A M J J A S O N D

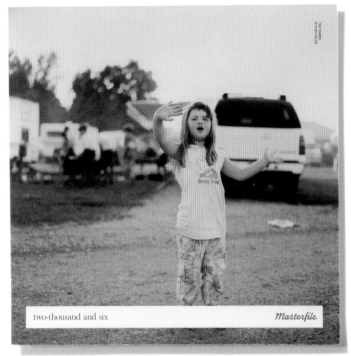

two-thousand and six

Masterfile

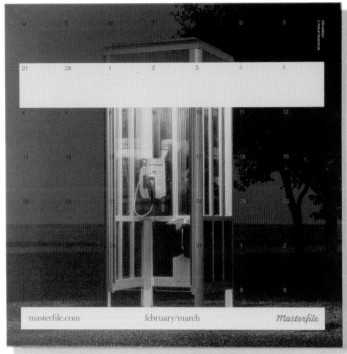

masterfile.com february/march Masterfile

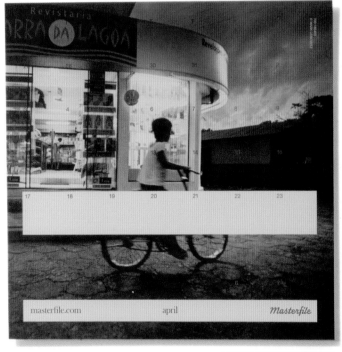

masterfile.com april Masterfile

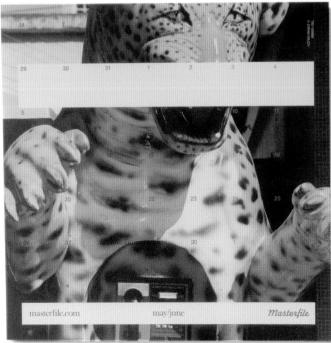

masterfile.com may/june Masterfile

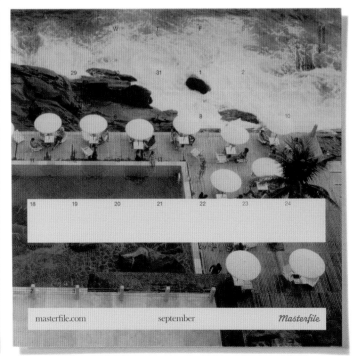

masterfile.com september Masterfile

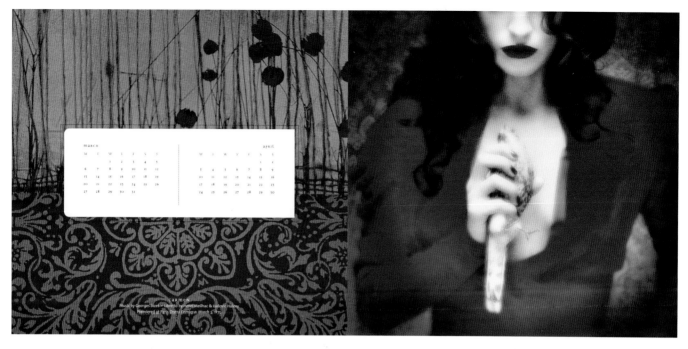

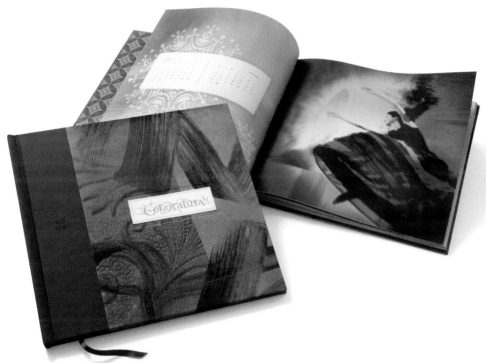

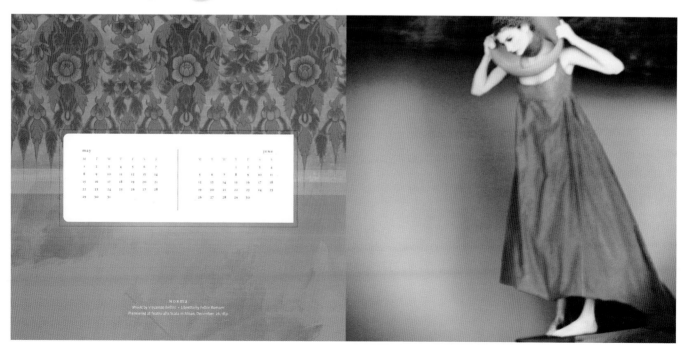

CALIFORNIA C
...E OF THE
ARTS GRAPHIC D
ESIGN PAINTIN
G DRAWING CERA
MICS CREATIV E
RITING N TE
OR DESIGN I GR
STRIAL ES U O
ARCHIT CT R R
TEACHING H O L
GRAPHY SCU L E
TURE T ILE N
FASHION DESIG
ILLUSTRATIO N
PRINTMAKING I
NDIVIDUALIZED
JEWELRY META A R
RTS WOOD FURNI T
TURE MEDIA ART S
S GLASS COMMU
NITY ARTS GRAD
UATE PROGRAMS
VISUAL STUDIES

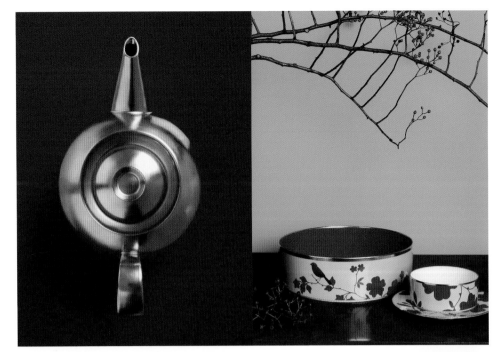

MY CHINA!

MICHAEL SIEGER

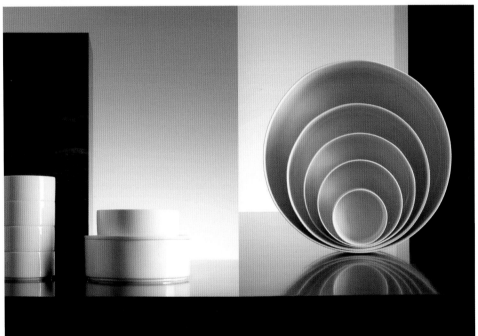

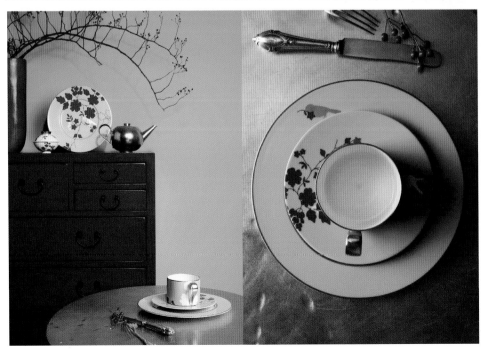

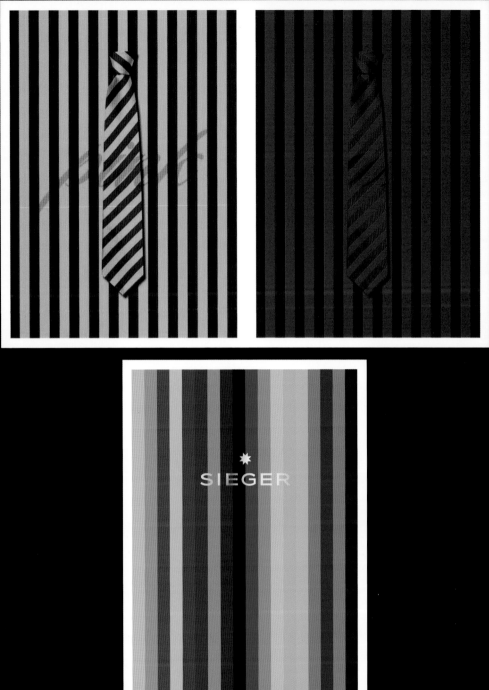

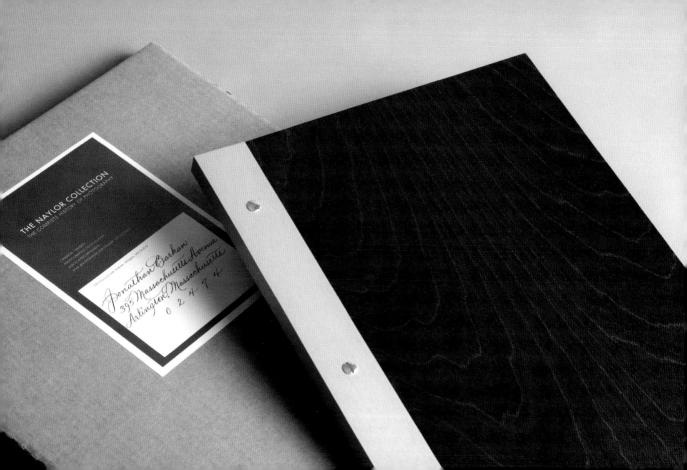

THE NAYLOR COLLECTION
THE COMPLETE HISTORY OF PHOTOGRAPHY

Jonathan Barkan
395 Massachusetts Avenue
Arlington, Massachusetts
0 2 4 7 4

SIEGER

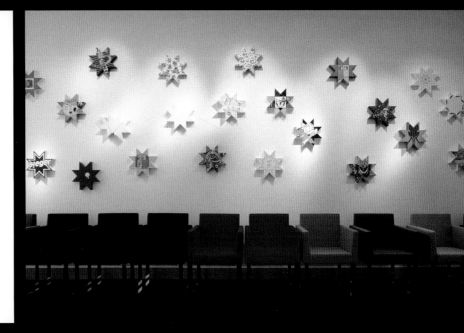
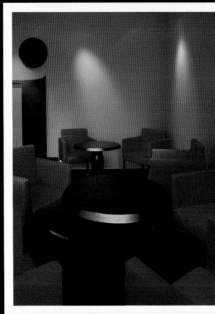

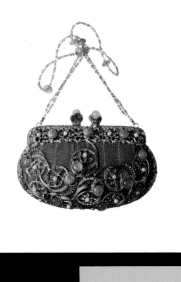

Adidi
NEW YORK
by
wendy lau

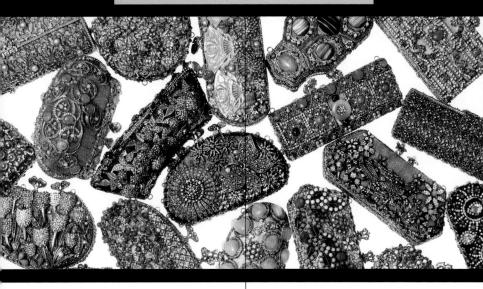

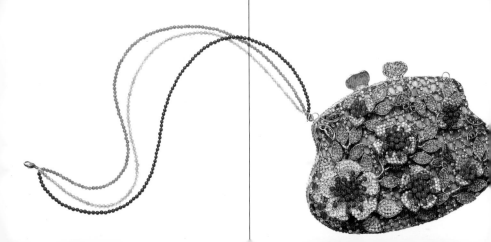

SPORTSTRETCH FLEECE FULL ZIP HOOD $35 S2240
RAGLAN BASEBALL JERSEY TEE $18 T1397
DOUBLE DRY COLORBLOCKED PANT $28 P2255

CHAMPION 06

SUPER HOOD $65 S2202
MILLENNIUM TEE $15 T201
MATTE DAZZLE SHORT $25 81642

REVERSE WEAVE PULLOVER $35 S1954
COLORBLOCKED SLEEVELESS JERSEY TEE $15 T1877
CHAMPION DEFENDER TRACK PANT $30 P2035

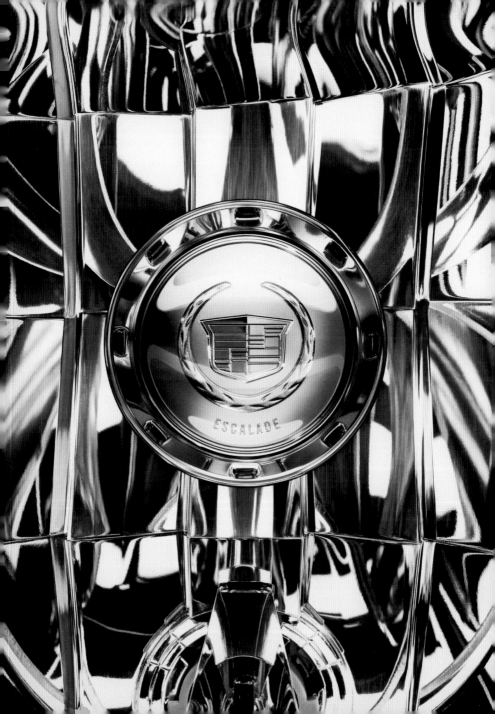

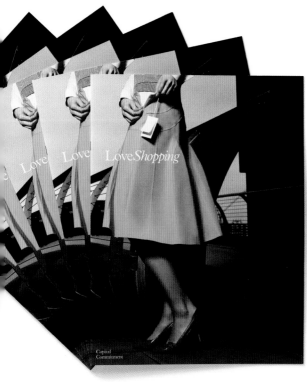

Maki-e is an ancient art form believed to have arrived from China during the Heian period (794-1185), but developed to its greatest artistic expression by Japanese artists. The Japanese word *maki-e* literally means 'sprinkled picture', as it involves sprinkling gold or silver dust over designs drawn in the lacquer surface while it is still damp and sticky. *Maki-e* itself is a general term covering three main techniques. *Hiramaki-e* is a relatively flat finish with a few layers of lacquer on the base pen, followed by applying the design onto the still-moist lacquer, typically covering it with a final clear layer for protection. *Togidashi-e* means 'brought out by polishing', the design is completely covered with lacquer, then buffed until the design reappears. Lastly, *Takamaki-e* features a surface that exhibits raised portions, created by building up relief on the design. Advanced *maki-e* typically involves combinations of these techniques. dunhill and Namiki believe that the Sakura-Rose represents the most ambitious application ever of *maki-e* to a fountain pen. To achieve the mix of colours and textures, and to provide the images with depth, the surface of the Sakura-Rose will exhibit all three applications: *hiramaki-e*, *togidashi-e* and *takamaki-e*. Additionally, details will be highlighted through the use of the finest gold leaf and minuscule slivers of mother-of-pearl acquired from abalone shells. *Maki-e* Master Kyusai Yoshida has conceived a pattern rich in significance to honour the 75th Anniversary of the dunhill-Namiki alliance. Held vertically, the pen displays a visual progression from heaven to earth. In-between the sky and the soil are, on the cap, cherry blossoms (*sakura*) to represent Japan, while the barrel bears golden roses to represent England. It is, without doubt, a perfectly apt symbol of this most highly-regarded and productive partnership.

How appropriate the brief span of the *sakura's* flowering: this delicate bloom is Japan's symbol for the ephemeral nature of life. *Sakura* is the Japanese name for the breathtakingly beautiful ornamental cherry trees that grew wild throughout the country but emerged as a symbol of pride during the Heian period. It was during the 8th to the 12th Centuries that the Japanese developed a national awareness, and the *sakura* emerged as the flower they most cherished. An enduring metaphor for life's brevity, the *sakura* appears throughout Japanese life, represented in both the precious and the mundane, from works of art to items of clothing. Perhaps the most beloved variety is the *Somei Yoshino*, nearly pure white with a hint of pink near the stem, developed in the 19th century, on the cusp of the Edo and Meiji periods. Other varieties include the *yaezakura*, with large flowers and rich pink petals, and *shidarezakura*, with branches reminiscent of a weeping willow, bearing cascades of pink flowers. With an intrinsic poignancy, the *sakura's* flowers bloom and normally fall within a week, adding an urgency to the experience of seeing these gorgeous flowers during the *sakura zensen*, or Cherry-Blossom Front. An annual obsession for the Japanese, it begins in February in Okinawa, proceeding north over the next few months. Friends and families hold 'flower viewing parties', or *hanami*, in parks, at shrines and at temples, perfect opportunities to relax and enjoy the beauty of the flowers. As a symbol of both the ephemeral nature of life and of Japan itself, the *sakura* has served as a token of friendship: the Japanese government gave 3,000 *sakura* as a gift in 1912 to the United States, where they line the Tidal Basin in Washington, DC. On the dunhill Sakura-Rose pen, *sakura* blossoms represent one-half of an enduring Anglo-Japanese partnership.

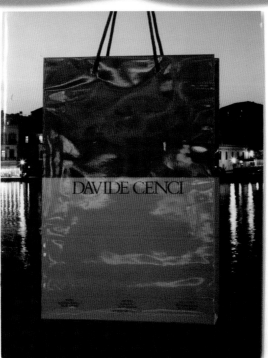

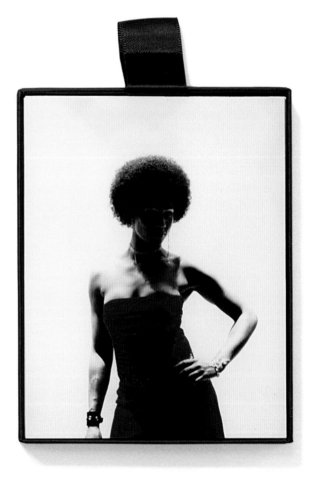

BLACK OSCARS

SEVEN PHOTOGRAPHS
BY
ELAC BOCK

Farrington

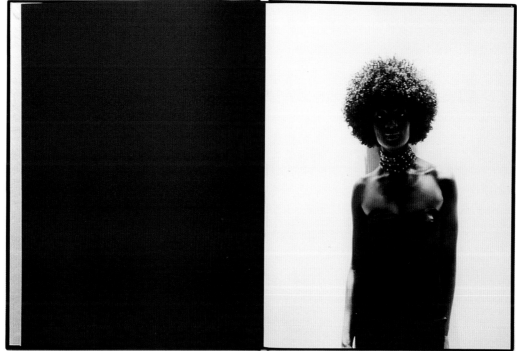

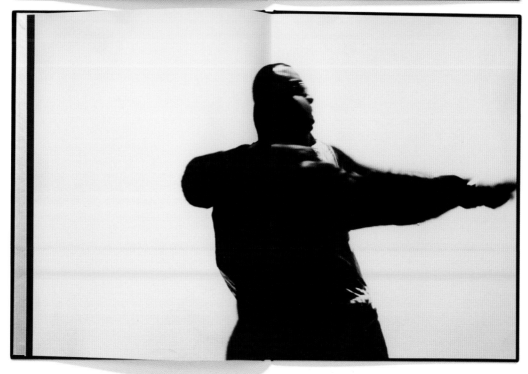

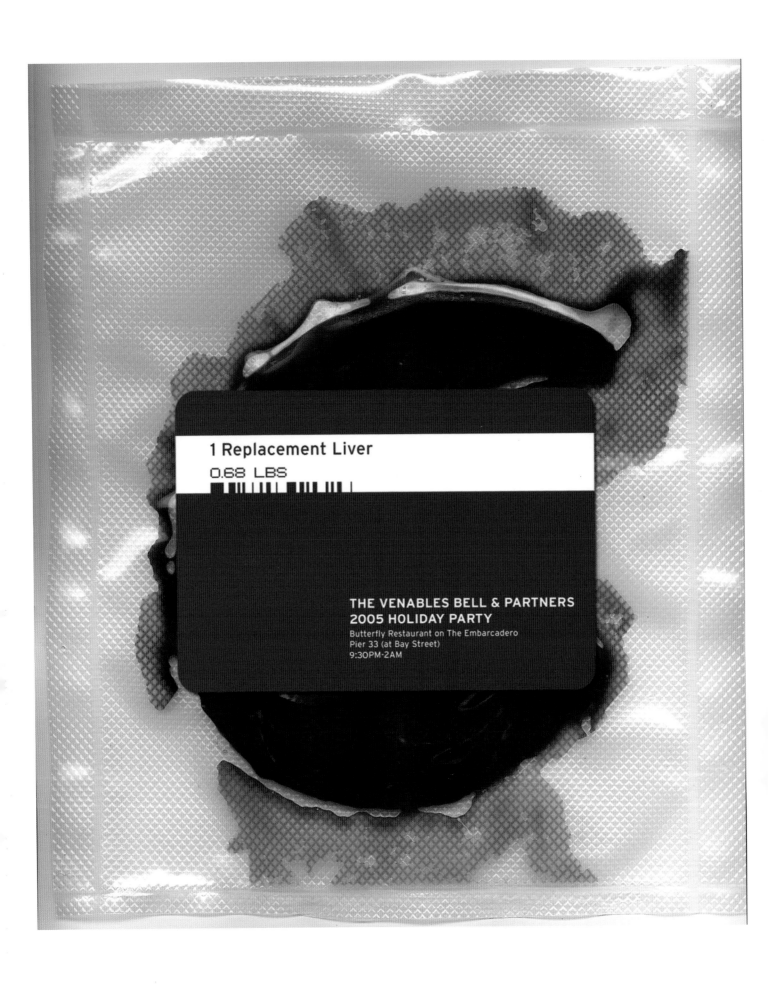

1 Replacement Liver

0.68 LBS

THE VENABLES BELL & PARTNERS
2005 HOLIDAY PARTY
Butterfly Restaurant on The Embarcadero
Pier 33 (at Bay Street)
9:30PM-2AM

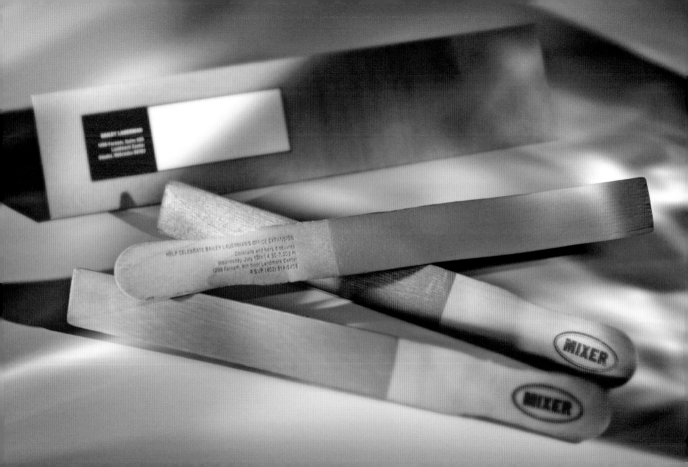

HELP CELEBRATE BAILEY LAUERMAN'S OFFICE EXPANSION
Cocktails and hors d'oeuvres
Wednesday, July 13th | 4:30-7:00 pm
1299 Farnam, 8th floor Landmark Center
R.S.V.P. (402) 514-0406

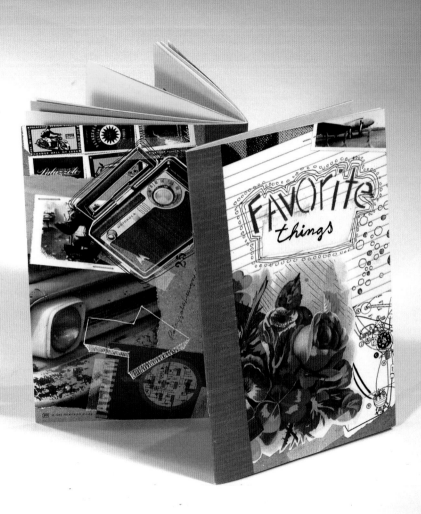

EAT, DRINK & BE MERRY

FORTY YEARS OF SAINT HIERONYMUS PRESS
SIXTY YEARS OF DAVID LANCE GOINES :: MAY 29, 2005
1703 MLK WAY, BERKELEY CA 94709 :: 510.549.1405 :: goines.net

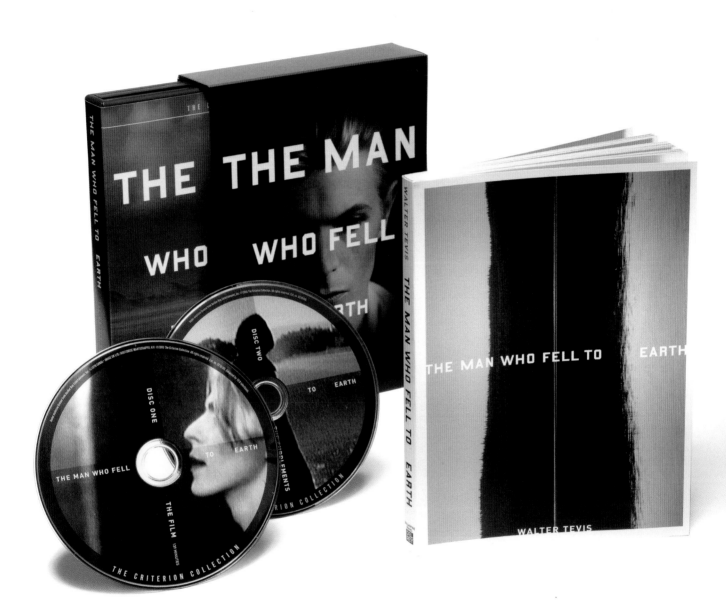

THE CRITERION COLLECTION

肉体の門

SEIJUN SUZUKI'S
GATE OF FLESH

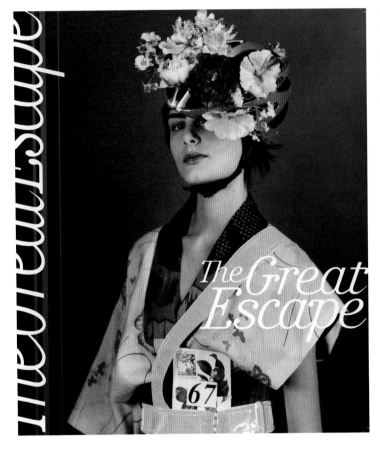

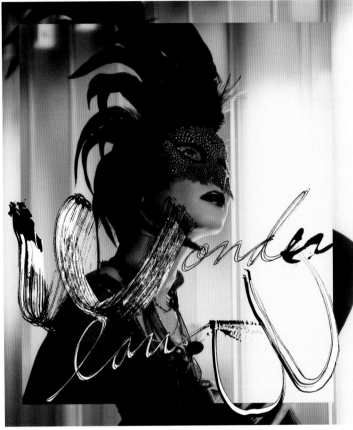

Image by Matthew Haigh

"It was not prudent of me to embark a solitary walk at this hour. The roads are fast becoming dark and I cannot find the way back. The situation could become complicated." Dante Alighieri, Firenze (Italy) 1300

"Non zona prudente ad avventurarsi in una passeggiata solitaria a quest'ora. Il buio e la diventando buio in fretta, e non trovo la strada per tornare. La situazione potrebbe farsi complicata." Dante Alighieri, Firenze (Italia) 1300

HUNTERS
HUNT BEARS
WITH DOGS
SO NATURE
GOES CRAZY
HUMANS
WITH
POWER
DESTROY

Text by Guillermo Rivero / Image by Federico Urdaneta

"My hairdresser says that my hair looks better like this. Short, blonde and puffy. I certainly look like someone else. God, look at me, with my hair like this I look just like a movie star! What if I changed my name?" Norma Jeane, Los Angeles (USA) 1946 / by HS

"Il mio parrucchiere dice che con i capelli così sto molto meglio. Corti, biondi, e gonfi. Certo è che sembro un'altra: Dio, ma guardami, pettinata così sembro proprio una diva del cinema! E se mi cambiassi il nome?" Norma Jeane, Los Angeles (USA) 1946

INDEX / INDICE

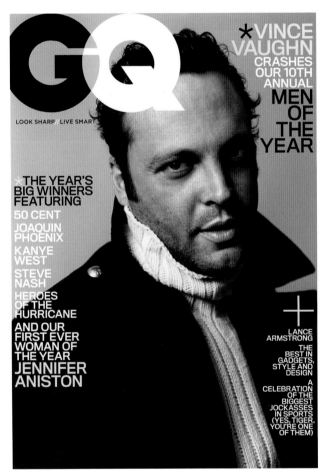

GQ

LOOK SHARP / LIVE SMART

*VINCE
VAUGHN
CRASHES
OUR 10TH
ANNUAL
MEN
OF
THE
YEAR

*THE YEAR'S
BIG WINNERS
FEATURING

50 CENT
JOAQUIN
PHOENIX
KANYE
WEST
STEVE
NASH
HEROES
OF THE
HURRICANE

AND OUR
FIRST EVER
WOMAN OF
THE YEAR
JENNIFER
ANISTON

LANCE
ARMSTRONG

THE
BEST IN
GADGETS,
STYLE AND
DESIGN

A
CELEBRATION
OF THE
BIGGEST
JOCKASSES
IN SPORTS
(YES, TIGER,
YOU'RE ONE
OF THEM)

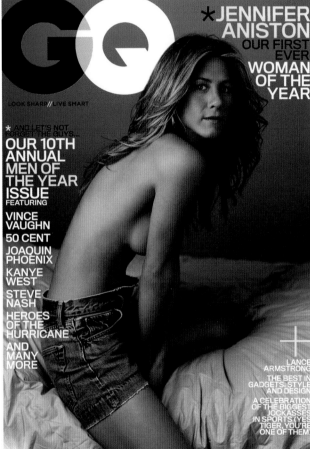

GQ

LOOK SHARP // LIVE SMART

*JENNIFER
ANISTON
OUR FIRST
EVER
WOMAN
OF THE
YEAR

* AND LET'S NOT
FORGET THE GUYS...

OUR 10TH
ANNUAL
MEN OF
THE YEAR
ISSUE
FEATURING

VINCE
VAUGHN

50 CENT

JOAQUIN
PHOENIX

KANYE
WEST

STEVE
NASH

HEROES
OF THE
HURRICANE

AND
MANY
MORE

LANCE
ARMSTRONG

THE BEST IN
GADGETS, STYLE
AND DESIGN

A CELEBRATION
OF THE BIGGEST
JOCKASSES
IN SPORTS (YES,
TIGER, YOU'RE
ONE OF THEM)

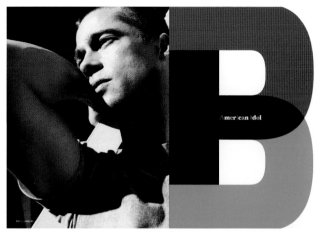

B

American Idol

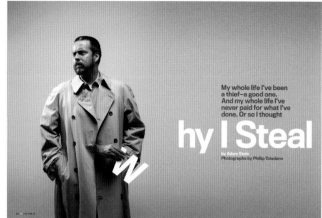

My whole life I've been a thief—a good one. And my whole life I've never paid for what I've done. Or so I thought

hy I Steal

by Adam Stein
Photographs by Phillip Toledano

W

VON T SEYMOUR · BRAD D SQUIRES · JAS
· CHRISTOPHER P LYONS · THOMAS O KEE
THY · MICHAEL J CIFUENTES · DUSTIN A DE
AARON H REED · JEFFREY A BOSKOVITCH ·
· BRIAN P MONTGOMERY · WESLEY G DAV
NATHANIEL S ROCK · ANDRÉ L WILLIAMS
O · TIMOTHY M BELL Jr · **16 DEAD IN OHIO**
REWS · DANIEL N DEYARMIN Jr · CHRISTOP
· ERIC J BERNHOLTZ · BRADLEY J HARPER
MOUR · DAVID KENNETH J KREUTER · ROBE
ING · EDWARD A SCHROEDER II · MICHAEL
CHRISTOPHER J DYER · JUSTIN F HOFFMAN
WILLIAM B WIGHTMAN · GQ 323 · DECEMB
KENDALL H IVY II · NICHOLAS B ERDY · DE

#%@!

(JACKASS FOR LIFE) Johnny Knoxville would like to be taken seriously as an actor. But that's hard when every ass roll wants him to be the guy who kicked himself in the balls. by Jason Gay Photographs by Devon Yong

What makes a soldier desert and risk arrest by the government and rejection from his family and friends? by Jeanne Marie Laskas · Photographs by Jeff Riedel

A**W**OL

IS CHINA READY FOR THE >>>>> NEXT STAGE OF CAPITALISM?
HOW ABOUT A $400,000, 12-CYLINDER >>>>>>>>> 540-HORSEPOWER, CORINTHIAN-LEATHERED HUNK OF LUST AND ENVY KNOWN AS THE >>>>> FERRARI GTS CONTINI
MICHAEL PATERNITI DROVE ONE ALL THE WAY >>>>> FROM BEIJING TO THE GOBI DESERT TO FIND OUT

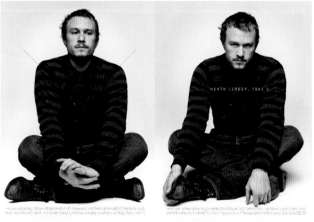

HEATH LEDGER, TAKE 2

by Chris Heath · In which the initially sought-after man, King King, actor and part-time career crook and reprobate, is taken, himself, captive, retells the recent family event he admitted to a filthy and delight's why everyone 20-40 be defiled ... **photographs by Mark Seliger**

BLACK POWER

B

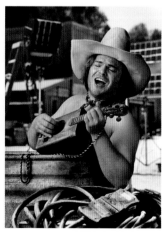

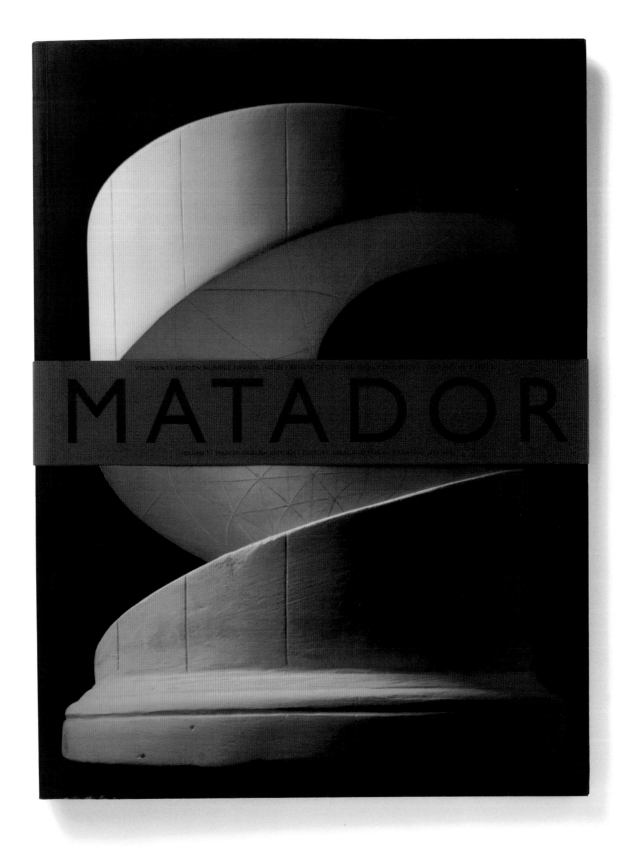

Z!NK

the element of style

89
ways to heat your holiday

king kong's adrien brody

santa & the seven deadly sins

best albums of the year

thinking outside the box

Dec. 2005 $4.99 U.S./$5.99 CAN.

1 2>

0 74851 08412 4

www.zinkmag.com

Amore strisciante

AL RETTILARIO DI EDIMBURGO

Il cucciolo di Pitone Burmese che ha raggiunto la testa di sua madre è nato da pochi giorni. Originari delle zone umide indocinesi, questi due esemplari vivono in cattività all'interno dell'Edinburgh Butterfly and Insect World, in Scozia. Per riuscire a determinare il suo sesso gli esperti dovranno attendere alcune settimane. I serpenti di questa specie possono raggiungere da adulti cinque metri di lunghezza.

FOTO DAVID CHESKIN

TUTTI PAZZI PER LEI

Cameron Diaz

LA DONNA CANNONE

VENGHINO, SIGNORI, VENGHINO A VEDERE LA DIVA PIÙ PAGATA DEL MONDO: 30 MILIONI DI DOLLARI A FILM. PIÙ DI TOM CRUISE, MOLTO PIÙ DI DICAPRIO, ECCO I RETROSCENA DELLA VERTIGINOSA ASCESA DI UNA SUPERDIVA CHE ADESSO BRILLA PER ASSENZA MA CHE DAL 2005...
A FOTOGRAFARLA, NIENTE MENO CHE LA GRANDE ANNIE LEIBOVITZ
DI GLENN O'BRIEN

PRONTA A TUTTO
Cameron Diaz, 31 anni, posa pirotecnica per Annie Leibovitz. È cresciuta in un quartiere malfamato di Los Angeles, dove il padre cubano le ha insegnato a prendere a pugni chi le dava fastidio.

COSTUME INTERO,
UNDER COLORS
OF BENETTON
(€ 34,90). SOTTO,
TOP GIALLO,
PLEIN SUD (€ 250).
MINI DI PIZZO,
CHANEL. GUANTI
PRADA SPORT.
SCARPE GOLA.

RITMI CONTEMPORANEI

LA MINI DI RASO
SUI PANTAJOGGING,
IL PIUMINO IMBOTTITO
E LA PELLE BORCHIATA,
LE STAMPE OPTICAL
CON IL TARTAN
E I COLORI FLUO.
E IL PIÙ ESTREMO DEGLI
STILI D'AUTUNNO.
CON UNA TESTIMONIAL
ESCLUSIVA: EDA
MEGUMI, NUOVA STAR
DELLA DANZA
AVANT-GARDE

FOTO LUCA BABINI

Nata in Giappone, Eda ha
debuttato come danzatrice
classica con la Matsuyama
Ballet Company di Tokyo.

S

E L'ORA DI MANICURE E PEDICURE "DECISE". COLPA DEI SANDALI
CON OBLÒ CHE METTONO IN MOSTRA COLORI E FORME. E DEL
DIFFONDERSI DI UN MITO USA: I CENTRI BENESSERE PER UNGHIE

SMALTI *fetish*

DI MICHELA MOTTA

160 VANITY FAIR

MICROGUIDA
Gli smalti rossi si
sposano con la pelle
chiara, i fucsia e gli
aranciati sono ancora
più vibranti su
incarnati caldi, lilla
e rosa freddi esaltano
il colorito olivastro.

11 SETTEMBRE
TRE ANNI DOPO

PER QUALCUNO, DA QUEL GIORNO, È COMINCIATA UNA SPECIE DI TERZA
GUERRA MONDIALE, DI CUI ANCORA OGGI NON SI VEDE LA FINE,
E CON UN NEMICO CONTRO CUI NOI OCCIDENTALI NON ERAVAMO
ABITUATI A COMBATTERE: LA PAURA

DI FERRUCCIO DE BORTOLI

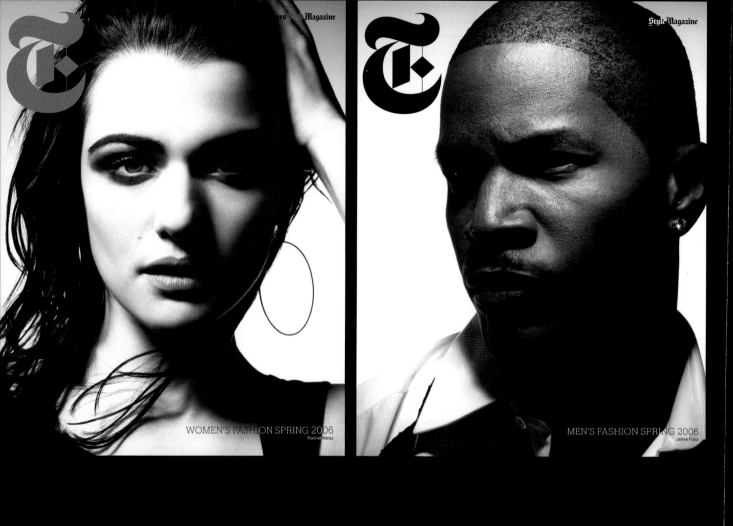

WOMEN'S FASHION SPRING 2006
Rachel Weisz

MEN'S FASHION SPRING 2006
Jamie Foxx

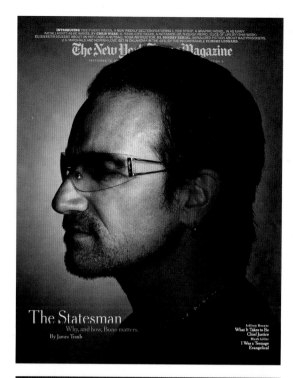

The Statesman
Why, and how, Bono matters.
By James Traub

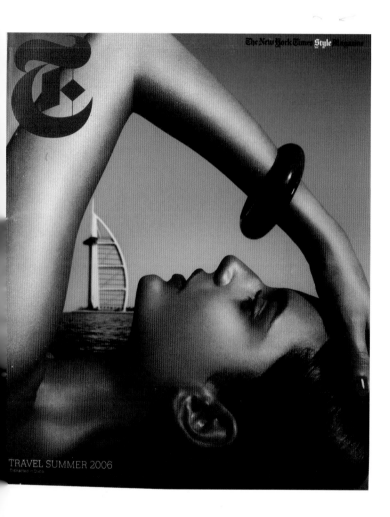

TRAVEL SUMMER 2006

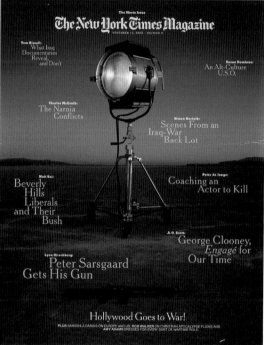

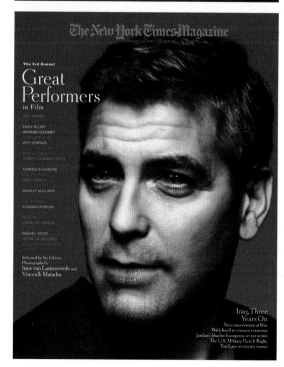

ESOPUS

US $10

ISBN 0-9761141-2-4

9000

9 780976 164128

AZURE

DESIGN
ARCHITECTURE
ART

THE ULTIMATE SUMMER
SLEEPING CABIN

TRENDS FROM MILAN

FRENCH DESIGNER
PATRICK NORGUET

HERZOG AND DE MEURON
TAKE MINNEAPOLIS

PREFAB

ALTERNATIVE
HOUSING
NEVER LOOKED
SO GOOD

CAN/US $6.95
WWW.AZUREMAGAZINE.COM

08

PM40048072 R09064

DISPLAY UNTIL AUGUST 15

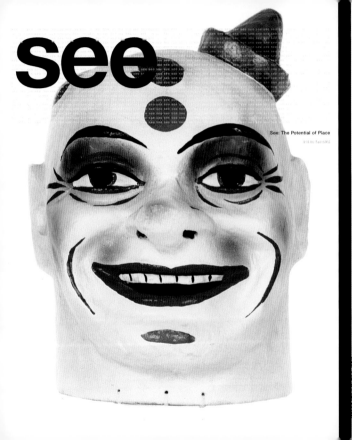

see.

See: The Potential of Place

$14.00 Fall 2005

ìtems

¹

Tijdschrift voor ontwerpen en verbeelding januari/februari 2006 €12,50

Creatief Utrecht breeduit
Alround realist Konstantin Grcic

S I E R A D E N

Global Fashion/Local Tradition
James Avati, King of paperbacks

Braun 50 jaar Catalysts! Xbox Pictoplasma De Effenaar Sprookjesboeken Goed Wonen

8 710966 562396

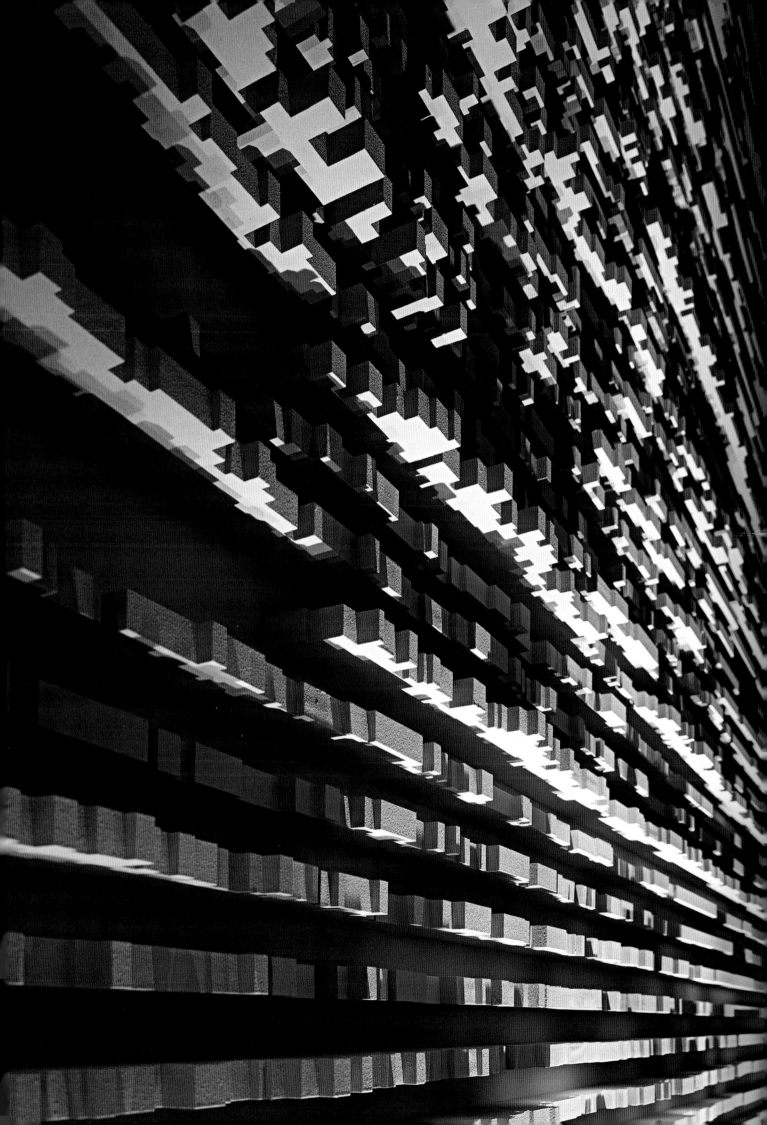

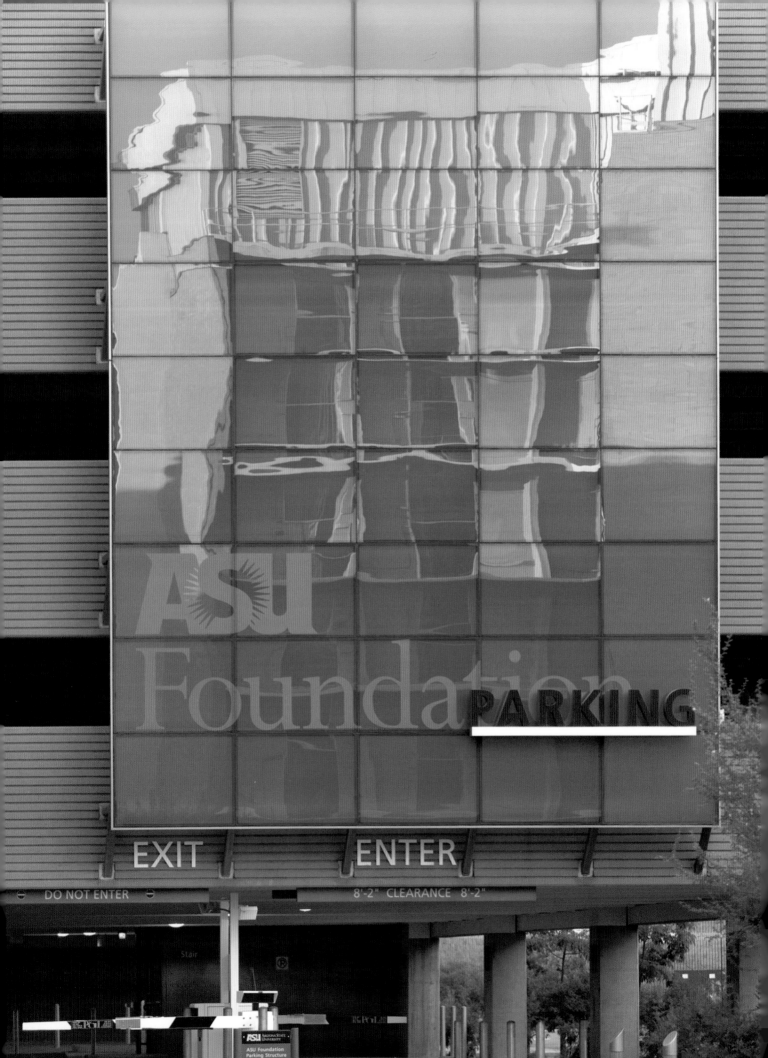

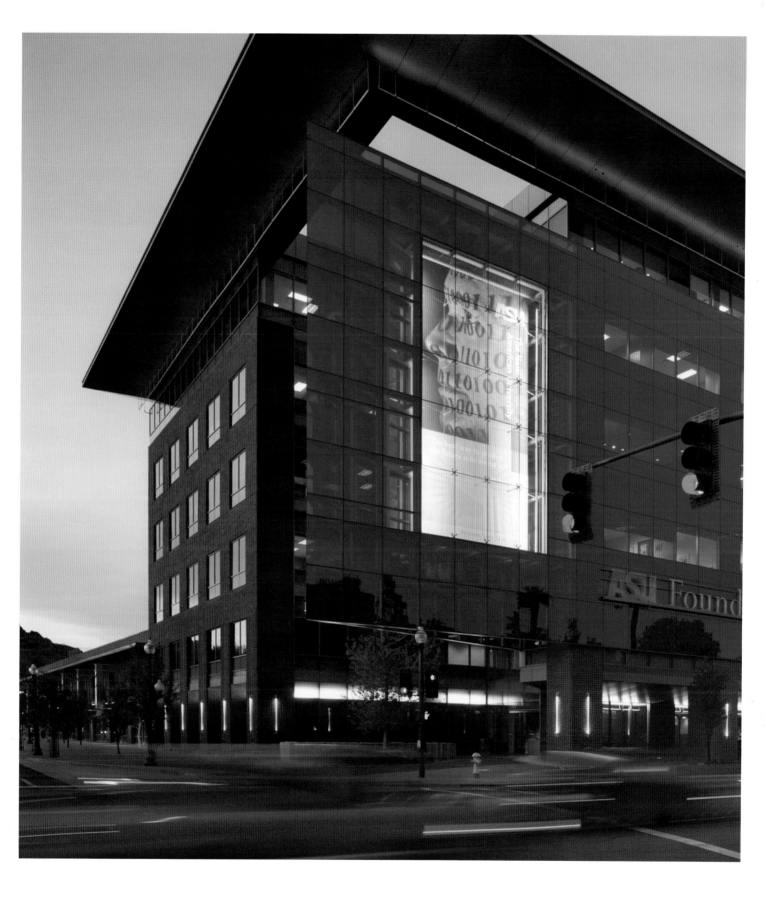

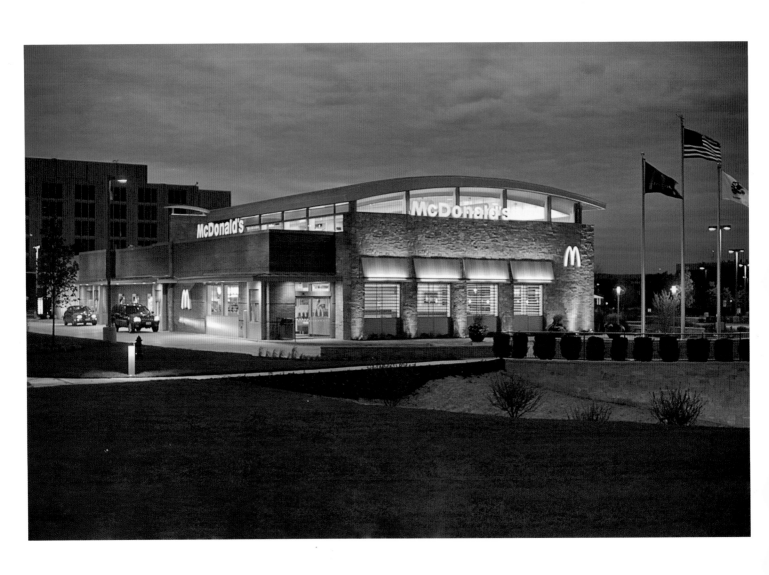

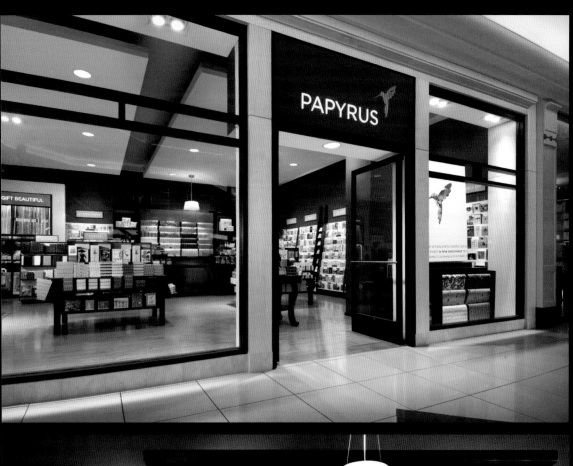

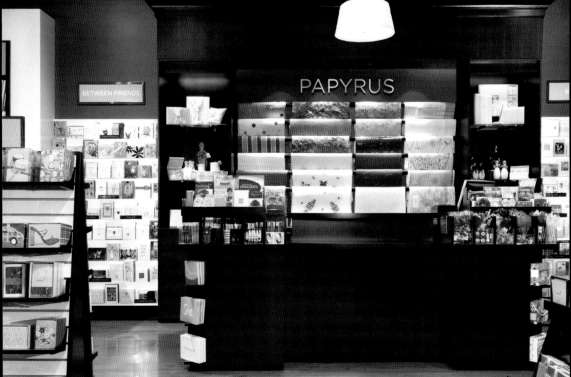

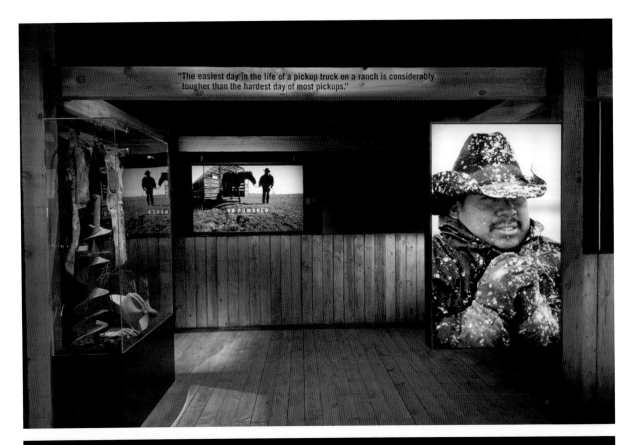

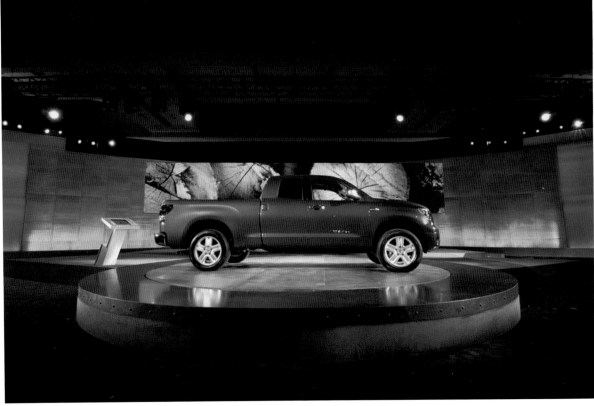

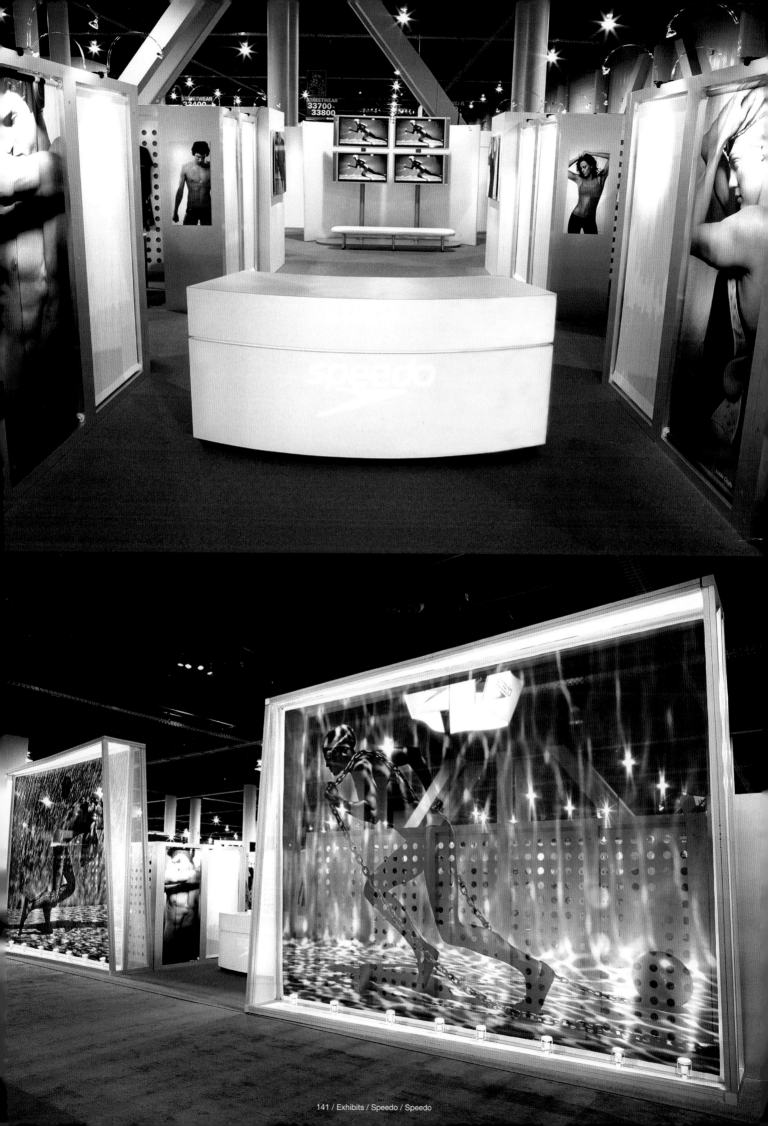

There is a little bit of Leonardo in every designer. Today's best designers, inventors as much as they are artists, not only improve form, but also restore function. They add both beauty – and value – to our lives. Their approach calls into question the status quo and leads them to discover opportunities where others may not, their design solutions stand the test of time.

The twentieth century saw an outpouring of design innovation. In postwar Europe, the Vespa, manufactured with the expertise of the aircraft industry, became the most admired and imitated scooter in the world. A generation later the unprecedented speed of the Concorde, with its graceful design and luxurious interior, turned an ocean into a pond. The Shinkansen, Japan's aptly-named bullet train, can exceed distant cities with speed and style. The Pontiac Aztec along with many other innovative twentieth-century designs, used unconventional materials and daring technology to change the way we think about interior and industrial design.

But a design is rarely smarter than the Smart Car, which addresses this environment with fuel efficiency, safety such as compact Trolon steel housing, and providing with its own rearward wheelbase. No wonder the Museum of Modern art, which has exhibited the Smart Car, cited it for challenging facets of personal mobility. Products like Smart – with function and form reinvented in tandem, prove that designers who ask out-of-the-ordinary questions can arrive at out-of-the-ordinary solutions that improve the way we live.

The details are not the details.
They make the design.

Charles Eames

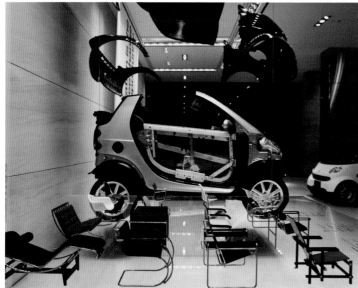
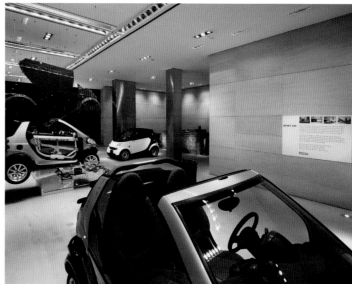
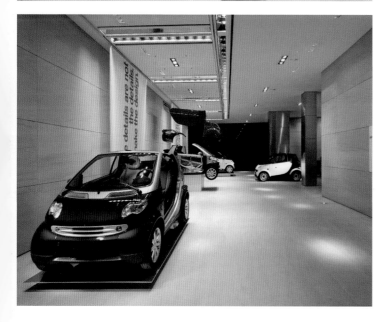

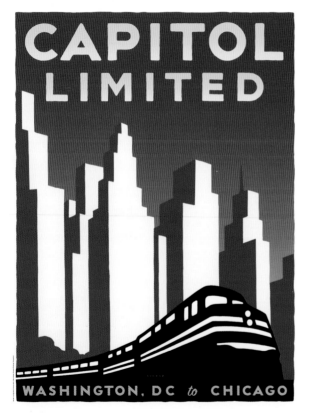

CAPITOL LIMITED

WASHINGTON, DC *to* CHICAGO

AMTRAK

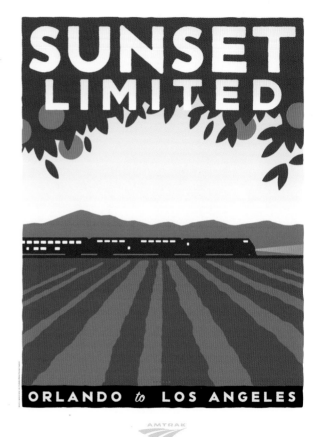

SUNSET LIMITED

ORLANDO *to* LOS ANGELES

AMTRAK

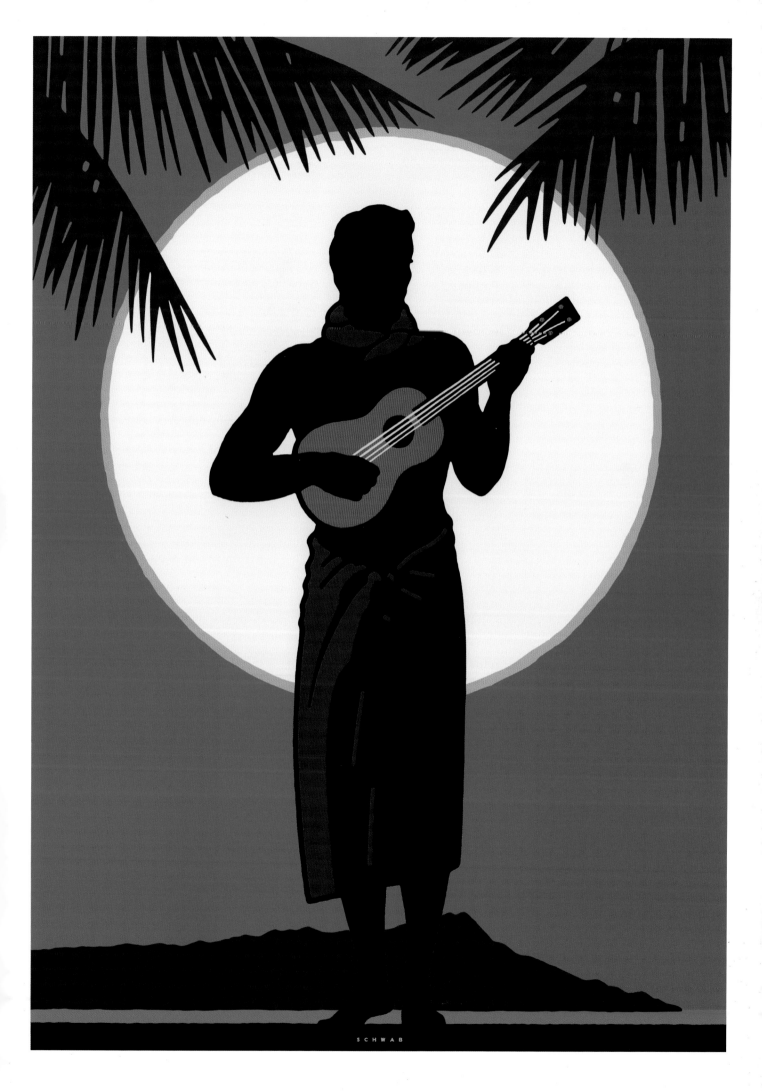

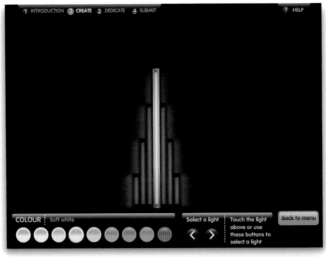

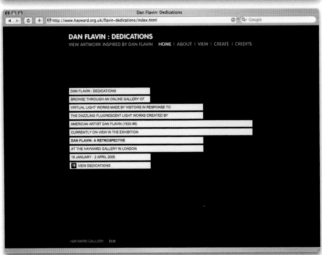

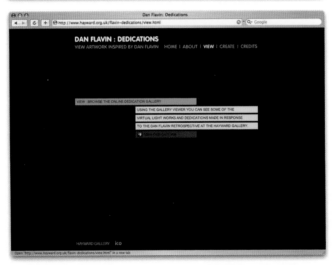

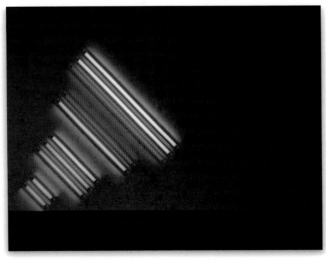

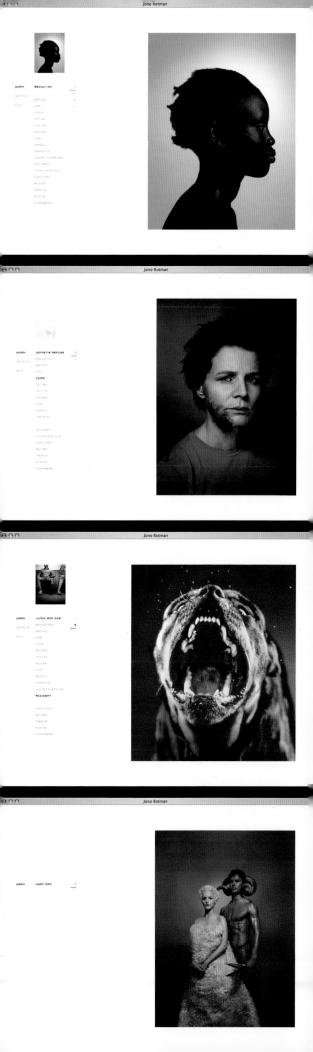

150 / Interactive / Damashek Consulting / Bacardi Global Brands

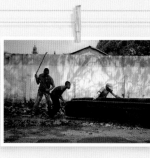

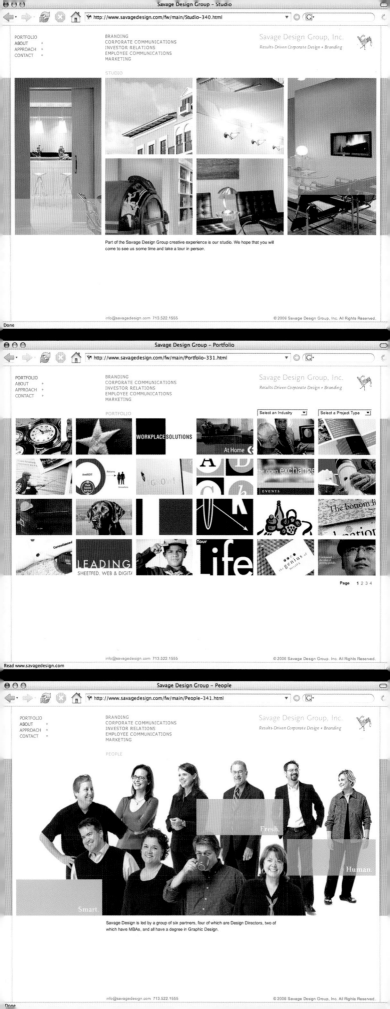

http://www.savagedesign.com/fw/main/Studio-340.html

PORTFOLIO
ABOUT •
APPROACH •
CONTACT •

BRANDING
CORPORATE COMMUNICATIONS
INVESTOR RELATIONS
EMPLOYEE COMMUNICATIONS
MARKETING

Savage Design Group, Inc.
Results Driven Corporate Design • Branding

STUDIO

Part of the Savage Design Group creative experience is our studio. We hope that you will
come to see us some time and take a tour in person.

info@savagedesign.com 713.522.1555 © 2006 Savage Design Group, Inc. All Rights Reserved.

Done

http://www.savagedesign.com/fw/main/Portfolio-331.html

PORTFOLIO
ABOUT •
APPROACH •
CONTACT •

BRANDING
CORPORATE COMMUNICATIONS
INVESTOR RELATIONS
EMPLOYEE COMMUNICATIONS
MARKETING

Savage Design Group, Inc.
Results Driven Corporate Design • Branding

PORTFOLIO Select an Industry ▼ Select a Project Type ▼

WORKPLACE SOLUTIONS

At Home

the open exchange
EVENTS

The bottom li

LEADING
SHEETFED, WEB & DIGITA

Your
life

the genius of

Page 1 2 3 4

info@savagedesign.com 713.522.1555 © 2006 Savage Design Group, Inc. All Rights Reserved.

Read www.savagedesign.com

http://www.savagedesign.com/fw/main/People-341.html

PORTFOLIO
ABOUT •
APPROACH •
CONTACT •

BRANDING
CORPORATE COMMUNICATIONS
INVESTOR RELATIONS
EMPLOYEE COMMUNICATIONS
MARKETING

Savage Design Group, Inc.
Results-Driven Corporate Design • Branding

PEOPLE

Fresh.

Human.

Smart

Savage Design is led by a group of six partners, four of which are Design Directors, two of
which have MBAs, and all have a degree in Graphic Design.

info@savagedesign.com 713.522.1555 © 2006 Savage Design Group, Inc. All Rights Reserved.

Done

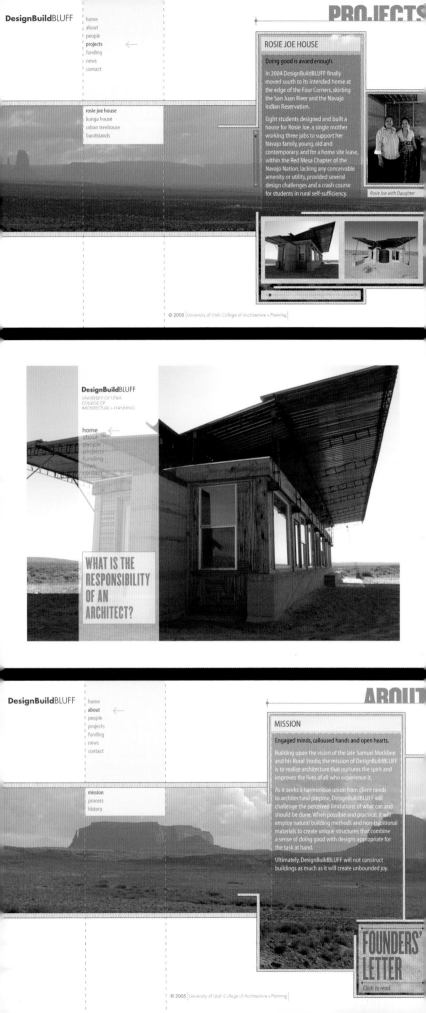

DesignBuildBLUFF

- home
- about
- people
- **projects** ←----
- funding
- news
- contact

- rosie joe house
- kunga house
- urban treehouse
- bandstands

ROSIE JOE HOUSE

Doing good is award enough.

In 2004 DesignBuildBLUFF finally moved south to its intended home at the edge of the Four Corners, skirting the San Juan River and the Navajo Indian Reservation.

Eight students designed and built a house for Rosie Joe, a single mother working three jobs to support her Navajo family, young, old and contemporary, and for a home site lease, within the Red Mesa Chapter of the Navajo Nation, lacking any conceivable amenity or utility, provided several design challenges and a crash course for students in rural self-sufficiency.

Rosie Joe with Daughter

DesignBuildBLUFF
UNIVERSITY OF UTAH
COLLEGE OF
ARCHITECTURE + PLANNING

- **home** ←----
- about
- people
- projects
- funding
- news
- contact

WHAT IS THE RESPONSIBILITY OF AN ARCHITECT?

DesignBuildBLUFF

- home
- **about** ←----
- people
- projects
- funding
- news
- contact

- mission
- process
- history

MISSION

Engaged minds, calloused hands and open hearts.

Building upon the vision of the late Samuel Mockbee and his Rural Studio, the mission of DesignBuildBLUFF is to realize architecture that nurtures the spirit and improves the lives of all who experience it.

As it seeks a harmonious union from client needs to architectural purpose, DesignBuildBLUFF will challenge the perceived limitations of what can and should be done. When possible and practical, it will employ natural building methods and non-traditional materials to create unique structures that combine a sense of doing good with designs appropriate for the task at hand.

Ultimately, DesignBuildBLUFF will not construct buildings as much as it will create unbounded joy.

FOUNDERS' LETTER
Click to read.

Sæmundur St. Magnússon
STJÓRNARFORMAÐUR

Vagnhöfði 13 · 110 Reykjavík
Sími 414 6500 · Fax 414 6501
GSM 692 6020
saemundur@mjolka.is
www.mjolka.is

Vagnhöfði 13
110 Reykjavík
Sími 414 6500
Fax 414 6501
www.mjolka.is

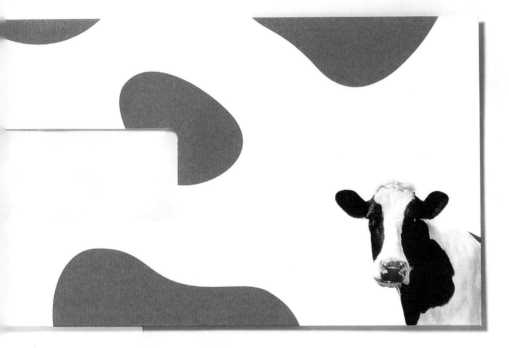

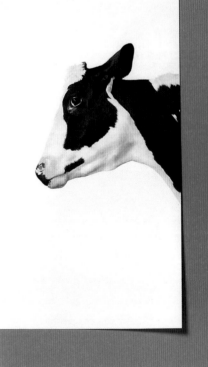

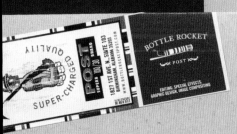

RICK D'ANDREA • PRESIDENT
EXECUTIVE PRODUCER
rick@bottlerocketpost.com

P
205
263
767
8

F
205
254
600
0

1827 1ST AVE. N., SUITE 103, BIRMINGHAM, ALABAMA 35203 P 205.263.7678 F 205.254.6000

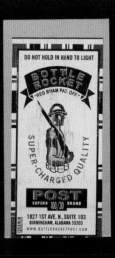

Deborah Kings.

totalcontent. Studio The Abbey Warwick Road
Southam Warwickshire United Kingdom CV47 0HN
T +01926 812286 M +07870 751958 F +01926 811386
deb@totalcontent.co.uk www.totalcontent.co.uk

totalcontent. Studio The Abbey Warwick Road Southam Warwickshire United Kingdom CV47 0HN
T +01926 812286 M +07976 160967 F +01926 811386 jim@totalcontent.co.uk www.totalcontent.co.uk

VAT No. 795 3718 85

totalcontent. Studio The Abbey Warwick Road Southam Warwickshire United Kingdom CV47 0HN
T +01926 812286 M +07976 160967 F +01926 811386 jim@totalcontent.co.uk www.totalcontent.co.uk

VAT No. 786 3716 85

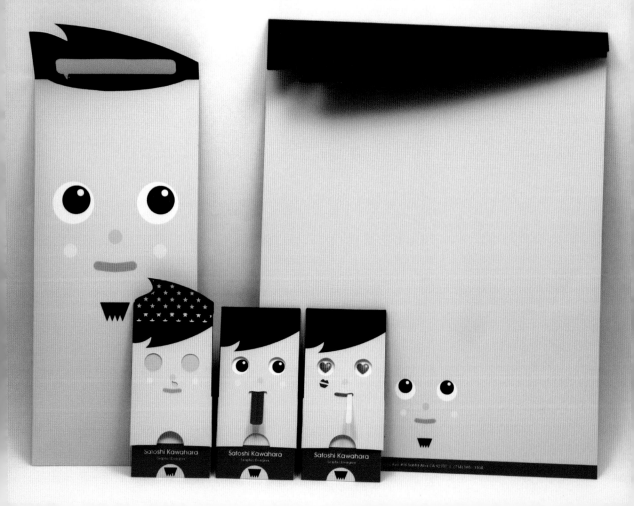

Driving fresh solutions to market

Driving fresh solutions to market

Driving fresh solutions to market

Driving fresh solutions to market

Blake Brand Growers, Inc.
9457 S. University Blvd., #350
Highlands Ranch, CO 80126

Blake Br

9457 S. Uni
Highlands R

t 720-320-7
f 866-209-4

brandgrowe

Blake Br

9457 S. Uni
Highlands R

t 720-320-7
f 866-209-4

brandgrowe

Blake Brand Growers, Inc.

9457 S. University Blvd., #350
Highlands Ranch, CO 80126

t 720-320-7656
f 866-209-4190

brandgrowers.com

ULOLA

ULOLA

SAPIO, Josipa Vogrinca 18, 10000 Zagreb
tel/fax: (01) 3833-193 • info@ulola.com • www.ulola.com
MB: 91756472 • ŽIRO RAČUN: RBA 2484008-1100121200

PRIRODNI KOZMETIČKI PROIZVODI

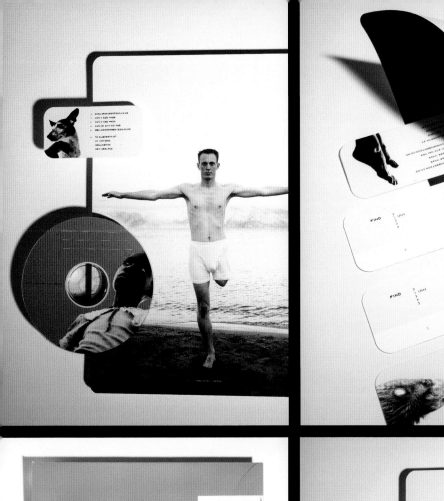

124 DESIGN.
GRAFISCH ONTWERPERS BNO

onderwerp

Prins Hendrikkade 124
1011 AN Amsterdam
t 020 62 63 062
f 020 63 83 009
mail@124design.nl
www.124design.nl

124 DESIGN

PHILIP DE JOSSELIN DE JONG
grafisch ontwerper

abn-amro 54.61.49.103
btw 808083946 b01
kvk amsterdam 34118254

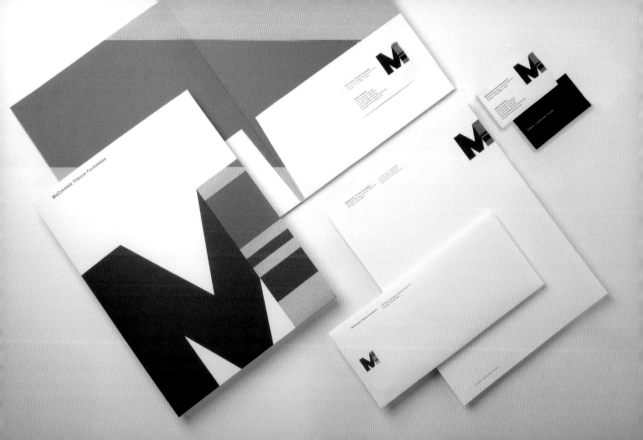

Frost Design / Warner Music Australia
Sebastien Canepa / Priamo Pascal
HKLM / Dixon
Hao Shi / Dulcefina
164 / Logos / Brian Owens / Williamson Printing Corporation

Graphics & Designing Inc. / Takus Office
Stromme Throndsen Design / Melkeveien
The ROC Company / Douglaston Development
Meta4 Design / McCormick Tribune Foundation
166 / Logos / Kevin Bailey / Lobo Tortilla Factory

Michael Schwab Studio / Red & White Fleet
Steve Liska / Tim Bieber
Sukle Advertising & Design / Deep Rock Water
Barkley Evergreen & Partners / Barkley Evergreen & Partners
169 / Logos / Initio Advertising / The Trike Shop

goodies

Michael Telesco / Rich Products
Patience F. Williams / Monica Whang
ixo / Fotoj
Duffy & Partners / Kerzner International Limited
170 / Logos / David Orr / STORY

Orn Smari Gislason / Mjolka
Goodby, Silverstein & Partners / USA Cycling
Kevin Bailey / Dallas Legal Foundation
Addis / Turn
172 / Logos / Michael Miller Yu / Brandtailor Ltd.

Tim Frame Design / Ironhead Athletic
Scott Ray / Crossroads Coffeehouse & Music Company
KMS Team GmbH / Ausstellungsgesellschaft Zollverein
Vanderbyl Design / Scarecrow Wines
175 / Logos / FutureBrand / Exomos

scott howard

raw

Scallops & caviar
Fennel pollen
Yuzu
Almond oil
$14

Lightly smoked salmon
Cucumber
Yogurt
Salmon caviar
$10

Fluke sashimi
Muscat grape gelée
Kaffir lime
Hon shimeji mushrooms
$12

Hog Island Oysters
Gazpacho
Vodka
Cumin
$14

Sea urchin
Toro
Avocado
Fresh wasabi
$16

Big eye tuna
Serrano ham
Pineapple
Bau ram
$12

charcuterie

Foie gras terrine
Mint
Summer melon salad
Honey
$14

Country pork pâté
Purslane
Pickled shallots
Frisse mustards
$8

Pintade gallantine
Pistachio
Truffles
Figs feet
$12

Spiced Oxtail Terrine
Port
Shiitake mushrooms
Watercress
$12

salads

White Crane Ranch greens
Olio verde
Meyer lemon
Chives
$9

Heirloom tomato
Heart of palm
Lemon verbena
Petite lemongrass
$10

Summer Beans
Black mission figs
Summer truffles
Fig vinegar
$10

appetizers

Sweetbreads
Truffled Medeira
Smoked bacon
Potato purée
$10

Foie gras
Ancho jam
Brioche
Watercress
$14

soups

Carrot broth
Sabayon
Chervil
Truffle oil
$8

Hama Hama oysters
Saffron
Orange
Star anise
$10

seafood

Salmon
Mer noir
Montpellier butter
Leeks
$20

Tuna
Foie gras
Onion marmalade
Pinot noir reduction
$24

Maine scallops
Golden raisins
Capers
Almonds
$21

Halibut
Bouillabaisse
Fennel pollen
Squash
$21

meats

Short ribs
Celery root
Horseradish
Porcini jus
$22

Duck breast
Leek fondue
Red wine gastrique
Black pepper
$24

Lamb loin
Herb jus
Orange saffron
Picholine olives
$28

Rib steak
Beef marrow
Bordelaise
Béarnaise
$32 per person
(serves 2)

vegetables

Cauliflower
Saffron
Pear
$6

Chanterelles
Spinach
Caper berries
$8

Cranberry beans
Bacon
Tomato
$6

Baby beets & carrots
Cumin
Walnut
$6

potatoes

Gratin
Goat cheese
Thyme
$6

Gnocchi
Parmesan
Sage
$6

Purée
Truffle oil
Chives
$6

Confit
Garlic
Aioli
$6

grains

Risotto
Maitake mushrooms
Parmesan
$8

Polenta
Eggplant
Peppers
$6

scott howard

carrot broth
try this at home

5-6 servings
3 cups diced carrots (small dice)
6 1/2 cups carrot juice
Salt & pepper to taste
1 cup heavy cream
1/2 tablespoon curry powder

technique
1. Put diced carrots in a small pot.
2. Cover with carrot juice (reserve remaining for later).
3. Cook carrots in juice until the juice is reduced until dry.
4. In blender, puree cooked carrots (in small batches) with remaining juice until smooth.
5. Return to stove. Slowly heat to a simmer.
6. Add curry powder and then salt and pepper to taste.
7. Add cream
8. Strain through Chinoise (fine mesh strainer).
9. Garnish with cream fraiche and truffle oil.

(415) 956 7040
500 Jackson Street, San Francisco, CA 94133
www.scotthowardsf.com

scott howard

thank you

thank you

thank you

03

Celje
Trbovlje

04

Kranj

Potentilla nitida

Triglavska roža

Iz zlatorogove krvi vznikne ta čudodelna roža mogota.

05

Koper
Nova Gorica

Iris illyrica

*Ilirska
perunika*

Sveti cvet starih Ilirov.

07

Novo mesto

Cypripedium calceolus

Lepi čeveljc

Najlepša slovenska orhideja ponos Dolenjske.

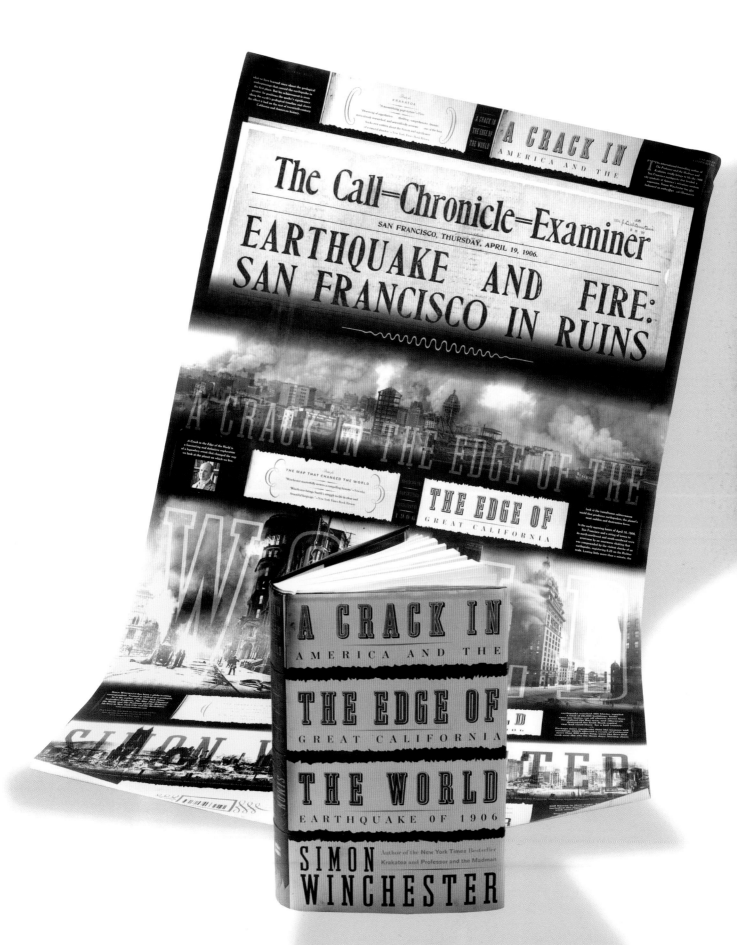

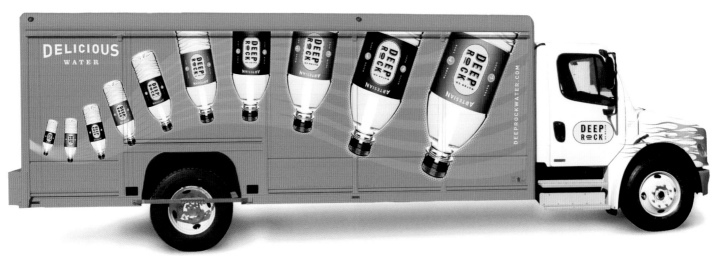

MARIO BATALI™
THE ITALIAN KITCHEN

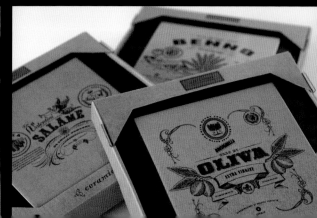

Waitrose
COOKS' INGREDIENTS

A HANDFUL OF
FLAGEOLET
BEANS

Waitrose
COOKS' INGREDIENTS

A SPOONFUL OF
NONPAREILLE
CAPERS SALTED

Waitrose
COOKS' INGREDIENTS

EASY ON THE
CRUSHED
CHILLI

Waitrose
COOKS' INGREDIENTS

A HANDFUL OF
PORCINI
MUSHROOMS

Waitrose
COOKS' INGREDIENTS

A DRIZZLE OF
TRUFFLE
INFUSED EXTRA
VIRGIN OLIVE OIL

Waitrose
COOKS' INGREDIENTS

A DASH OF
SHERRY
VINEGAR

Waitrose
COOKS' INGREDIENTS

A GENEROUS HELPING OF
GRILLED SUN-DRIED
TOMATOES

Waitrose
COOKS' INGREDIENTS

A GENEROUS HELPING OF
GRILLED ARTICHOKES
IN OLIVE OIL

Waitrose
COOKS' INGREDIENTS

A SCOOP OF
VIALONE NANO
RISOTTO RICE

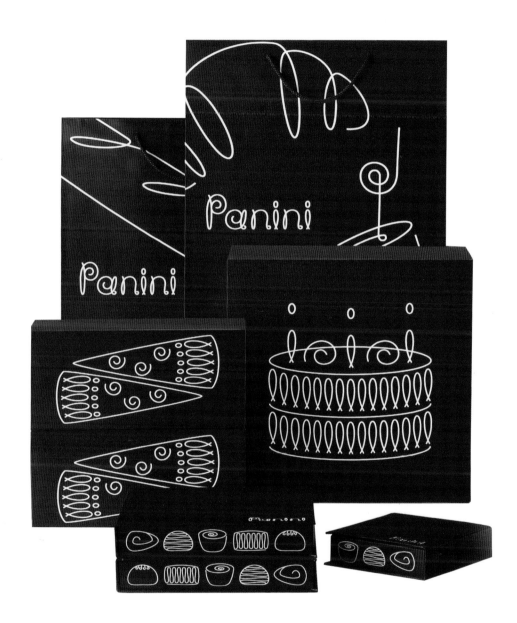

LYNWOOD

Blood Orange Marmalade

HOMEBASE

SOFT VANILLA WHITE

ᵀᴴᴱ WHITE ROOM®

A durable, wipeable emulsion for interior walls and ceilings

MATT EMULSION

HOMEBASE

SOFT THISTLE

ᵀᴴᴱ WHITE ROOM®

A quick drying, low odour, mid sheen paint for interior wood and metal

EGGSHELL

HASSELFORS
GARDEN

Naturgödslad
Plant
jord

Naturgødet Plantemuld/Naturgjødslet Plantejord
Till jordförbättring och plantuppdragning

50 liter

HASSELFORS
GARDEN

Dress
jord

Finnedress/Toppdressing
Ger en finare gräsmatta

50 liter

HASSELFORS
GARDEN

Bark
mylla

Barkmuld/Barkkompost
Luckrar besvärliga jordar

50 liter

HASSELFORS
GARDEN

Täck
bark

Dækbark/Dekkbark
Skyddar mot vinterkyla och ogräs

50 liter

Target Guest

AMOXICILLIN 500MG

Take: One capsule by mouth
three times daily.

qty: **30**
refills: **No**
Dr. Smith
disp: 02/27/05 REL
mfr: GENEVA NDC: 00781-2613-05
(877) 798-2743 Rx:**1234567**-0000

⊙ **TARGET PHARMACY**
900 Nicollet Mall
Minneapolis, MN 55401

AMOXICILLIN
Common Uses:

CAUTIONS

⚠ Important: Finish all this
medication unless otherwise
directed by prescriber.

Take with food or milk.

⊙ Some Medicines May Decrease The
Effectiveness Of Birth Control Pills.
Ask Your Doctor Or Pharmacist.

Drink Plenty Of Water While
Taking This Medicine

Patent Pending

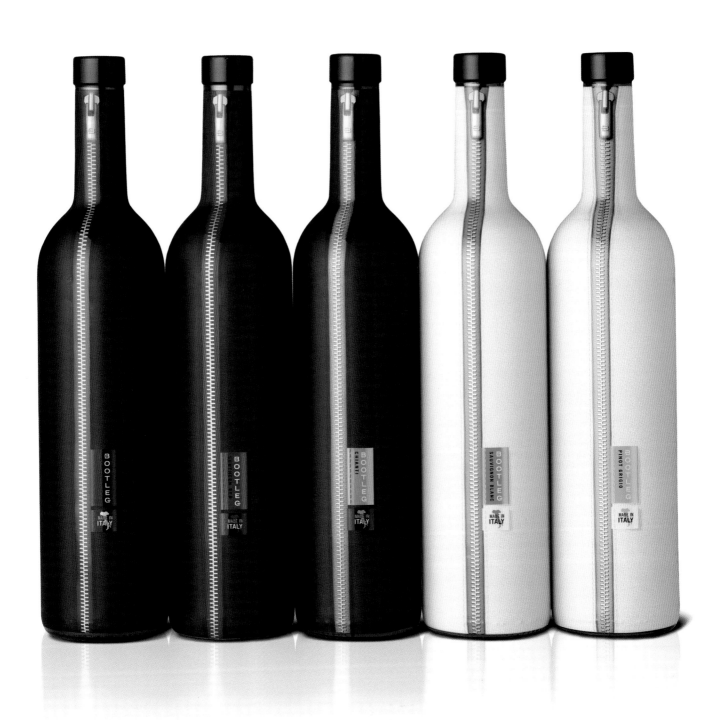

COLUMBIA VALLEY

WHITE TABLE WINE

COLUMBIA VALLEY

RED WINE

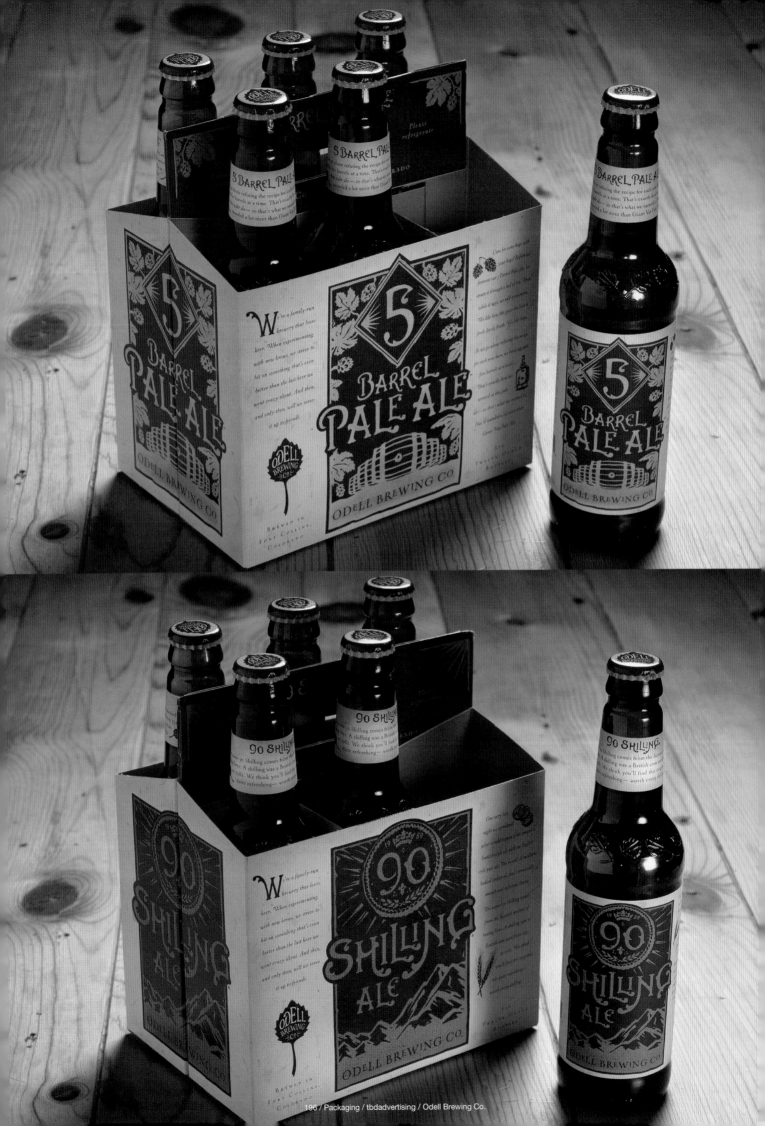

BLENDED WHISKEY

75
SOUTH

| BLENDED WHISKEY | 40% ALC./VOL (80 PROOF) | 1.75 LITERS |

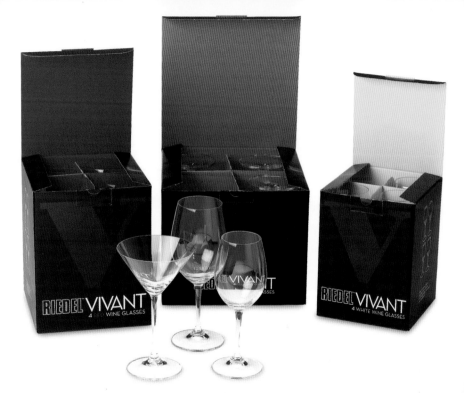

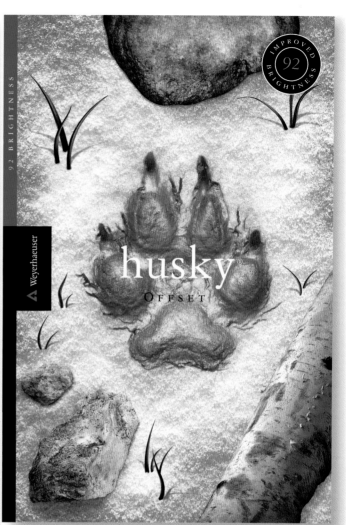

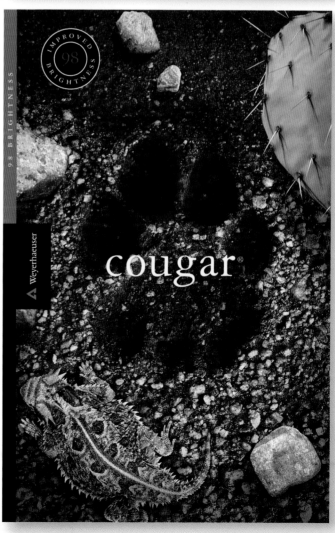

sappi

1

The Standard

A Sappi Guide to Designing for Print:

Tips, Techniques and Methods for

Achieving Optimum Printing Results

Prepress:

Preparing

Files

for Print

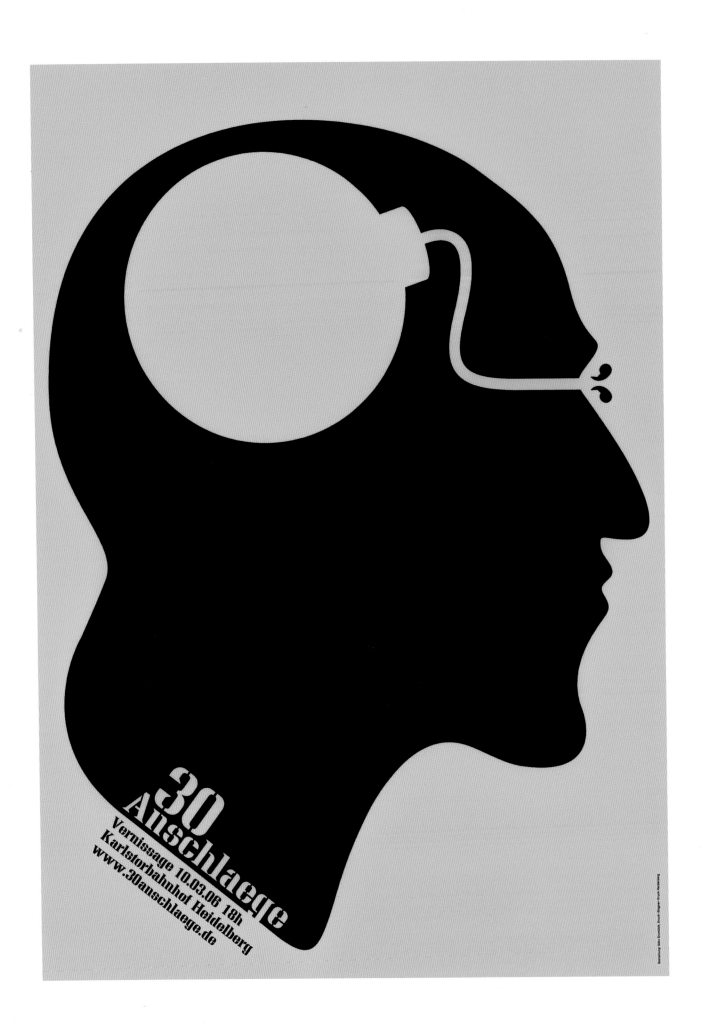

タイムトンネルシリーズ Vol.21　五十嵐威暢展『平面と立体の世界』

2005.10.31|月|−11.25|金| 11:00−19:00　土・日・祝祭日休館｜水曜日20:30終了｜入場無

[第1会場] クリエイションギャラリーG8 104-8001 東京都中央区銀座8-4-17リクルートGINZA8ビル1F tel:03-3575-6918 [第2会場] ガーディアン・ガーデン 104-0061 東京都中央区銀座7-3-5リクルートGINZA7ビルB1F tel:03-5568-8818 http://www.recruit.co.jp

主催:クリエイションギャラリーG8・ガーディアン・ガーデン｜協力:五十嵐威暢シリーズ展実行委員会｜五十嵐威暢の故郷・北海道と東京で様々な展覧会とイベントを開催。2005.10-12 「五十嵐威暢シリーズ展―デザインとアートの軌跡―」｜公式ウェブサイト:http://www.takanobuigarasi

PEET'S

SINCE 1966

SCHWAB

PEET'S COFFEE & TEA 40TH ANNIVERSARY WWW.PEETS.COM

ECOPOLIS

INSPIRED BY THE LAND

DIG PULL

Building as Noble Machine

Inertia
Inspiration
Dedication
Endurance Balance
Tempo Aerodynamics
Rhythm Geometry
Dynamism Gravity
Pacing Resistance
Tandemness Framing
Pelotony Leverage
Efficiency Symmetry
Viability Asymmetry
Mobility Branching Meeting
Effort Harmony Greeting
 Embarking
 Returning Vistas

Power Moment History Advocacy
Kinetics Axes Community Guidance
Recreation Mechanisms Mingling Art & Land
Sport Maintenance Celebration Stewardship
Vitality Stasis Tomorrow

ENERGY STRUCTURE LINKAGE VISION

INSPIREDBYPEDALPOWER

VELOCITY

From literary art to performing art, EPCOR is bringing the best of Alberta to Ottawa for the National Arts Centre Alberta Scene

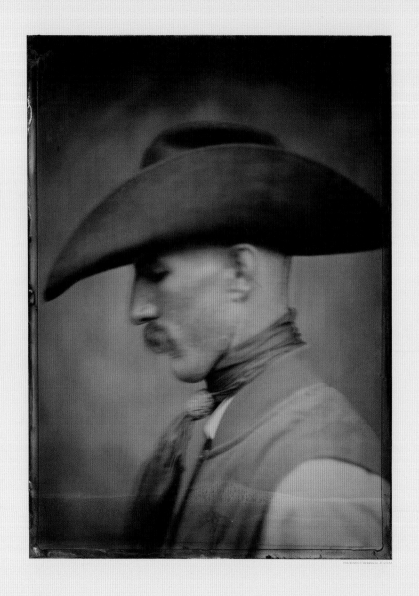

REVEALING CHARACTER

TEXAS TINTYPES *by* ROBB KENDRICK

UNIVERSITY OF
SAN FRANCISCO
150TH ANNIVERSARY
JESUIT ∷ EDUCATION

Vom Restposten zum Wachstumswunder

Gestern noch der absolute Renner, heute träge im Regal – wer mit Restposten, Überproduktionen oder Saisonartikeln Umsatz machen möchte, der braucht Durchblick, sprich: Vertixx. Denn wir durchleuchten nicht nur Ihren Warenbestand und sorgen für dessen optimale Platzierung auf den relevanten Online-Plattformen – sondern wir übernehmen auch den Verkauf und Versand sowie ein eventuelles Reklamations- und Retourenmanagement. Kurz: Wir kümmern uns um Ihren Zusatzumsatz. Und als Teil der Deutschen Telekom AG sind Zuverlässigkeit und Seriosität für uns selbstverständlich. Neugierig? Anruf oder Mail genügt: wachstumswunder@vertixx.de oder telefonisch unter 0800 7 72 46 30. Weitere Informationen: www.vertixx.de

vertixx.
persönlich.sicher.handeln.

Vom Produktionsüberhang zum Gewinnbringer

Gestern noch der absolute Renner, heute träge im Regal – wer mit Restposten, Überproduktionen oder Saisonartikeln Umsatz machen möchte, der braucht Durchblick, sprich: Vertixx. Denn wir durchleuchten nicht nur Ihren Warenbestand und sorgen für dessen optimale Platzierung auf den relevanten Online-Plattformen – sondern wir übernehmen auch den Verkauf und Versand sowie ein eventuelles Reklamations- und Retourenmanagement. Kurz: Wir kümmern uns um Ihren Zusatzumsatz. Und als Teil der Deutschen Telekom AG sind Zuverlässigkeit und Seriosität für uns selbstverständlich. Neugierig? Anruf oder Mail genügt: gewinnbringer@vertixx.de oder telefonisch unter 0800 7 72 46 30. Weitere Informationen: www.vertixx.de

vertixx.
persönlich.sicher.handeln.

Vom Restposten zum Umsatzrenner

Gestern noch der absolute Renner, heute träge im Regal – wer mit Restposten, Überproduktionen oder Saisonartikeln Umsatz machen möchte, der braucht Durchblick, sprich: Vertixx. Denn wir durchleuchten nicht nur Ihren Warenbestand und sorgen für dessen optimale Platzierung auf den relevanten Online-Plattformen – sondern wir übernehmen auch den Verkauf und Versand sowie ein eventuelles Reklamations- und Retourenmanagement. Kurz: Wir kümmern uns um Ihren Zusatzumsatz. Und als Teil der Deutschen Telekom AG sind Zuverlässigkeit und Seriosität für uns selbstverständlich. Neugierig? Anruf oder Mail genügt: umsatzrenner@vertixx.de oder telefonisch unter 0800 7 72 46 30. Weitere Informationen: www.vertixx.de

vertixx.
persönlich.sicher.handeln.

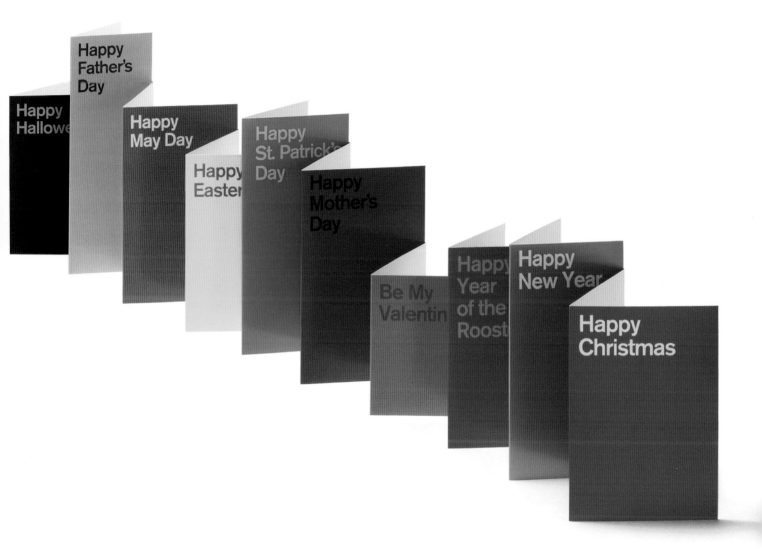

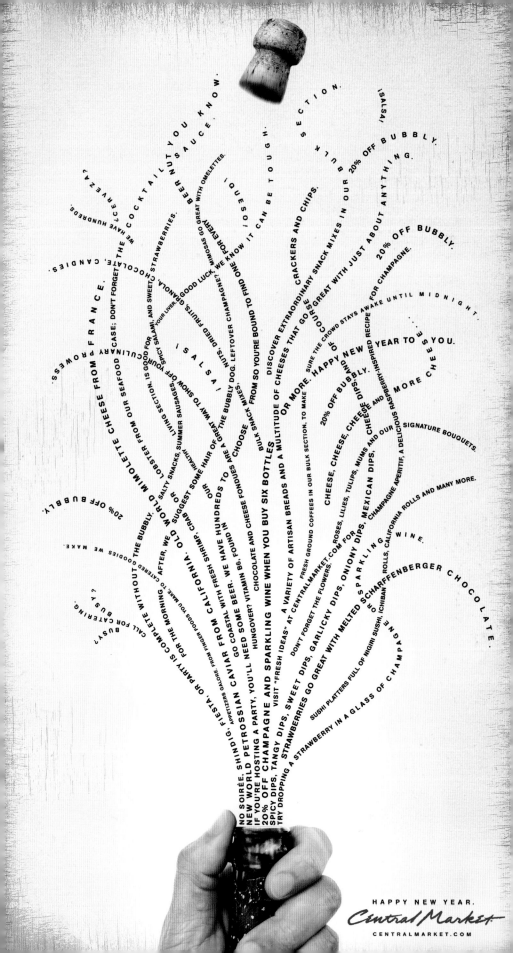

HAPPY NEW YEAR.
Central Market
CENTRALMARKET.COM

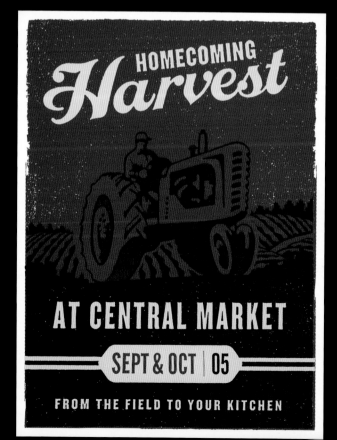

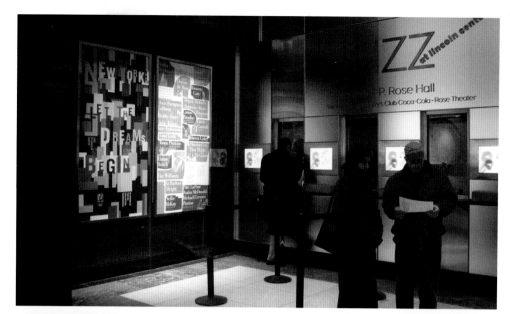

NEW YORK:
LET THE
DREAMS
BEGIN

WEDNESDAY
FEBRUARY 24

7:30 PM

JAZZ
AT LINCOLN
CENTER

NYC 2012.
CANDIDATE CITY

IN HONOR OF
THE IOC
EVALUATION
COMMISSION

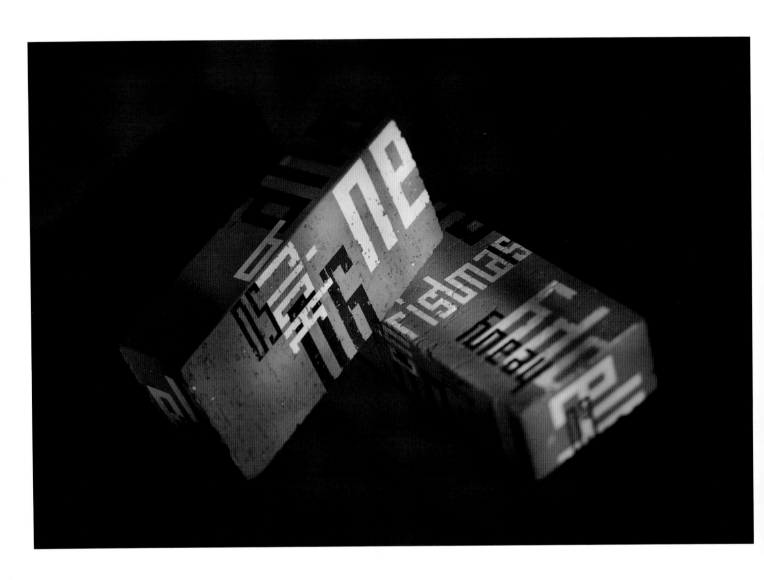

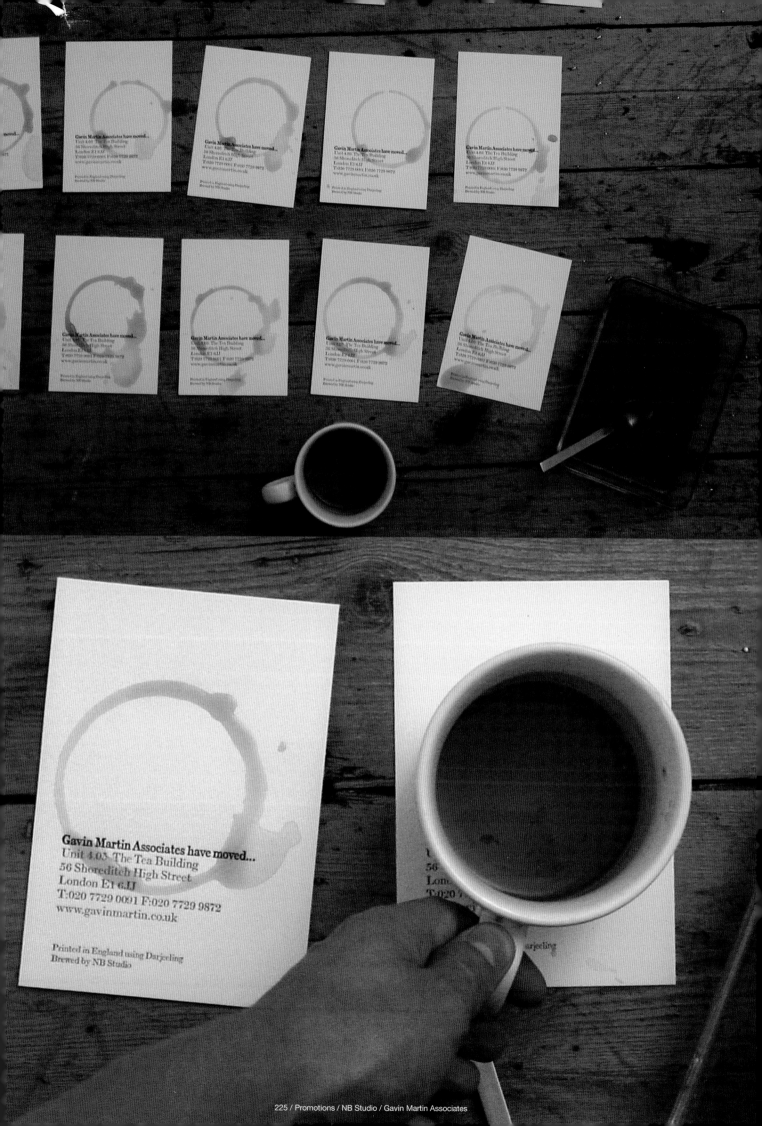

$1

PHAR LAP'S
racing silks

Australia

50c

SIR DONALD
BRADMAN'S
baggy green

Australia

$1

MARJORIE JACKSON'S
running spikes

Australia

50c

LIONEL ROSE'S
boxing gloves

Australia

Stamp image reproduced with permission from Australia Post. © Australia Post

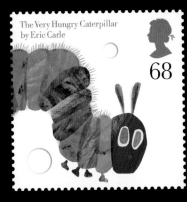

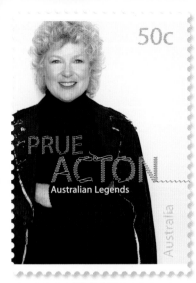

50c

PRUE
ACTON
Australian Legends
Australia

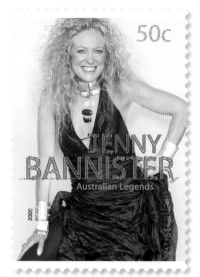

50c

JENNY
BANNISTER
Australian Legends
2005

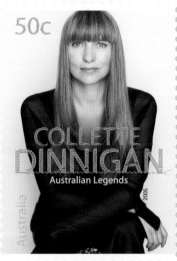

50c

COLLETTE
DINNIGAN
Australian Legends
Australia
2005

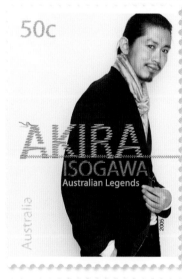

50c

AKIRA
ISOGAWA
Australian Legends
Australia
2005

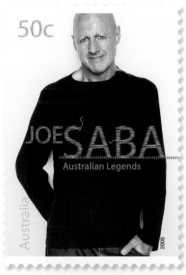

50c

JOE SABA
Australian Legends
Australia
2005

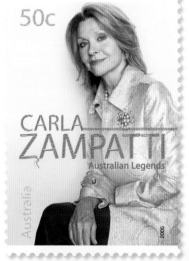

50c

CARLA
ZAMPATTI
Australian Legends
Australia
2005

Stamp image reproduced with permission from Australia Post © Australia Post

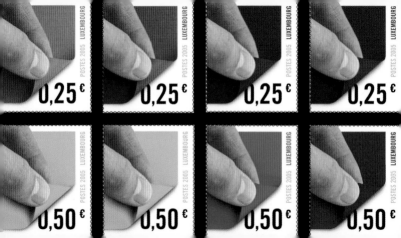

BACK

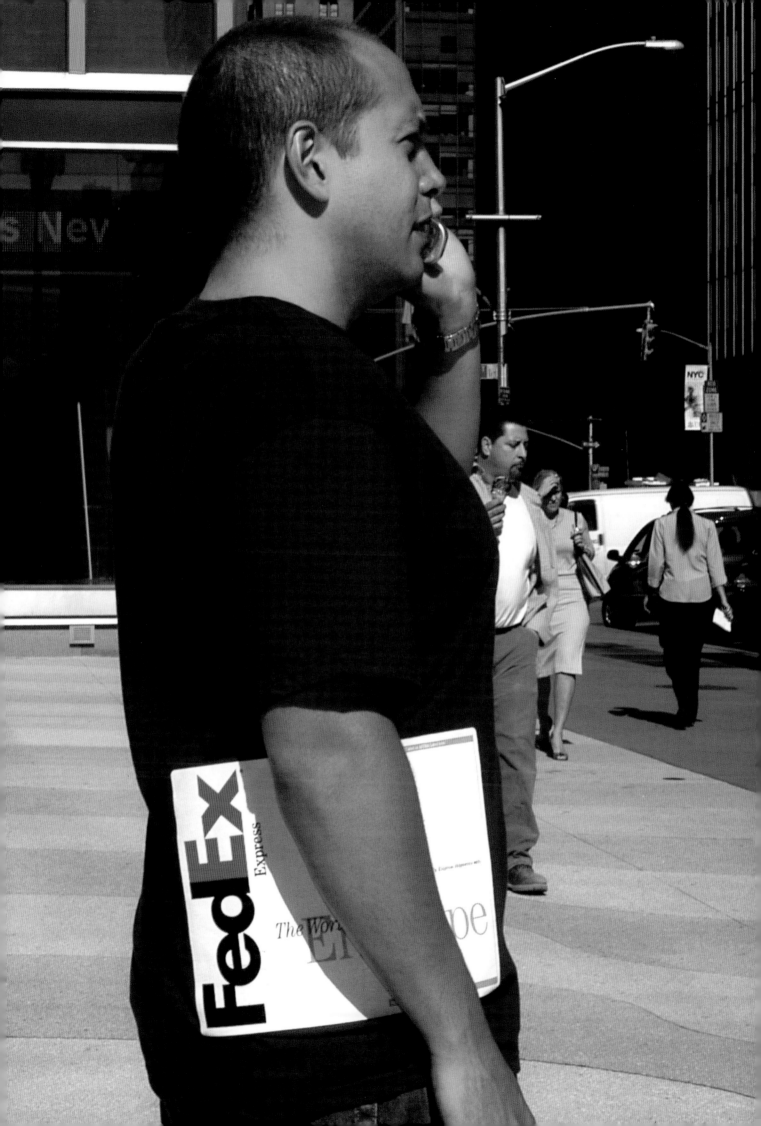

CARCLEW
AABCCDEEFFGHII
JKKLLMMNOOPQ
RSSTUUVWWXYZZ
&&?!! ??[].

Index

124 Design
Prins Hendrikkade 124
Amsterdam, NH
Netherlands
Phone: 31 0 206263062
Fax: 31 0 206383009
www.124design.com

A Charles Design
15 Glen Lake Drive
Pacific Grove, California
United States
Phone: 831 645 9842
www.acharlesdesign.com

Adapter
154-0004
SF Sasai-Building 1-1-13
Taishido Setagaya-ku
Tokyo, Japan
Tel/Fax: 81 0 5779 7374
www.adapter.jp

Addis
2515 Ninth Street
Berkeley, CA United States
Phone: 510 704 7500
www.addis.com

Addison
20 Exchange Place
18th Floor
New York, NY
United States
Phone: 212 229 5000
Fax: 212 929 3010
www.addison.com

Amerge
P.O. Box 4132 Wellington
Wellington, New Zealand
Phone: 64 4 4 384 3223

ANTHEM
35 South Park
San Francisco, CA
United States
Phone: 415 896 9399
Fax: 415 896 9387
www.anthemworldwide.com

Arih Advertising Agency
Celovska 32
Ljubljana, Slovenia
Phone: 386 1 43 41 700
Fax: 386 1 43 41 701
www.arihadvertisingagency.com

Atelier Trois Petits Points
68, rue Gabriel Peri
Montrouge, France
Phone: 0033149859834
www.3petitspoints.net

Authentic Fitness (Speedo)
6040 Bandini Boulevard
Los Angeles, CA
United States
Phone: 323 837 6537
Fax: 323 837 6108
www.authenticfitness.com
www.speedo.com

Bailey Lauerman
1299 Farnam Street
Suite 930
Omaha, NE
United States
Phone: 402 514 9400
Fax: 402 514 9401
www.baileylauerman.com

Bamboo
119 N. 4th St.
Ste. 503
Minneapolis, MN
United States
Phone: 612 332 7105
Fax: 612 332 7101
www.bamboo.com

Barkley Evergreen & Partners
423 W. 8th Street
Kansas City, MO
United States
816 842 1500
www.beap.com

BARLOCK bv
Pastoorswarande 56
the hague, Zuid-holland
Netherlands
Phone: 0031703451819
Email: bergmans@barlock.nl

BBDO Detroit
880 W. Long Lake Rd.
Troy, MI
United States
Phone: 248 293 3500
www.bbdo.com

BBDO New York
1285 Avenue of the Americas
6th floor
New York, NY
United States
Phone: 212 459 5000
www.bbdo.com

The Bradford Lawton Design Group, Inc.
1020 Townsend
San Antonio, Texas
United States
Phone: 210 832 0555
Fax: 210 832 0007
www.thebradfordlawtondesign-groupinc.com

Breeze Creative Design Consultants
15 Dominie Park
Balfron
Glasgow,
United Kingdom
Phone: 01360 449347
www.breeze-creative.com

Bussolati Associates
1541 14th Street, NW
Washington, DC
United States
Phone: 212 319 2222
Fax: 212 319 2223
www.bussolati.com

BVK/Serve
250 W Coventry Ct
Milwaukee, WI
United States
Phone: 414 228 1990
Fax: 414 228 7561
www.bvk.com

Cahan & Associates
171 Second Street, 5th Floor
San Francisco, California
United States
Phone: 415 621 0915
www.cahanassociates.com

California State University, Fullerton
821 W.Stevens Ave #16
Santa Ana, CA
United States
Phone: 714 585 3104

Canada Post
555 McArthur St Suite 14//
St-Laurent QC H4T 1T4
1 866 607 6301
(Outside Canada 1 416 979 8822)
www.canadapost.ca/

Carmichael Lynch Thorburn
800 Hennepin Avenue
Minneapolis, MN
United States
Phone: 612 334 6000
www.clynch.com

CARRIO/SANCHEZ/LACASTA
Madrid, Spain
Phone: 914016855
www.retemail.es

Cento per Cento s.r.l
Via Montevideo 11a-20144
Milan, Italy
Phone: 39 0248 0127 62
www.pitacco.com

Clemenger Design
Clemenger BBDO
House 8 Kent Terrace
Wellington, New Zealand
Phone: 04 802 3362
www.clemengerdesign.co.nz

Communication Arts Inc.
1112 Pearl Street
Boulder, Colorado
United States
Phone: 303 447 8202
Fax: 303 440 7096
www.commarts-boulder.com

Communications for Learning
395 Massachusetts Avenue
Arlington, MA
United States
Phone: 781 641 2350
Fax: 781 646 9873
www.thecia.net

Concrete Design Communications Inc.
2 Silver Avenue
Toronto, Ontario
Canada
Phone: 416 534 9960
Fax: 416 534 2184
www.concrete.ca

Creactis
Grand-Rue 12 Case postale 46,
Tavannes, Switzerland
Phone: 41 32 4812173
www.creactis.ch

Damashek Consulting / CollectiveLab
390 - 1st Avenue
Suite 14B
New York, NY, 10010
United States
Phone: 212 253 5859

Danielle Foushee Design
10865 Bluffside Dr #308
Studio City, CA
United States
Phone: 818 613 7459
www.daniellefoushee.com

Design Center Ltd.
Knezova 30
Ljubljana, Slovenia
Phone: 386 1 5195072
Fax: 386 1 5195072

The Designory
211 East Ocean Blvd.
Ste. 100
Long Beach, California
United States
Phone: 562 624 0200
Fax: 562 432 3518
www.designory.com

DNA Design
262-264 Thorndon Quay
P.O. Box 3056
Wellington,
New Zealand
Phone: 64 4 4990828
Fax: 64 4 499 0888
www.dnadesign.com

Duffy & Partners
710 2nd Street South Suite 602
Minneapolis, MN
United States
Phone: 612 548 2333
www.duffy.com

Elevator
Bana Berislavica 1
Split, Croatia
(local Name: Hrvatska)
Phone: 098 434556
www.elevator.com

emerystudio
80 Market Street
Southbank, Victoria
Australia
Phone: 61 3 9699 3822
Fax: 61 3 9690 7371
www.emerystudio.com

Epigram
75 Sophia Road
Singapore, Singapore
Phone: 65 62924456
www.epigram.com.sg

Equus Design Consultants Pte Ltd
8B Murray Terrace
Singapore, Singapore
Phone: 63232996
Fax: 63232991
www.equus-design.com

Esopus Magazine
532 LaGuardia Place, #486
New York, New York 10012
Phone: 212 473 0919
Fax: 212 473 7212
www.esopusmag.com

Evenson Design Group
4445 Overland Ave
Culver City, CA
United States
Phone: 310 204 1995
Fax: 310 204 4879
www.evensondesigngroup.com

Fabrica
Via Ferrarezza
31020 Catena Di Villorba
Italy
Tel: 39 0422 516111
Fax: 39 0422 516308

Flow Creative
1644 North Honore Suite 105
Chicago, IL
United States
Phone: 773 276 4425
Fax: 773 276 4425
www.flowcreative.net

Foote Cone & Belding (Shanghai)
26/F Eastern Tower, No.689
Beijing Rd
Shanghai, China
Phone: 86 21 63609298
www.shanghai.fcb.com

Frost Design
Level 1, 15 Foster Street
Surry Hills, NSW
Australia
Phone: 61 2 9280 4233
Fax: 61 2 9280 4266
www.frostdesign.com.au

FutureBrand
300 Park Avenue South 5th Fl
New York, NY
United States
Phone: 212 931 6300
www.futurebrand.com

gggrafik-design
Treitschkestrasse 3
Heidelberg, Baden Wuertemberg
Germany
Phone: 0049 6221 8901656
www.gggrafik.de

Giorgio Davanzo Design
232 Belmont Ave E #506
Seattle, WA
United States
Phone: 206 328 5031
www.davanzodesign.com

Goodby, Silverstein & Partners
P.O. Box 3
Cedarville, Ohio
United States
937 766 3749

Gouthier Design: a brand collective
2604 NW 54 Street
Fort Lauderdale, Florida
United States
Phone: 954 739 7430
Fax: 954 739 3746
www.gouthier.com

GQ Magazine
4 Times Square
New York, NY
United States
Phone: 212 286 7523
Fax: 212 286 8515
www. condenast.com

Graphic Design, Apple Computer
1 Infinite Loop
MS 83-PPS
Cupertino, CA
United States
Phone: 408 974 5286
Fax; 408 974 9649
www.apple.com

Graham Hanson Design LLc
60 Madison Avenue Floor 11
New York, NY
Phone: 212 481 2858
Fax: 212 481 0784
www.jghgrahamhanson.com

Graphics & Designing Inc.
3-3-1 Shirokanedai,Minato-ku
Tokyo, Japan
Phone: 81 3 3449 0651
Fax: 81 3 3449 0653

Green Mantis Design
1548 Mapleton Dr.
Dallas, TX
United States
Phone: 214 738 6056

Haase & Knels + Schweers
Franziskanerstr. 1-2
28195 Bremen, Germany
Phone: 0421 33 498 22
Fax: 0421 33 498 33
www.haase-und-knels.de

Harcus Design
3/46 Foster Street
Surry Hills
Sydney, NSW
Australia
Phone: 61 2 9212 2755
Fax: 61 2 9212 2933
www.harcusdesign.com

häfelinger+wagner design
Türkenstr. 55-57
Munich, Bavaria Germany
Phone: 498920257510
Fax: 498920239696
www.hwdesign.de

Hans Heinrich Sures
23 Barrington Road
Crouch End
London, London
United Kingdom
Phone: 44 0 208 348 0995
Fax: 44 0 208 348 0995

Harper Collins
10 East 53rd Street
New York, NY 10022
Telephone: 212 207 7014
Fax: 212 207 7904
www.harpercollins.com

Henderson Bromstead Art
101 W 4th Street
Winston-Salem, NC
United States
Phone: 336 7481364
Fax: 336 7481364
www.hendersonbromsteadart.com

HKLM
Building B No 4 Kikuyu Road,
Sunninghill Johannesburg,
Gauteng South Africa
Phone: 011 461 6600
www.hklm.co.za

Hornall Anderson Design Works
1008 Western Avenue, Suite 600
Seattle, WA
United States
Phone: 206 467 5800
www.hadw.com

Hort
Egenolffstrasse 29
60316 Frankfurt
Germany
Phone: 49 69 944 198 20
Fax: 49 69 944 198 21
www.hort.org.uk

Hoyne Design Pty Ltd.
Level 1, 77a Acland Street
St. Kilda, Victoria
Australia
Phone: 61 3 9537 1822
Fax: 61 3 9537 1833
www.hoyne.com.au

ico Design Consultancy
75-77 Great Portland Street
London,
United Kingdom
Phone: 020 7323 1088
Fax: 020 7323 1245
www.icodesign.co.uk

IKD Design Solutions
173 Fullarton Road
Dulwich, SA
Australia
Phone: 61 8 8332 0000
Fax: 61 8 8364 0726
www.ikdesign.com.au

Initio Advertising
212 Third Ave N
Minneapolis, Minnesota
United States
Phone: 612 339 7195
www.initioadvertising.com

ixo
2837.5 Sheridan Place
Evanston, Illinois
United States
Phone: 847 997 3266
www.ixovision.com

Jens Lattke
Phone: 0931 660660
Schlo Reichenberg
Reichenberg 97234
Germany
www.lattkeundlattke.de

Kellerhouse Inc.
3781 Greenwood Avenue
Mar Vista, California
United States
Phone: 310.915.0191
Fax: 310.915.0212
www.kellerhouse.com

Kevin Mackintosh
United Kingdom
www.pearcestoner.com

KMS Team GmbH
Deroystr. 3-5
Munich, Bavaria
Germany
Phone: 004989 490411 0
Fax: 004989 490411 49
www.kms-team.de

Kostym
Box 216
Karlstad, Sweden
Phone: 4654102444
Fax: 4654102099
www.clara.se

Kristin Johnson
118 Oak Street
Brooklyn, NY
United States
Phone: 612 202 9315

Kuhlmann Leavitt, Inc.
7810 Forsyth Blvd., 2W
St. Louis, MO
United States
Phone: 314 725 6616
Fax: 314 725 6618
www.kuhlmannleavitt.com

Landor Associates
1001 Front Street
San Francisco, CA
United States
Phone: 415 365 1700
Fax: 415 365 3188
www.sfo.landor.com

Leo Burnett
3310 West Big Beaver Rd.
Suite 107
Troy, Michigan 48084
United States
Phone: 248 458 8300
Fax: 248 458 8729
www.leoburnett.com

Les Cheneaux Design
124 East Reed Ave
Bowling Green, OH
United States
Phone: 419 409 0568

Lewis Moberly
33 Gresse Street
London,
United Kingdom
Phone: 44 0 207 580 9252
Fax: 44 0 207 255 1671
www.lewismoberly.com

Lippincott Mercer
499 Park Avenue
New York, NY United States
Phone: 212 521 0037
Fax: 212 754 2591
www.lippincottmercer.com

Liska + Associates
515 N. State St., 23rd Floor
Chicago, IL United States
Phone: 312 644 4400
www.liska.com

Lloyd (+ co)
80 Varick Street, Suite 1018
New York, NY
United States
Phone: 212 414 3100
Fax: 212 414 3113
www.lloydandco.com

Luckie & Company
600 Luckie Drive
Birmingham, Alabama
United States
Phone: 205.879.2121
Fax: 205.877.9855
www.luckie&company.com

Maclaren McCann
600, 926 – 5 Avenue SW
Calgary, Alberta
Canada
Phone: 403.261.7155
www.maclaren.com

Matsumoto Incorporated
127 West 26th Street, 9th Floor
New York, NY
United States
Phone: 212 807 0248
Fax: 212 807 1527
www.matsumotoinc.com

MBA
5250 S Capital of Texas Hwy
Bldg 2, Ste 325
Austin, TX United States
512 971 7820

McGarrah/Jessee, CHAOS
205 Brazos
Austin, Texas
United States
Phone: 512 225 2000
Fax: 512 225 2020
www.mc-j.com

Meta4 Design
11 West Superior, Suite 504
Chicago, IL
United States
Phone: 312 337 4674
www.meta4design.com

Michael Courtney Design
121 E. Boston
Seattle, WA
United States
Phone: 206 329 8188
www.michaelcourtneydesign.com

Michael Schwab Studio
108 Tamalpais Ave
San Anselmo, CA
United States
Phone: 415 257 5792
Fax: 415 257 5793
www.michaelschwab.com

Michael Solve
3-78 High Street, 6/F Flat 8,
Fang Sing Mansion,
Tai Ying Poon, Hong Kong
A Perfect Commercial,
5 Sharp Street West,
Wanchai, Hong Kong
Hong Kong, Comoros
Phone: 852 900938703
www.michaelsolve.com

Mirko Ilic Corp.
207 East 32nd St.
New York, NY
United States
Phone: 212 481 9737
www.mirkoilic.com

Moses Media
84 Broadway, Suite 607
New York, NY
United States
Phone: 212 625 0331
Fax: 212 625 0332
www.mosesmedia.com

Mytton Williams
15 St James's Parade
Bath, United Kingdom
Phone: 44 0 1225 442634
Fax: 44 0 1225 442639
www.myttonwilliams.co.uk

National Geographic Books
1145 17th Street, NW
Washington, DC, DC
United States
Phone: 202 862 8264
Fax: 202 429 5727
Email: czotter@ngs.org

NB Studio
4-8 Emerson St.
London, United Kingdom
Phone: 020 7633 9046
Fax: 020 7580 9196
www.nbstudio.co.uk

**New Moment
New Ideas Company**
Hilandarska 14
Belgrade, Serbia and Montenegro
Yugoslavia
Phone: 381 11 3229 992
Fax: 381 11 3346 560
www.newmoment.com

The New York Times
229 W 43rd St
New York NY 10036 3913
Phone: 212 556 1234
www.nytimes.com

NOISE, Inc.
1863 North Farwell Avenue
Milwaukee, WI
United States
Phone: 414 226 4900
Fax: 414 226 4901
www.make-noise.com

Ó!
Armuli 11
Reykjavik, Iceland
Phone: 354 562 3300
www.o!.com

**osamu misawa
desigh room co., Ltd.**
#413
5-4-35
minamiaoyama
minato-ku
Tokyo, Japan
Phone: 81 3 5766 3410
Fax: 81 3 5766 3411
www.omdr.co.jp

Palazzolo Design
6410 Knapp St NE
Ada, MI
United States
Phone: 616 676 9979
Fax: 616 676 1579
www.palazzolodesign.com

Pentagram San Francisco
387 Tehama Street
San Francisco, California
United States
Phone: 415 896 0499
Fax: 415 541 9106
www.sf.pentagram.com

Pentagram Design UK
11 Needham Road
London, London
United Kingdom
Phone: 020 7229 3477
Fax: 020 7727 9932
www.pentagram.co.uk

Peterson Ray & Company
311 N Market Street, Suite 311
Dallas, Texas
United States
Phone: 214 954 0522
www.peterson.com

pfw design
127 Main Street Dobbs Ferry
New York United States
Phone: 914 482 1969
www.pfwdesign.net

q30design inc.
416 596 6500
489 King St. W. Suite 400
Toronto, ON
Canada
www.q30design.com

Rand McNally
8255 North Central Park Ave
Skokie, IL
United States
Phone: 847 329 6256
www.randmcnally.com

RBMM
7007 Twin Hills, Suite 200
Dallas, TX
United States
Phone: 214 987 6500
Fax: 214 987 3662

Riordon Design
131 George Street
Oakville, ON
Canada
Phone: 905 339 0750
www.riordondesign.com

RMAC Brand Design
Calçada do Sacramento 18
2º dtº - Chiado
1200-394 Lisboa
Portugal
Phone: 351 213 514 180
Fax: 351 213 433 283
www.ricardomealha.com

The ROC Company
158 Greenwood Avenue
Bethel, CT 06801
United States
Phone: 203 778 2303
www.therocco.com

Ron Taft Design
PMB 372
2934 Beverly Glen Circle
Los Angeles, CA
United States
Phone: 818 990 5967

Rose Design Associates Ltd.
70 St Marychurch Street
London, England
Phone: 020 7394 2800
Email: sarah@rosedesign.co.uk

Rubberbandland
4-21-5 Saginomiya, Nakano-ku
Tokyo
Japan
Phone: 81 3 3330 0876
Fax: 81 3 3330 0876
www.rubberbandland.com

Saatchi + Saatchi Los Angeles
3501 Sepulveda Blvd.
Torrance, CA
90505
Phone: 310 214 6000
Fax: 310 214 6160
www.saatchila.com

Saint Hieronymus Press
1703 Martin Luther King, Jr. Way
Berkeley, CA
United States
Phone: 510 549 1405
www.goines.net

Sandstrom Design
808 SW 3rd Avenue Ste. 610
Portland, OR
United States
Phone: 503 248 9466
Fax: 503 227 5035
www.sandstromdesign.com

**Savage Design
(Ann Nava, Paula Savage)**
4203 Yoakum Blvd., 4th Floor
Houston, TX
United States
Phone: 713 522 1555
Fax: 713 522 1582
www.savagedesign.com

School of Visual Arts
209 East 23 Street
NY, NY 10010-3994
United States
Tel: 212 592 2000
Fax: 212 725 3587
www.schoolofvisualarts.edu

**Sieger Design GmbH
& Co. KG**
Schloss Harkotten
Sassenberg, Germany
Phone: 49 54 26/94 92 22
Fax: 49 54 26/94 92 39
www.sieger-design.com

Shin Matsunaga
98-4, Yarai-cho, Shinjuku-ku
Tokyo,
Japan
Phone: 81 3 5225 0777
Fax: 81 3 3266 5600
http://homepage.mac.com/dino3/
antinuke/french95/doc/
shin_matsunaga.html

Shine Advertising
612 W Main Street
Suite 105
Madison, WI
United States
Phone: 608 442 7373
www.shinenorth.com

Siegel & Gale LLC
437 Madison Avenue
12th Floor
New York, NY
United States
Phone: 212 817 6650
Fax: 212 817 6680
www.siegelgale.com

Sonner, Vallee u. Partner
Eduard-Schmid-Str. 2
Muenchen, Germany
Phone: 49 0 89 767768 3
www.sonnervallee.de

Sotheby's
1334 York Avenue
New York, NY
United States
Phone: 212 894 1231
Fax: 212 894 1231
www.sothebys.com

Spark Studio
Phone: 61 03 9686 4703
Address: 11 Yarra Street
South Melbourne
Melbourne, Victoria
Australia
sean@sparkstudio.com.au

Squires & Company
2913 Canton Street
Dallas, TX
United States
Phone: 214 939 9194
www.squirescompany.com

Stand Advertising
2351 N. Forest Road Amherst,
New York United States
716 210 1065
www.standad.com

Steven Wilson
United Kingdom
www.pearcestoner.com

Stromme Throndsen Design
Holtegata 22
Oslo, Norway
Phone: 47 22963900
Fax: 47 22963901
www.stdesign.no

STORY
401 W. Superior Street
Chicago, IL United States
Phone: 312 642 3173
www.storyco.tv

Studio Dumbar
Lloydstraat 21
3024 EA Rotterdam
the Netherlands
Telephone: 31 0 10 448 22 22
Fax: 31 0 10 448 22 44
www.studiodumbar.com

Sukle Advertising & Design
2430 West 32nd Avenue
Denver, CO
United States
Phone: 303 964 9100
www.sukleadvertisingagency.com

Sutton Cooper
7 King William IV Gardens
Penge
London,
United Kingdom
Phone: 0208 776 8101
Fax: 0208 659 6692
www.suttoncooper.com

Takeshi Hamada
Tokyo-Japan
www.hamada-takeshi.com

Tangram Strategic Design s.r.l.
Viale Michelangelo Buonarroti 10B
Novara, Italy
Phone: 39 0321 35 662
Fax: 39 0321 390 914
www.tangramsd.it

Target
1000 Nicollet Mall
TPS-2777
Minneapolis, MN
United States
Phone: 612 696 4446
www.target.com

TAXI
495 Wellington Street West, Suite 102
Toronto, Ontario
United States
Phone: 416 979 7001
Fax: 416 979 7626
www.taxi.ca

tbdadvertising
327 NW Greenwood Ave
Suite 100
Bend, Oregon
United States
Phone: 541 388 7558
Fax: 541 388 7532
www.tbdadvertising.com

Team One
1960 E. Grand Avenue
El Segundo, CA
United States
Phone: 310 615 2000
Phone: 310 615 2138
www.teamone.com

Thinking Caps
407 West Osborn
Suite 200
Phoenix, AZ
United States
Phone: 602 495 1260
Fax: 602 495 1258
www.thinkingcaps.com

Thomas Manss & Company
3 Nile Street
London,
United Kingdom
Phone: 020 7251 7777
www.manss.com

Tim Frame Design
P.O. Box 3
Cedarville, Ohio
United States
Phone: 937 766 3749

Tomlinson Inc.
54 State St.
Newburyport, MA
United States
Phone: 978 499 9699
Fax: 978 499 9799
www.tomlinsoninc.com

**Turner & Duckworth
(Lisa Bennett)**
831 Montgomery St.
San Francisco, CA
United States
Phone: 415 6757777
Fax: 415 6757778
www.turnerduckworth.com

Vanderbyl Design
171 2nd Street
2nd Floor
San Francisco, CA
United States
Phone: 415 543 8447
Fax: 415 543 9058
www.vanderbyl.com

VehicleSF
275 Sixth Street
San Francisco, CA
United States
Phone: 415 882 3414
Fax: 415 777 0370
www.vehiclesf.com

Venables, Bell & Partners
201 Post Street,
Suite 200
San Francisco, CA
United States
Phone: 415 288 3300
Fax: 415 421 3683
www.venablesbell.com

Vic Huber
1731 Reynolds Avenue
Irvine, CA
United States
Phone: 949 261 5844
Fax: 949 261 5973

Webster Design Associates
5060 Dodge Street
Suite 2000
Omaha, NE
United States
Phone: 402 551 0503
Fax: 402 551 1410
www.websterdesign.com

Weymouth Design
332 Congress Street
Boston, MA
United States
Phone: 617 542 2647
Fax: 617 451 6233
www.weymouthdesign.com

WXS
Herengracht 572
Amsterdam,
Netherlands
Phone: 31 20 6209 353
www.wxs.nl

ZIBA Design, Inc.
334 NW 11th Avenue
Portland, OR
United States
Phone: 503 223 9606
Fax: 503 223 9785
www.zibadesigninc.com

Zink Magazine
304 Park Avenue South
Penthouse South
New York, NY 10010
United States
Phone: 646 792 2333
ZinkMag.com

Award Winning Designers

Honored Clients

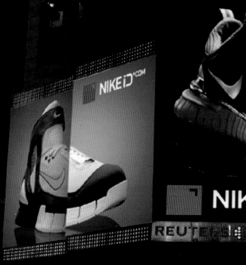

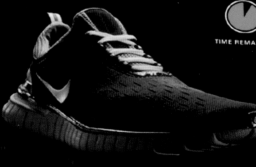

www.graphis.com

NewGraphisTitles

PosterAnnual2005

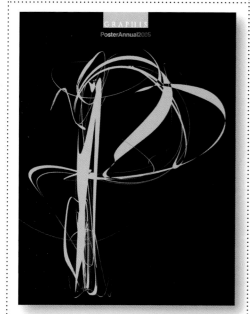

April 2005
Hardcover: 256 pages;
250 plus color illustrations

Trim: 7 x 11 13/16"
ISBN: 1-931241-43-0
US $70

Graphis Poster Annual 2005 presents outstanding Poster Design by the world's leading Graphic Designers. This edition shows a variety of graphic virtuosity and modes of expression that only this powerful medium makes possible. Featuring commentary with Poster collector Rene Wanner from Basel, Switzerland and a Q+A with the Ginza Graphic Gallery Creative Team on what qualifies posters for their museum design collection, and what they predict may be the values in the future.

NewTalentDesignAnnual2006

Summer 2006
Hardcover: 256 pages;
300 plus color illustrations

Trim: 7 x 11 13/16"
ISBN: 1-932026-23-1
US $70

The only international forum for the best work produced by students internationally. *New Talent* provides young talent a rare opportunity for exposure and recognition. It also serves as an unmatched resource for Design and Advertising firms seeking new talent. In classic Graphis quality, the featured work presented shows fresh and innovative examples of effective Advertising, Branding, Illustration, Product Design and more. Detailed indices and credits for the students, schools and teachers complete the book.

PosterAnnual2006

Summer 2006
Hardcover: 256 pages;
200 plus color illustrations

Trim: 8 1/2 x 11 3/4"
ISBN: 1-932026-25-8
US $70

Graphis Poster Annual 2006 features the year's finest Poster Designs, selected from thousands of international entries. In addition, this year's collection contains an essay by the internationally celebrated Designer, Milton Glaser, on his process for designing two socially significant posters. The selected, award winning Posters were produced for various corporate and social causes, and clearly illustrate the power and potential of the Poster as a forceful, visual medium.

DesignAnnual2004

October 2004
Hardcover: 256 pages;
300 plus color illustrations

Trim: 8 1/2" x 11 13/16"
ISBN: 1-931241-32-5
US $70

Graphis Design Annual 2004 proudly showcases more than 300 of the year's most outstanding designs in a variety of disciplines. The selected work reflects both current trends and classic interpretations of design solutions, all conveniently categorized in sections such as Corporate Identity, Exhibit, Product, Interactive and Typography Design. The *Graphis Design Annual* is an essential reference. This year's annual features Q&As with Iranian designer Reza Abedini and Swiss designer Melchior Imboden.

NewTalentDesignAnnual2005

Spring 2005
Hardcover: 256 pages;
300 plus color illustrations

Trim: 7 x 11 3/4"
ISBN: 1-931241-44-9
US $70

Firms looking for new talent and professionals looking for fresh ideas find the *New Talent* series an inexhaustible resource. The premier international forum for students about to enter the professional arena, *New Talent* gives young professionals a rare opportunity for exposure and recognition. Showcased in lavish color, the featured work includes examples of effective Advertising, Corporate Identity Design, Illustration, Product Design and more, all prepared for school assignments.

DesignAnnual2006

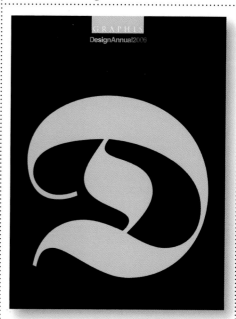

October 2005
Hardcover: 256 pages;
300 plus color illustrations

Trim: 8 1/2 x 11 3/4"
ISBN: 1-931241-47-3
US $70

Graphis Design Annual 2006 is the first Annual ever produced by Graphis and has been a consistent best seller. The definitive presentation of more than 300 of the year's most outstanding graphic work produced in all the design disciplines. The award winning work is conveniently categorized for easy refrencing into sections such as Annual Reports, Corporate Identity, Editorial. Exhibits, Interactive, Letterheads, Logos, Packaging, and Typographic Design with an extensive index.

Available at www.graphis.com or 212-532-9387

Graphis — THE BEST IN ASIA & OCEANIA
Advertising

Graphis — THE BEST IN EUROPE & AFRICA
Photography

Graphis — THE BEST IN THE AMERICAS
Design&Art